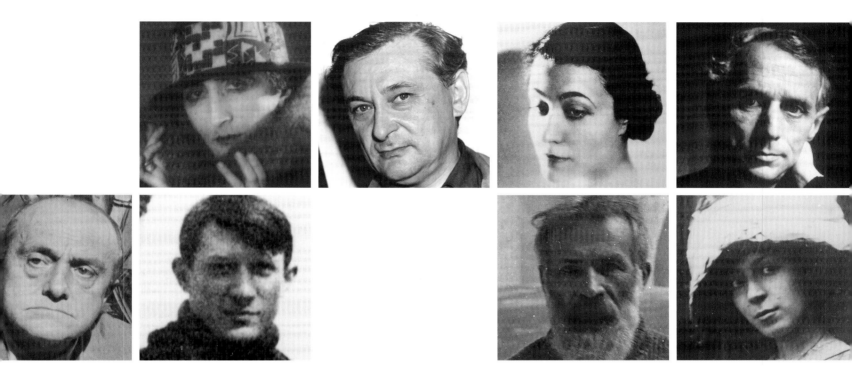

PARIS PORTRAITS: *Artists, Friends, and Lovers*

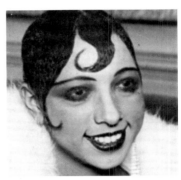

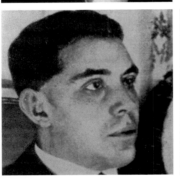

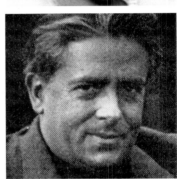

PARIS PORTRAITS

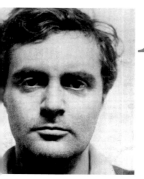
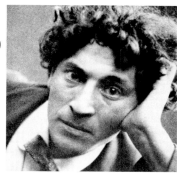
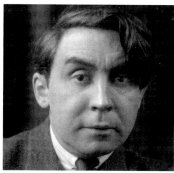
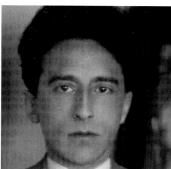

Artists,

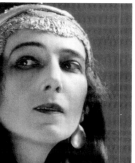
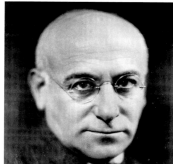

Friends,

and Lovers

by Kenneth E. Silver

with catalogue entries
by Abigail D. Newman

Bruce Museum, Greenwich, Connecticut
in association with Yale University Press

This catalogue is published in conjunction with the exhibition *Paris Portraits: Artists, Friends, and Lovers,* organized by the Bruce Museum, Greenwich, Connecticut, September 27, 2008–January 4, 2009.

Published by Yale University Press, New Haven and London
Colormatching by Kirkwood Printing Company, Wilmington, Massachusetts
Printed by CS Graphics, Singapore

Catalogue designer: Anne von Stuelpnagel
Copy editor: Fronia W. Simpson
Proof reader: Kathy Reichenbach

Exhibition Coordinator: Abigail D. Newman
Registrar: Jack Coyle

Library of Congress Cataloging-in-Publication Data
Silver, Kenneth E.
Paris portraits : artists, friends, and lovers / Kenneth E. Silver.
p. cm.
Catalog of an exhibition at the Bruce Museum, Greenwich, held Sept. 27, 2008-Jan. 4, 2009. Includes bibliographical references.
ISBN 978-0-300-14543-4 (alk. paper)
1. Paris (France)—Biography—Portraits—Exhibitions.
2. Portraits, European—20th century—Exhibitions.
1. Bruce Museum. II. Title.
N7604.S55 2008
704.9'420940904—dc22
2008029553

Cover:
Max Ernst (French, born Germany, 1891–1976)
Gala Eluard, 1924
Oil on canvas
81.3 x 65.4 cm
The Metropolitan Museum of Art,
The Muriel Kallis Steinberg Newman Collection,
Gift of Muriel Kallis Newman, 2006 (2006.32.15)
(Cat. 14)

CONTENTS

WELCOME

Van Cleef & Arpels and Betteridge Jewelers are delighted to share the signal honor of jointly sponsoring the Bruce Museum's centennial exhibition *Paris Portraits: Artists, Friends, and Lovers*.

At no other time and place was the art of portraiture as rich in expressive potential as early-twentieth-century Paris. The cult of personality that drove the brilliant careers of Pablo Picasso, Henri Matisse, Marc Chagall, and Marcel Duchamp, among others, demanded new forms of human likeness. While naturalistic portraiture still flourished in the French capital, entirely unprecedented kinds of portraits—Fauve, Cubist, Dada, Surrealist, and Expressionist—now joined the avant-garde *comédie humaine*. This exhibit will be the first, by any museum, to present the great mosaic of Parisian art as a "group portrait" of its leading practitioners.

Just as French art was defining a new aesthetic sensibility, jewelry design and manufacture were evolving in ways similar to the changes that were occurring in art and society at the turn of the century. Van Cleef & Arpels, founded in Paris in 1906 by Alfred Van Cleef and his brothers-in-law Charles and Julien Arpels on the place Vendôme, was a pioneer in the evolution of jewelry design during this period. The house's distinctive creativity combined with the jewelry makers' masterful use of only the world's top-quality gemstones became quickly desired across the globe. Such iconic stars as Marlene Dietrich, Elizabeth Taylor, Grace Kelly, and Eva Perón were clients, as were several bespoke members of some of the most famous royal families.

Across the Atlantic, Betteridge Jewelers was opening its first stores on Fifth Avenue and Wall Street, and soon thereafter at its current location at 117 Greenwich Avenue. A local Greenwich standard-setter for superb craftsmanship and customer service, Betteridge Jewelers has been an integral part of the Greenwich cultural, business, and civic community since 1897, and an ardent supporter of the Bruce Museum over its one-hundred-year history.

Van Cleef & Arpels and Betteridge would like to applaud Executive Director Peter Sutton and his colleagues at the Bruce Museum for their tirelessly creative commitment to the preservation of art and cultural history for the enjoyment and enlightenment of generations to come.

Emmanuel Perrin
President
Van Cleef & Arpels

Terry Betteridge
Owner
Betteridge Jewelers

Paris Portraits: Artists, Friends, and Lovers is generously underwritten by

Van Cleef & Arpels

BETTERIDGE
Serious jewelers since 1897

The Charles M. and Deborah G. Royce Exhibition Fund

and a

Committee of Honor

under the Chairmenship of

Homer and Coverly Rees
Jean Doyen de Montaillou and Michael Kovner

Art history is full of unexpected delights and surprises. One might have expected that the advent of photography, with its unprecedented powers of mimetic representation, would have obviated the need for traditional portraiture. After all, when he first saw a daguerreotype, the artist Paul Delaroche is said to have announced that painting was dead. However, as Professor Kenneth E. Silver has demonstrated in this thoughtful exhibition and its catalogue, far from eliminating portraiture, photography in fact liberated the genre. During the first half of the twentieth century in Paris, which was then the capital of the art world, the practitioners of all the major artistic movements—Fauvism, Cubism, Dada, Surrealism, and Expressionism—embraced portraiture and greatly extended its expressive possibilities. Freed from the need to render a likeness, flattering or otherwise, they probed deeper more insightful ideas about the sitter, the artist's personal relationship with individuals, and their acts of observation and reportage. These new and unprecedented portraits also served as a way of inventing the avant-garde—creating, as it were, a gallery or group portrait of the worthies and enlightened. These new portraits codified the pantheon of modernity, compiling a who's who of contemporaneity that was less concerned with mere appearance than interior essence. In Paris's vibrant and burgeoning art scene, virtually all the leading artists, whether French or expatriate, made portraits of their colleagues, patrons, critics, dealers, and partners. As this show attests, these works included paintings, sculpture, and works on paper of exceptional quality and originality. Whereas portraiture had traditionally been regarded as the artist's staple, the practice of which might provide a reliable livelihood though scarcely constituted an expression of artistic ambition or liberation (portraitists in the seventeenth century were called the "common foot soldiers" of art), it now became an instrument to explore higher human ideals and the interior life of individuals. Even casual acquaintances were subjected to expressive probing, while personal friends and lovers might be portrayed with great poignancy and passion. It was in this period and in the cosmopolitan locus of Paris that portraiture first truly became unfettered.

We are deeply indebted to Ken Silver, Professor of Modern Art, Department of Art History at New York University, and the Bruce Museum's Adjunct Curator, for the conception and organization of this show. I also wish to thank Abigail D. Newman, our exceptionally talented Curatorial Assistant, for her contributions to the catalogue and assistance in research.

Our greatest debt however is to the many generous lenders, who have made the sacrifice of temporarily living without the pleasure of their art to the great benefit of this exhibition. We also are deeply indebted to our lead sponsors, Betteridge Jewelers and Van Cleef & Arpels, for their wonderfully generous support of this exhibition. What could be more fitting for this show than joint sponsorship by the legendary Parisian firm of Van Cleef & Arpels and Betteridge Jewelers, who have been generous leaders of the Greenwich business and cultural community over the entire century-long existence of the Bruce Museum. Further, our enduring gratitude goes out to First Republic Bank for its sponsorship of the exhibition. I also wish to thank the members of the exhibition's Committee of Honor under the leadership of Homer and Coverly Rees, and Jean Doyen de Montaillou and Michael Kovner for their wonderful personal support of the exhibition. Finally, a special mention of thanks to our distinguished Trustee, Leah Rukeyser, who is infinitely creative in her support of the Bruce Museum.

Peter C. Sutton
The Susan E. Lynch Executive Director and CEO

ACKNOWLEDGMENTS

An exhibition like *Paris Portraits: Artists, Friends, and Lovers*—with dozens of artists represented, a sizable period of time surveyed, and much historical research to be done—is an enormous undertaking. It requires the efforts of many people in countless capacities. First and foremost, my thanks go to Peter C. Sutton, The Susan E. Lynch Executive Director of the Bruce Museum, whose remarkable vision for the Bruce and its programs has inspired me from the start of this project; it was he who encouraged me to undertake an innovative project about Parisian art, and it is in fulfillment of that mandate that the present show has been realized. The immensely talented Anne von Stuelpnagel, Director of Exhibitions, is responsible for both the design of this splendid catalogue and the superb exhibition installation. I have had the great good fortune, as well, to be assisted in all stages of this project by Abigail D. Newman, Curatorial Assistant, who is also the author of the formidable catalogue entries in this book. I am grateful to be working again with Fronia W. Simpson, who has masterfully edited the catalogue. I also want to thank at the Bruce Nancy Hall-Duncan, Senior Curator of Art; Jack Coyle, Registrar; Robin Garr, Director of Education; Kathy Reichenbach, Assistant to the Executive Director and Board Liaison; Liz Hopper, Development Manager; Whitney Lucas Rosenberg, Major Gifts Officer/Membership Manager; Mike Horyczun, Director of Public Relations; Cynthia Ehlinger, Public Relations Assistant; and Deborah Good, Director of Strategic Planning and External Affairs.

No exhibition is possible without the generosity of lenders. Aside from the acknowledgment of our debt to every one of them as they appear on our list of lenders, I want especially to thank a number of individuals who have lent works to the exhibition or who have helped us to secure loans: at the Albright-Knox Art Gallery, Louis Grachos, Douglas Dreishpoon, Holly E. Hughes, and Amber Uptigrove; at the Baltimore Museum of Art, Doreen Bolger and Katherine Rothkopf; at the Columbus Museum of Art, Nannette V. Maciejunes, Dominique H. Vasseur, Elizabeth Hopkin, and Amy Petsch; at the Salvador Dalí Museum, Charles Henri Hine, Joan R. Kropf, and Carol Butler; at the Frick Art Reference Library, Inge Reist, Don Swanson, Deborah Kempe, and Lydia Dufour; at the Solomon R. Guggenheim Museum, Thomas Krens, Susan Davidson, and Vivien Greene; at the Hirshhorn Museum and Sculpture Garden, Kerry Brougher, Valerie Fletcher, Keri Towler, and Aimee Soubier; at the Indiana University Art Museum, Adelheid M. Gealt, Diane Pelrine, Anita Bracalente, and Jenny McComas; at the Los Angeles County Museum of Art, Michael Govan, Carol Eliel, and Hollis Goodall; at the Metropolitan Museum of Art, Philippe de Montebello, Gary Tinterow, George R. Goldner, Samantha Rippner, Nykia Omphroy, Kit Basquin, Catherine Heroy, and Cynthia Iavarone; at the Mount Holyoke College Art Museum, Marianne Doezema, Wendy M. Watson, and Linda Delone Best; at the Museum of Modern Art, Glenn Lowry, John Elderfield, Anne Umland, Cora Rosevear, Ann Temkin, Cornelia Butler, Jodi Hauptman, Kathleen Curry, Mattias Herold, and Carla Bianchi; at the National Gallery of Art, Washington, D.C., Earl A. Powell III, Judith Brodie, Leah Dickerman, Ginger Crockett Hammer, Gregory Jecmen, and Lisa MacDougall; at the Norton Museum of Art, Christina Orr-Cahall; at the Philadelphia Museum of Art, the late Anne d'Harnoncourt, William Valerio, Michael Taylor, Shannon Schuler, and Ashley Carey; at the Phillips

Collection, Eliza Rathbone, Jay Gates, Elizabeth Hutton Turner, Lilli Steele, and Joseph Holbach; and at the Smithsonian American Art Museum, Elizabeth Broun, Alison H. Fenn, James P. Concha, and Heather Delemarre. I am also indebted to Bruce Altshuler, Patrick Amsellem, William Acquavella, Frances Beatty and Allen Adler, Erika Bolden, Nathalie Bondil, Edgar Peters Bowron, Emily Braun, Gavin Brown, Jennifer Burbank, Steve and Alexandra Cohen, Veronica Collins, Harry Cooper, Maya Dean, Judith Dolkart, Elizabeth Easton, Michael Findlay, Kathy Fuld, Jessica Furtig, Ivan Gaskell, Irene Gates, Pamela and Robert Goergen, Suzanne Hascoe, Caroline Hayward, Tom Hill, Sophia James, Ursula and R. Stanley Johnson, Pepe Karmel, Ed LaMance, Karen Leader, Maryellen Lupinacci, Allison Malinsky, Ellen McBreen, Francis M. Naumann, Dennis and Ronna Newman, Jack Rennert, Shelley Rice, John Richardson, Joseph Rishel, David and Leslee Rogath, Charles Scribner, Thomaï Serdari, Terry Shargel, Roy Simpson, William Kelly Simpson, Gian Enzo Sperone, Jennifer Stockman, Cristin Tierney, Jennifer Tonkovich, Paul Tucker, David Tunick, Suzanne Varkalis, Angela Westwater, Paul Whitney, Malcolm Wiener, and Alex Yudzon. Finally, I would like to thank the students in my New York University Institute of French Studies graduate seminar, spring 2008, who investigated topics in Parisian portraiture: Anna Czerniawski, Melissa Hanson, Jackson Malle, Ellen Mittleholzer, and Kira Sheber.

Kenneth E. Silver

PARIS PORTRAITS:
Artists, Friends, and Lovers

by Kenneth E. Silver

The sculptor Jacques Lipchitz seems to have known exactly what he thought Gertrude Stein [ill. 1] looked like: "I was particularly impressed by her resemblance to a fat, smooth, imperturbable Buddha, and it was this effect that I tried to get."[1] More or less life-size, his superb bronze head of the American-writer-in-Parisian-residence manages to convey, beyond her implacability, Stein's formidable brain power and self-possession: her topknot of hair functions as a crown or intellectual power pack, her hollowed-out eyes betray her "shadowed introspection."[2]

Zenlike serenity notwithstanding, as a working artist Stein seems to have had little of Lipchitz's unclouded certainty of purpose. In the more than 130 literary portraits of her friends and acquaintances that Gertrude Stein produced over the course of nearly four decades, she struggled with the very question of resemblance in art: "And does it make any difference what they do or how they do it, does it make any difference what they say or how they say it," the poet, without normal punctuation, asked of the portraitist's usual goals. "Must they be in relation with any one or with anything in order to be one of whom one can make a portrait. I began to think a great deal about all these things."[3] It was these kinds of questions—about likeness, visuality, and the role of empathy in the portrait project—that Stein was still thinking about when, a few years later, she composed her portrait of the man who had earlier made *her* bronze effigy.

"Lipschitz"

Like and like likely and likely likely
and likely like and like.
.
When I knew him then he was looking
looking at the looking at the looking. When
I knew him then he was so tenderly
standing.
.
When I know him I look at him for
him and I look at him for him and I look at
him for him when I know him.
I like you very much.[4]

Despite mutual affection and a shared loved of gossip,[5] there was an important issue on which they disagreed. Although he was the finest Cubist sculptor in Paris, and she among the foremost collectors of Cubist art, they stood firmly opposed on questions of artistic resemblance in portraiture: "My Cubist friends were all making Cubist portraits. I was always against that," Lipchitz recollected years later. "I had long discussions about it, especially with my good friend [Juan] Gris. I felt, and still do, that it is not legitimate, because a portrait is something absolutely different. It has to do with likeness, with psychology, and at the same time it must be a work of art."[6]

The question of likeness in modern portraiture was already a hot topic in 1906, when Pablo Picasso painted Stein's portrait [ill. 2]. Anticipating Lipchitz's comparison of Stein to Buddhist sculpture, Picasso had turned to ancient Iberian and medieval Spanish sculpture as a way to suggest the particular stoic qualities of his sitter's countenance. But the resulting lack of resemblance disturbed a number of the American's friends: "[E]verybody thinks

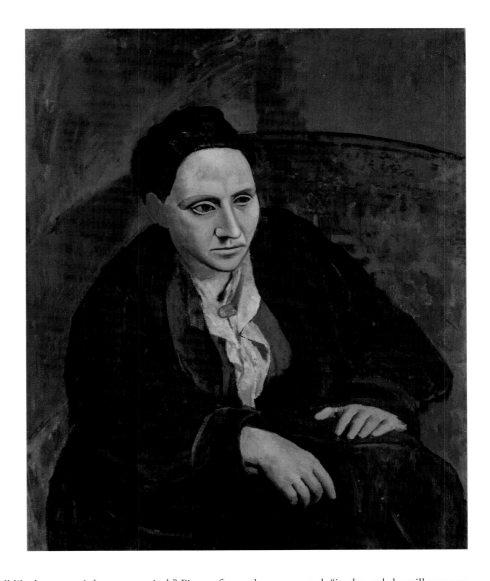

Ill. 2
Pablo Picasso
(Spanish, 1881–1973)
Gertrude Stein
1906
Oil on canvas
100 x 81.3 cm
The Metropolitan Museum of Art, New York,
Bequest of Gertrude Stein, 1946 (47.106)
(Fig. 11)

she is not at all like her portrait but never mind," Picasso famously commented, "in the end she will manage to look just like it,"[7] a succinct way of asserting both the artist's right to interpret his subject as he sees fit and that he had the upper hand in relation to his sitters. Stein must have liked it this way, at least as far as Picasso was concerned. She was immensely pleased with his version of her and kept it her whole life long (bequeathing it to the Metropolitan Museum of Art, New York), whereas she declined to purchase Lipchitz's sculpture, all the while protesting that she liked it, and the artist, very much.[8]

By the twentieth century, commissioning a portrait from an important artist was a rare and expensive proposition, and, in the strictest sense, unnecessary. With the invention of photography just before the middle of the nineteenth century, those of even moderate means could possess likenesses of themselves or their loved ones, or of celebrated strangers . . . Queen Victoria, Abraham Lincoln, Sarah Bernhardt, Chancellor Bismarck. When in 1839 the French painter Paul Delaroche, on seeing a daguerreotype for the first time, declared, "From today painting is dead!" he seemed to mark the end not only of a medium but of painted portraits in particular. But that's not what happened. By the last decades of the century, it started to occur to many of the best artists that photography, as a foil for the expressive possibilities offered by painting and sculpture, might be a force for aesthetic *liberation*. Vincent van Gogh, for instance, wrote to his sister that the genre that excited him most was "the modern portrait" and that he was thinking in particular about posterity and maybe even time travel: "I would like to make portraits that a century later might appear to people of the time like apparitions. . . . I don't try to do that by way of photographic resemblance, but by way of our impassioned expressions."[9]

Henri Matisse also saw painting's potential for expressing strong feeling as utterly different in kind than the resemblances photography could deliver up instantaneously, and he felt set free by it: "The painter

no longer has to preoccupy himself with details," he told an interviewer in 1909. "The photograph is there to render the multitude of details a hundred times better and more quickly. Plastic form will present emotion as directly as possible and by the simplest means."[10] Elsewhere, Matisse insisted that the photograph cleared the air, and his mind, of preconceptions: "By making it possible to see things for the first time independent of feeling, photography has assigned a new role to the imagination."[11] Photography as a time saver and as painting's technological savior—that's how Picasso saw it:

> When you see what you [can] express through photography, you realize all
> the things that can no longer be the objective of painting. Why should the
> artist persist in treating subjects that can be established so clearly with the
> lens of a camera? It would be absurd, wouldn't it? Photography has arrived at
> a point where it is capable of liberating painting from all literature, from the
> anecdote, and even from the subject.[12]

For a Left-leaning artist like Fernand Léger, liberation from the privileged, overly individualistic genre of portraiture could not come soon enough, and for this he laid the credit at photography's doorstep: "Photography requires fewer sittings than portrait painting, captures a likeness more faithfully, and costs less. The portrait painter is dying out . . . not by a natural death but killed off by [his] period."[13]

It is true that traditional portraiture—whether "dynastic" pictures produced for a family gallery or institutional portraits made for statehouses and fraternal clubrooms—was certainly in a bad way by the twentieth century. Giovanni Boldini, who had enjoyed a brilliant career painting high society figures in turn-of-the-century Paris, was so disheartened by the lack of portrait commissions by 1920 that he wrote to his brother Gaetano that he was tempted to return home to Italy.[14] By the 1930s the portraits exhibited at the Paris Salons constituted a mere five percent of the total number of pictures on display. But conventional portraiture's loss, as it turned out, was the avant-garde's gain. Although there were still a few well-heeled patrons who wanted their portraits made by major Parisian artists—including Matisse, Constantin Brancusi, and Salvator Dalí—portrait sitters would henceforth, as William Rubin pointed out, be "drawn almost exclusively from among the friends and families of the painters. The artist was now the social equal of his or her subject . . . linked by personal, often complex psychological relations and sometimes sexual ones."[15] While the matter of flattering a client had been an inevitable part of the old portrait equation—this is what John Singer Sargent meant when he said, sounding like Oscar Wilde, that a portrait was "a likeness in which there was something wrong about the mouth"[16]—it no longer, or hardly, obtained. Now it was the client who was in danger of displeasing the artist. When, in the summer of 1937, Dorothy and William Paley (founder of the Columbia Broadcasting System) turned up two weeks late for Mrs. Paley's appointment to have her portrait painted by Matisse, the artist was so offended that he refused to go ahead with the commission for which he had already made at least eight charcoal drawings and an unknown number of pen and ink studies.[17]

New Portraits for New People

The modern period did not kill off the portrait painter, as Léger had hoped it would: instead he became a Pointillist, a Fauve, a Cubist, and a Surrealist. The Boldinis and Sargents lived long enough to see the end of high society portraiture as they knew it, as well as to see the triumph of avant-garde likeness. "Portraiture was, of course, the genre where likeness mattered, and the crux of likeness in portraiture is the face," writes Christopher Green. "Significantly, portraiture figured at key points in the most experimental work of leading modernists before 1914."[18] John Klein notes, of Matisse, "how important the genre of portraiture was within his overall exhibition strategy."[19] Although, as Shearer West has pointed out, a certain universalizing and abstract "ethos" in modernist art criticism was "alien to the specificity of the portrait,"[20] the portrait's specificity could be turned to modernism's advantage. What better way for an artist's deviation from the aesthetic norm to be recognized than through the genre where recognizability—resemblance, likeness— was its raison d'être? When young Robert Delaunay wanted to signal his allegiance to the new color theories and aggressive paint application that placed his art somewhere between the Divisionist aesthetics of Paul

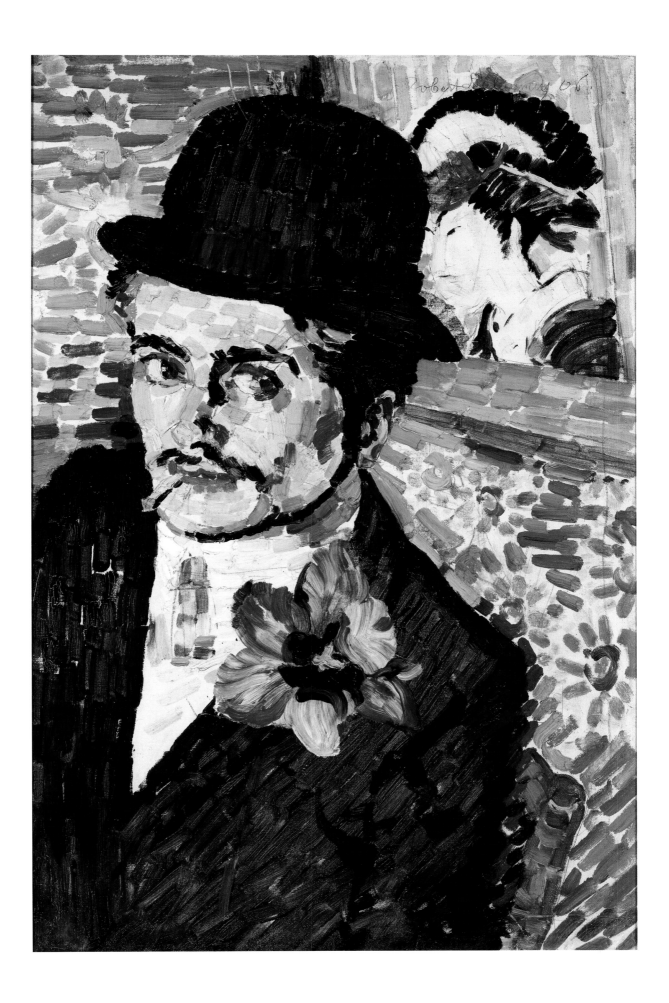

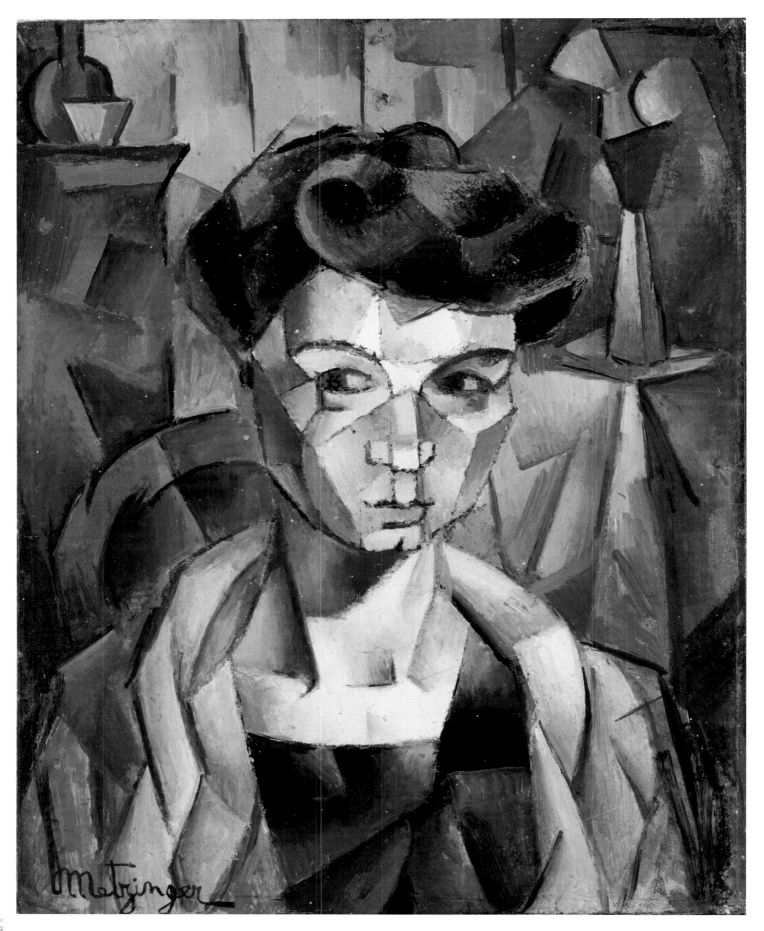

Signac and Matisse's Fauves, he did so in a portrait, of fellow artist Jean Metzinger [ill. 3]. Metzinger had gone to Paris from the Breton port city of Nantes three years earlier and become a friend of Delaunay, a Parisian native, only a few months before this picture was made. That the legacy of late-nineteenth-century French aesthetics hovers in the background here, that is, the love of bright, flat color and exotic inspiration, is made literal in the representation of a Japanese woodblock print of a woman who appears to whisper in the ear of the dandified young artist. The cigarette perched on his lower lip, the huge poppy affixed to his lapel, and especially his bowler—a sartorial compromise between the formality of the upper-class top hat and the casual, working-class soft cap—all mark Metzinger as an identifiable, Parisian, artistic type.[21] Most salient, though, is how the intensity of his gaze is matched by the intensely hued paint and its powerful, atomized application. Rendered in the complementary color opposites of blue/violet and yellow/orange, the young artist depicted is a metonym for the exciting, new Parisian aesthetic tribe of which he and Delaunay would be key players for the next decade.

In the years that followed, both would become Cubists of one kind or another. Metzinger, in fact, with Albert Gleizes, would coauthor the first book of Cubist theory, *Du cubisme*, in 1912. "Nature and painting seem to occupy two realms with nothing in common," Metzinger would say later on, by way of denigrating naturalistic depiction. "The excuse of providing documentation became [a] ridiculous [rationale] for painters. Photographers and film-makers went far beyond them. One might already say that a good portrait reminds you of its maker, not its sitter."[22] Perhaps we should take him at his word, since the sensitive portrait Metzinger made of his wife [ill. 4], the former Lucie Soubiran, in 1911, is almost overwhelmed by his deployment of the new Cubist idiom. In general tone and in specific ways it marks a decisive turning away from, and even a repudiation of, the strident palette and posterlike forms of his portrait by Delaunay. Now, all shapes seem to obey an unspoken law of planar development. Three-dimensionality is insisted on even as it is undermined: Lucie's face and body are lit so as to bring them into high relief, but the facets of which she is constructed are made of the same stuff as everything else in the room, bringing foreground and deep space into alignment. This give-and-take with solid geometry followed in the wake of the death of Paul Cézanne in the fall of 1906, he who had urged his friends to discover the secret language of the "cone, cylinder, and sphere" underlying observed reality. The Parisian avant-garde now remembered what it had apparently forgotten, Cézanne's effort to wrest something "durable" from the Impressionist aesthetic of fluctuation and indeterminacy. Reconciling the two-dimensional reality of the flat painted surface with the three-dimensional fact of the real world became the common task of numerous subgroups of Parisian artists, the Cubists in particular. The geometric faceting of Auguste Herbin's *Portrait of a Man*, of about 1909, [ill. 5] for example, translates this new Parisian Cézannism in an especially graceful fashion.

Metzinger was after something more extreme, as he's told us, a complete divorce between nature and art. Although that's not what he ended up with, he made moves in that direction—the portrait of his wife turns inward and establishes a self-sufficient world with its own look and feel. With the Master of Aix in mind, his palette has become far more subdued in comparison to the stridency of Delaunay's of five years earlier. Painted in the softest shades of blue and tan, Lucie is made to resonate with her setting. The great wave of her luxuriant pompadour is echoed by the rounded back of the chair in which she sits and with the round belly of the carafe in the upper left; the vase on the table at the right is constructed like a high-waisted female figure. A shawl around her shoulders, Madame Metzinger looks apprehensively to her right: is she observing their daughter getting into mischief somewhere beyond our ken, or anticipating a knock at the door from a bill collector? This glimpse into the Cubist *vie de bohème*, where a lack of heat in a cold-water flat might well account for Lucie's shawl, was an unfortunate forecast of things to come. Lucie Soubiran Metzinger would die by the end of World War I, most likely carried away by the influenza epidemic that killed more than twenty million people worldwide in 1918.

From the affecting modesty of Lucie Metzinger to the suave self-possession of Doctor Morinaud, the subject of *Man on a Balcony* (1912) by Albert Gleizes [ill. 6], the emotional range afforded by Cubism, at least as practiced by its two main theoreticians, appears greater than one might have suspected it to be. Leaning against what is probably the railing of his balcony, with a view over Paris (and what may be a glimpse of the Eiffel Tower just to the right), the protagonist of this celebrated Cubist portrait embodies all the self-confidence of the new technological age. We can well understand why the fabled American collector and supporter of modern art Arthur Jerome Eddy bought this portrait directly out of the famous Armory Show in New York in 1913. Gleizes is especially skilled here at interweaving the building blocks of his

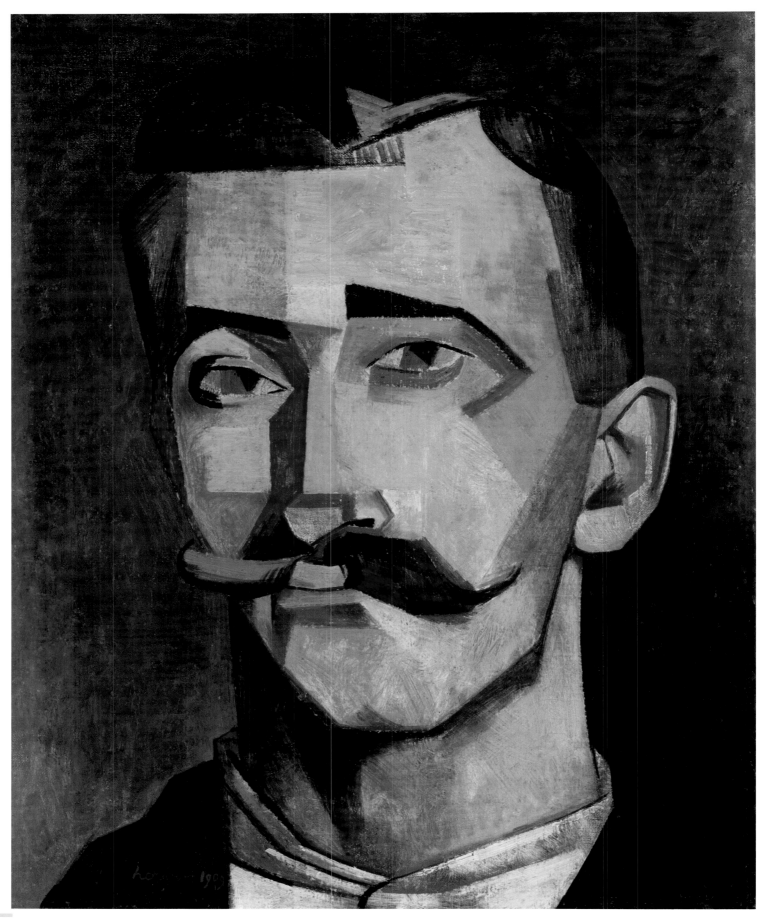

Opposite:
Ill. 5
Auguste Herbin
(French, 1882–1960)
Portrait of a Man
c. 1909
Oil on canvas
54.6 x 46 cm
William Kelly Simpson, New York
(Cat. 21)

Ill. 6
Albert Gleizes
(French, 1881–1953)
Man on a Balcony
(Portrait of Doctor Morinaud)
1912
Oil on canvas
195.6 x 114.9 cm
Philadelphia Museum of Art:
The Louise and Walter Arensberg
Collection, 1950
(Cat. 18)

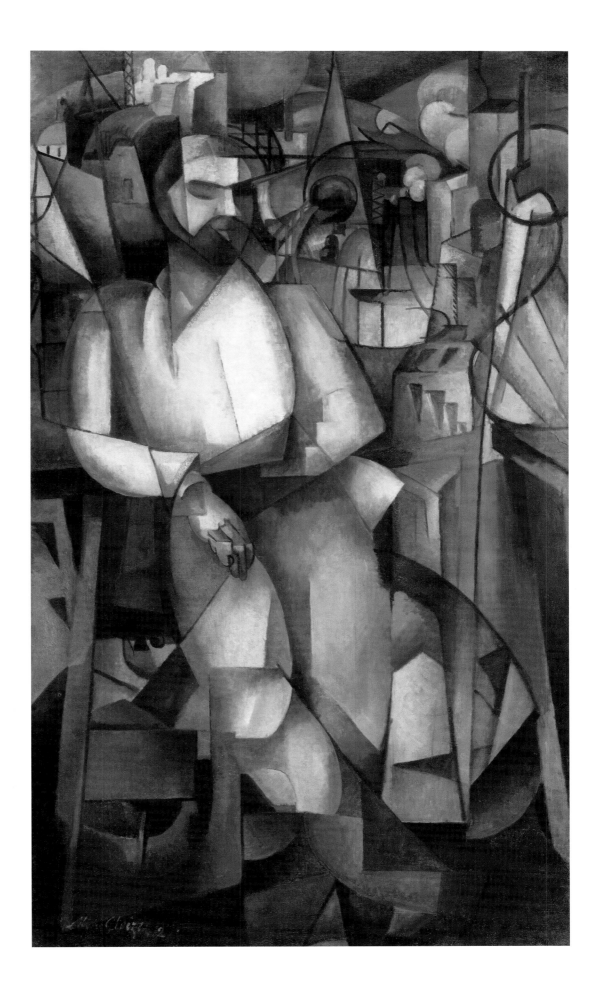

Ill. 7
Raymond Duchamp-Villon
(French, 1876–1918) /
Marcel Duchamp
(French, 1887–1968)
Portrait of Professor Gosset
Edition: 6/8, 1917–18
Bronze; cast posthumously by
Marcel Duchamp and Louis Carré
29.8 x 22.2 cm
Indiana University Art Museum:
Jane and Roger Wolcott Memorial,
Gift of Thomas T. Solley, 76.31.1
(Cat. 13)

composition—the ample forms of the physician and the rectilinear elements of the cityscape—with a curvilinear scaffolding created by the arabesque of what looks to be a spiral metal staircase at the right and the iron girders of various structures in the background. He also enlivens the typically subdued Cubist palette with brilliant touches of red and bright green.

Although we know little about Doctor Morinaud besides his name—and that he looks to be a thoroughly modern man—we know a great deal about Doctor (or Professor) Gosset, the subject of one of the most important and radical works of early-twentieth-century sculpture. Antonin Gosset [ill. 7] was a celebrated surgeon and medical professor at the famed Salpêtrière Hospital in Paris, known especially for his work in urology. According to a *Time* magazine article (December 30, 1929), he was no less than the "famed remover" of the prostate glands of the French statesmen Georges Clemenceau and Raymond Poincaré. He is also credited with devising the first ambulatory operating room during World War I, which is when he treated Raymond Duchamp-Villon. Having for a period studied medicine before embarking on his career as a sculptor, it was as a medical officer that Duchamp-Villon enlisted in the army at the outbreak of the war, only to be laid low with typhoid fever in 1916. It was at Corbineau Hosptial, in Châlons, one of the major encampments of the French army, that he was treated by Gosset and where he conceived the idea for this astonishing portrait or, rather, for the plaster head that was the model for this posthumous cast. Working as a caricaturist might and as the artist's preparatory drawings show, Duchamp-Villon submitted the famous physician's head and face to a radical process of simplification and abstraction: an impressive forehead and brow were joined to the line of the nose; a mustachioed upper lip was fused with the jaw and cheeks.[23] At one and the same time machine part, primitive mask, and skull—or, as Judith Zilczer has proposed, like one of the new and terrifying gas masks of the Great War[24]—Doctor Gosset here becomes a human X-ray in three dimensions. Duchamp-Villon, with grim appropriateness, was still working on this modernist death's-head when, already weakened by typhoid, he himself died, again probably of influenza, in 1918.

As austere as death itself, this strange portrait of a man famed for his lifesaving procedures (who was celebrated enough to have also sat for portraits by Edouard Vuillard and Marie Laurencin) is the antithesis of the energized image—in gouache, watercolor, and ink—that Louis Marcoussis drew of Edouard Gazanian, a now forgotten poet and Montmartre regular [ill. 8]. Dating from 1912, it is probably not accidental that this Cubist portrait betrays an affinity with contemporaneous Italian Futurist drawings, especially with the work of the painter and sculptor Umberto Boccioni. For it was in February of that year that the Italians, under the leadership of F. T. Marinetti, held their first group exhibition in Paris, at the

Galerie Bernheim-Jeune, and caused a sensation. Especially close to Boccioni's art here are not only the regularity of the stippled surface, which translates myriad shifts in illumination, but also the strong diagonal lines that traverse this portrait head, reminiscent of the Futurists' "lines of force," their schematic rendering of the visual laws of physics. Indeed, it is with works like these that literary critics, who have sometimes misguidedly referred to Gertrude Stein's poetry as "Cubist," might well make a case for the poet's Cubist intentions rather than her effects. As Wendy Steiner has convincingly argued, not only was Stein committed to portraiture as one of the central projects of her writing, but she worked her way toward an idea of portraiture that replaced physical resemblance with an interest in psychic "movement."[25] Stein said that the goal of her portraits was "to find out inside every one what was in them that was intrinsically exciting and I had to find out not by what they said not by what they did not by how much or how little they resembled any other one but I had to find it out by the intensity of movement that there was inside in any one of them."[26] Like the Futurists and like their Cubist forebears, Stein wants to show not what makes her sitters tick but what their ticking looks like. Gazanian's internal movement looks especially focused, we might say, and a bit overwrought, just as the Cubist drawing that Jacques Villon, brother of Raymond Duchamp-Villon and Marcel Duchamp, made of his father, Justin-Isidore Duchamp, [ill. 9] presents the psychic energy of this paterfamilias as a well-modulated resolution of force lines, appropriate, it would seem, for a portrait of the well-to-do provincial lawyer he was.

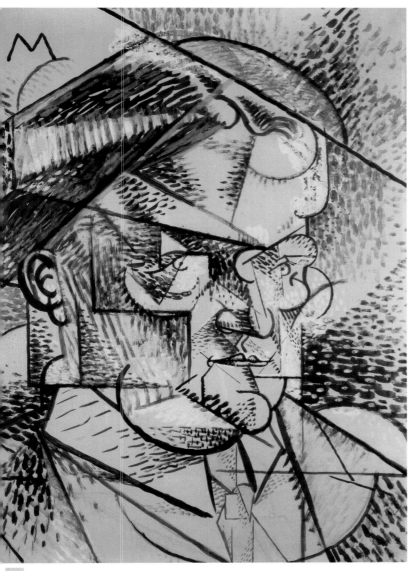

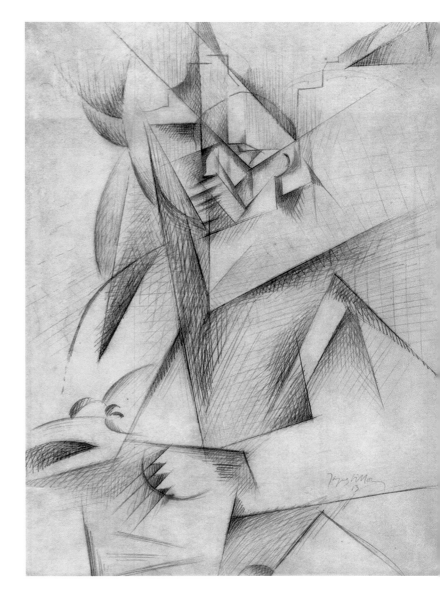

How does one begin to account for the network of motives that results in the making of portraits? When Juan Gris painted his portrait of Pablo Picasso, [ill. 10] which he exhibited at the Salon des Indépendants, it included the inscription "Hommage à Pablo Picasso / Juan Gris," at the lower right. Unquestionably, Gris's painting was first and foremost a sincere act of admiration for the reigning young master of contemporary Parisian art by an extremely talented but still little-known follower. But was it anything else as well? Was it a way to promote his name in Paris by association with a famous fellow Spaniard, so convincingly portrayed here despite the work's abstraction? Was it a declaration of aesthetic allegiance to the Cubist cause? So distinctive is the picture, with its myriad superimposed grids, raking light, and cool blue-gray and brown colors—cleverly contrasted to the painter's palette in Pablo's hand, daubed with the red, blue, and yellow primaries—that one wonders whether it was not, as well, an attempt by Gris to best his mentor under the cover of homage. We can only guess at all of the artist's reasons for making a portrait of Picasso. But that portraiture is more deeply implicated in these kinds of issues than other genres—issues at the intersection of affection, respect, competitiveness, and career building—is certain and worth keeping in mind as we watch the Parisian art world make a picture of itself.

The Cubist painter and printmaker Marcoussis owed more to the Parisian poet and critic Guillaume Apollinaire, [ill. 11] author of the pioneering study *Les Peintres cubistes* (1913), than his mere

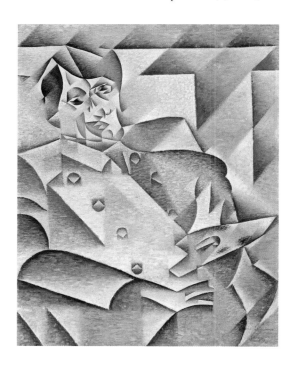

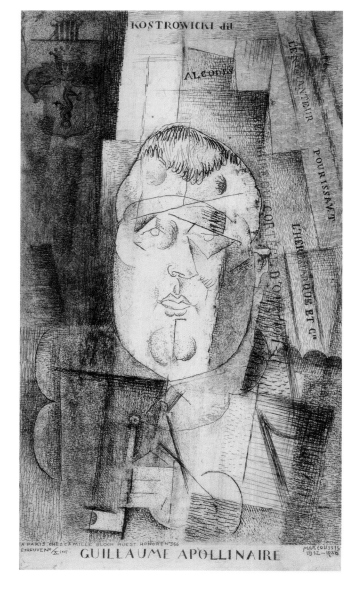

mention there as a "Scientific Cubist," although this was no small recognition for a struggling young artist. In fact, he owed his very name to Apollinaire, who suggested to the Warsaw-born émigré that he drop "Louis Casimir Ladislas Markus" for the simpler Louis Marcoussis (the new surname taken from a French village in the district of Essonne). Apollinaire had already done as much himself; his real, Polish name, "Kostrowicki," and what is presumably his family crest included at the upper left—the poet was always rumored to be of aristocratic origin—appear at the top of Marcoussis's greatest engraving, a splendid tribute to the man to whom he was so indebted. Like a number of other artists, including Gris, who had made drawings for the Parisian fashion and humor magazines early in their careers, Marcoussis's ability to capture likeness was well honed: the poet and critic's big head and small, amiable features are wonderful translations of the man we know from photographs and from Picasso's portraits of him. Set in a fluctuating Cubist space, where the titles of some of his major works float on the spines and covers of volumes arranged on a fanciful bookshelf—*Alcools, L'Enchanteur pourissant, L'Hérésiaque et Cie*, and *Le Cortège d'Orphée*—a severely wounded artilleryman, which is what Apollinaire became at the front in 1916, stares out at us. Along with his collected works and ubiquitous pipe, the bandage of his trepanation becomes a saintly attribute in this memorial for the thirty-eight-year-old poet who was tragically carried away by the influenza epidemic on November 9, 1918, two days before the armistice that ended *La Grande Guerre*.

World War I was accompanied by a sudden burst of portrait-making energy.[27] The reasons for this were numerous, including, as in Marcoussis's Apollinaire portrait, a desire to memorialize the departed. Also relevant was a wish to celebrate the heroism of those in uniform (with the hope, perhaps, that death itself might thus be magically forestalled) and, less concretely but probably more widespread in its impact, a need to depict what mattered most: friends and loved ones. The more radical forms of Parisian art suddenly looked inappropriate for tasks that were, at heart, conservative—holding fast and remembering—rather than the progressive drives, the inventing and building of new culture, which had distinguished the first decade and a half of the century. It was Picasso who inaugurated the new interest in naturalistic portraiture just as, with Georges Braque, he had inaugurated Cubist antinaturalism a few years earlier. There was no official announcement of the Spaniard's volte-face, but, beginning in the winter of 1914–15 a gallery of superb, traditional-looking portraits served to alert the Paris art world that a new spirit was coursing through the studios of Montmartre (the venerable artists' quarter, in the north of Paris) and Montparnasse (the new Left Bank artists' neighborhood, to which Picasso had moved in 1912). This suite of traditional drawings, ostentatiously invoking Jean-Auguste-Dominique Ingres, the great exemplar of nineteenth-century French classicism, situated itself about as far away from Cubism as possible. Not only was Picasso indulging in an orgy of old-fashioned mimetic draftsmanship—and there was no better draftsman in Paris than he—but he was simultaneously swearing allegiance to French culture by way of emulating Ingres. Among these portrait drawings, which caused no small measure of consternation among die-hard Cubist followers, was his sober and precise pencil portrayal of a seated Ricciotto Canudo, [ill. 12] music, dance, and film critic and editor of the prewar Parisian avant-garde journal *Montjoie!*. He wears the exotic uniform of the Zouave and leans ever so slightly on the carved wood cane in his right hand; the drawing is inscribed by Picasso, "A mon cher Canudo, Le Poète / Montrouge, 1918," indicative of the lyrical direction the Italian's recent work was taking. As it turned out, Canudo, only two years Picasso's senior, would be dead within five years. Were it not for this drawing, we might well be ignorant of a man who is sometimes called the "first film theorist."[28]

Gris discovered, to his delight, that he too could work in the new Ingres portrait mode. As he wrote to his dealer, "Nowadays when I have finished working I don't read serial novels but do portraits from life. They are very good likenesses and I shall soon have as much skill as a Prix de Rome winner. It is a perpetual thrill for me to discover how it is done. I can't get over it because I thought it was much more difficult."[29] One of these likenesses, in which his newly reacquired mimetic skills are especially apparent, is a pencil portrait of Max Jacob, [ill. 13] close friend of Picasso, Apollinaire, and Amedeo Modigliani from the prewar days in Montmartre. Like the brilliant draftsman he was, Gris delineates the Breton-born poet with nuanced modulation of line and judicious application of chiaroscuro. Hands crossed in his lap, Jacob looks surprisingly staid given his reputation for wild excess. Yet, surprise is probably the operative term where Jacob is concerned: Jewish, homosexual, and mystic, he had a vision of Jesus Christ in 1909, which led, in the middle of the war, to his conversion to Catholicism, with Picasso acting as his godfather when he was baptized at a church on the Boulevard Saint-Germain, in 1915. Two years after this portrait was made, Jacob entered a monastery at St.-Benoît-sur-Loire, where he remained until 1927.

Ill. 12
Pablo Picasso
(Spanish, 1881–1973)
Ricciotto Canudo
1918
Pencil on paper
35.4 x 26.2 cm
The Museum of Modern Art, New York.
Acquired through the Lillie P. Bliss Bequest, 1951,
18.1951
(Cat. 38)

Ill.13
Juan Gris
(Spanish, 1887–1927)
Portrait of Max Jacob
1919
Pencil on paper
36.5 x 26.7 cm
The Museum of Modern Art, New York.
Gift of James Thrall Soby, 1958,
84.1958
(Cat. 19)

Not everyone took the wartime "call to order" quite so far. Jean Cocteau, who in fact titled his book of postwar art and literary art criticism just that, *Le Rappel à l'ordre* (1926)—shorthand for the newfound sense of Frenchness and classicism exemplified by the Ingres revival—had himself fitted up in a military-looking uniform and joined an auxiliary ambulance corps when he was rejected for regular French army service.[30] Cocteau [ill. 14] sat numerous times for Modigliani over the course of 1916–17, as he did for a number of other artists (including Lipchitz, who sculpted his portrait shortly before undertaking Gertrude Stein's). A not inconsequential benefit of being an important critic is how compelling one's countenance becomes to artists about whom one has written or might write. Whether serious or superficial in their approach, it is the writers—professional journalists or, as is often the case, impecunious poets—who engage the interested public in debate about works of art. Visual artists are not averse to the assistance of those who can put into words what their silent works strive for, although they often feel betrayed by what seems to them obtuseness or intentional misinterpretation. Modigliani's lover Beatrice Hastings, for instance, claimed that the artist did not care for Cocteau,[31] although we would not be able to see that from the present drawing. Apart from a certain rigidity of pose and slight apprehensiveness of expression that may betray a lack of intimacy between artist and sitter, this is the picture of a dignified young man about town. Yet, it may well be that Modigliani saw and transcribed what others failed to notice—Cocteau had many fans but also many detractors. That Modigliani turns the entire Parisian art world into specimens of his own highly stylized, superelegant race of aesthetes has not always worked to his critical advantage, even if, as with

Ill. 14
Amedeo Modigliani
(Italian, 1884–1920)
Portrait of Jean Cocteau, c. 1916–17
Pencil on paper
41 x 25.7 cm
William Kelly Simpson, New York
(Cat. 33)

Ill. 15
Amedeo Modigliani
(Italian, 1884–1920)
Portrait of Frank Burty Haviland, 1915
Pencil on paper
36.2 x 27 cm
William Kelly Simpson, New York
(Cat. 32)

John Singer Sargent, this has never resulted in a lack of popularity. Modigliani's portrait drawings are some of the loveliest works of the early twentieth century. Even his roughest sketches, [ill. 15] like his study for a portrait of Frank Burty Haviland, the Franco-American artist and collector, is vivid in its particularity: using his sitter's name as a rectilinear scaffold at the lower left, Modigliani combines the line of Haviland's narrow jaw and the sweep of his wavy hair and widow's peak into a single, Art Nouveau-like circuit, as if he were the human embodiment of a Hector Guimard Paris Métro entrance.[32]

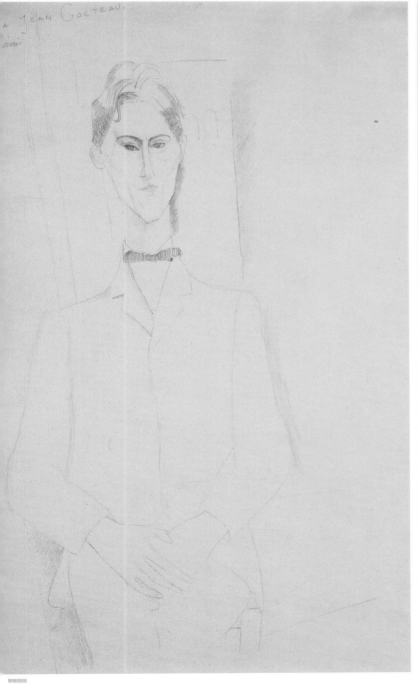

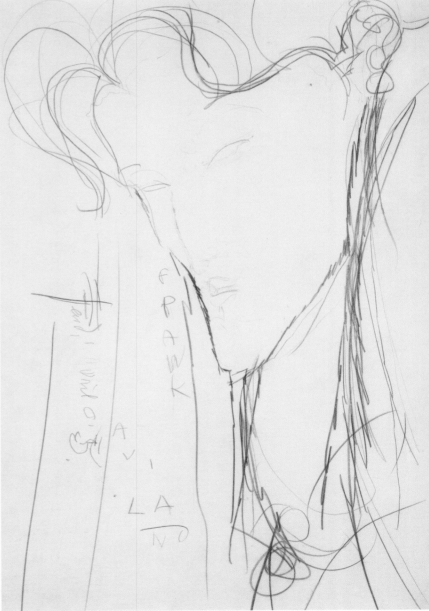

Stein, Gazanian, Apollinaire, Canudo, Jacob, Cocteau: for the many reasons already suggested—from pure affection and fellow feeling to the potential for free publicity—writers have occupied a great deal of space in the modernist portrait pantheon. But so have art dealers. Although the emphasis in motivation might be adjusted slightly in the direction of potential economic advantage when discussing artists' portraits of those who sell their art, we should not underestimate how emotionally involved artists and their dealers often are. For one thing, artists and art dealers are business partners, with all that is entailed in such a relationship, including but not limited to the unalloyed excitement of working together for a common goal; the potential for conflict between the lifestyles and values of the artist-producer and the dealer-merchandiser; the often tedious and sometimes fraught routine of keeping records, figuring reimbursements, calculating profits; the thrill of successful exhibitions and the despondency of a failure to attract collectors, curators, and critics; and the usual joys and missteps of all relationships between social equals. It is not always clear precisely what kind of transaction, financial or gift giving, takes place when an artist makes the portrait of a dealer. But unlike the case of writers—where, for instance, to judge by the dedicatory inscriptions on their portrait drawings, so many were offered as gifts—we may assume that, one way or another, art dealers paid for most of their portraits, whether cash changed hands or not. The portraits in question are no less significant for that, nor does it vitiate the possibilities for real empathy or artistic ambition on the part of the artist (undoubtedly, there are artists for whom the relation with their dealer is the most enduring, and thus profound, of their lives).

What, for instance, do we make of the two portrait drawings of the art dealer Martin Fabiani by Matisse [ill. 16] and Picasso [ill. 17], created in the midst of the German occupation of France and both now part of a collection in Greenwich, Connecticut? Rare is the chance to compare the visions of these two great masters in such a direct way, even in such relatively minor works as these: the same man, approximately the same moment, who presumably wanted some of the same things from both titans of the Parisian art world—and yet such utterly divergent portrayals. For Matisse, who made several drawings of the art dealer,[33] the man who appears through the stumped technique the artist employed to such great effect throughout his career, and with special frequency in the 1940s and 1950s, is a sensitive, even diffident soul, who just slightly cocks his head as might a dog hearing an especially high-pitched sound. Picasso's Fabiani could not be more different: handsome, determined, with tight-lipped mouth, high cheekbones, resolute gaze, and slicked-back hair. According to Fabiani, the sitting came about spontaneously: "You've got a beautiful mug," Picasso told him one day, "I'm going to do your portrait," and in five hours, "his eyes sparkling with mischief," the artist proceeded to make five drawings—working with no eraser and making no corrections—which he then gave to the dealer.[34] Fabiani's profile looks suitable for coinage, except for the fact that, recalling Duchamp-Villon's portrait of Doctor Gosset, we seem to be looking right into the man's head.

Had Picasso sensed something lurking beneath the surface of the same sitter that Matisse saw as mild-mannered? Martin Fabiani came into the two artists' lives during World War II, after the death of Ambroise Vollard, the legendary Paris art dealer and publisher with whom Picasso had dealings over the course of his career and with whom Fabiani had apprenticed. Fabiani inherited a number of Vollard's publishing ventures, including illustrations by Picasso to accompany Buffon's *Histoire naturelle* (1942), and shortly thereafter published Matisse's lithographic suite *Thèmes et variations* (1943). Since Paul Rosenberg, Matisse's dealer, a Jew, had fled to the United States at the outset of the occupation, Fabiani had the opportunity to function as Matisse's principal representative for a short time. It was during a three-month "honeymoon period" for artist and dealer—when Matisse was referring to Fabiani affectionately as "cher patron" (my dear boss)—that Fabiani sat for Matisse. The relationship, however, deteriorated rapidly. Referring to the artist in picturesque fashion as "the hydroplane Matisse who, once in the air, no longer needed his float Fabiani,"[35] the aggrieved dealer blamed Matisse for cupidity and capriciousness. Matisse, for his part, began to mistrust Fabiani, who balked during the occupation at having a known Communist, Louis Aragon, as the author of the preface to *Thèmes et variations*.[36]

Yet that was but the tip of the iceberg. On September 22, 1945, the following short piece appeared in the *New York Times*:

Opposite:
Ill. 16
Henri Matisse
(French, 1869–1954)
Portrait of Fabiani
1943
Charcoal and estompe on paper
55.9 x 38.1 cm
Malcolm Wiener Collection
(Cat. 29)

Ill. 17
Pablo Picasso
(Spanish, 1881–1973)
Portrait of Fabiani
c. 1943
Pencil on paper
51.1 x 32.1 cm
Malcolm Wiener Collection
(Cat. 40)

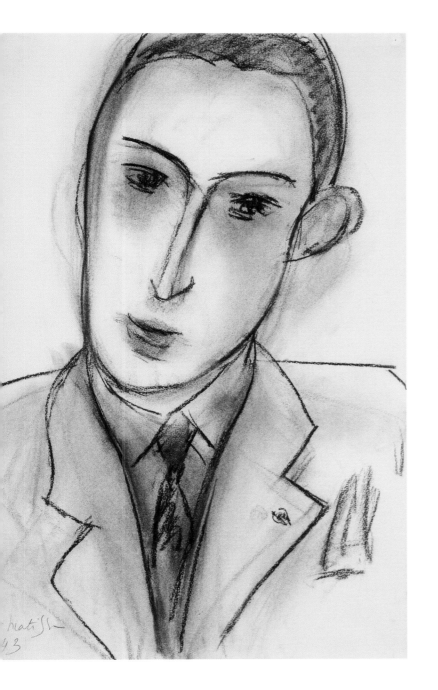

Parisian Held in Art Sales
PARIS, Sept. 21 (AP)—The National Police announced today the arrest of
Martin Fabiani, well known Parisian bon vivant and racing stable owner, on
charges of having made huge and illegal profits during the occupation in the
sale of Nazi-confiscated art works. One of his patrons was said to have been
former Reich[s]mars[c]hal[l] Hermann G[ö]ring.

It turns out that Fabiani—the gentle soul of Matisse's portrait and Picasso's dashing X-ray—had a
flourishing business during the occupation, according to David D'Arcy, "by trading Old Masters for
'degenerate' pictures that the Nazis had seized from French Jews, many of whom died in concentration
camps."[37] Picasso had been among those who bought art from Fabiani, including a painting by the
Douanier Rousseau that came from a collection stolen by the Nazis; Picasso returned it to the rightful
owners after the war.[38] Fabiani was indicted in 1946 by the French government for embezzlement of the
Wertheim collection and for "attempts against the security of the state," for which he was fined a huge sum

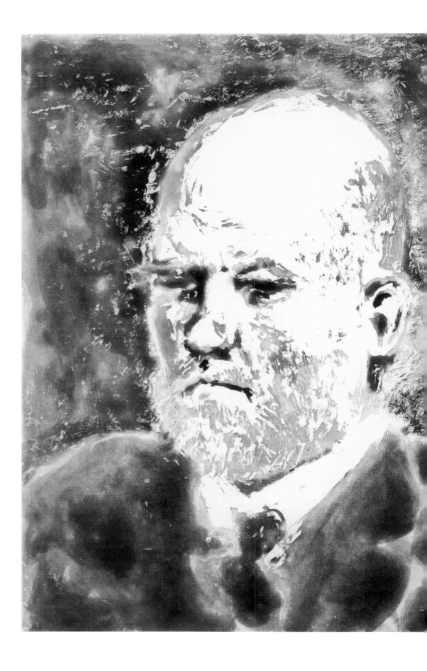

(although he does not seem to have received a prison term). But there's more: Martin Fabiani inherited a good deal of art from the estate of Ambroise Vollard, whose death just before the war had always seemed mysterious, and almost funny. During an automobile accident, while being chauffered to his country house outside Paris, he was apparently knocked on the head either by an Aristide Maillol bronze or by a large pot of chicken curry (or cassoulet, according to some) perched on a ledge behind the back seat. Picasso's great biographer, John Richardson, who was acquainted with a dealer close to Vollard's heirs, is convinced that Fabiani had his mentor murdered, or had a hand in it.[39]

In making Fabiani's portrait so soon after his predecessor's death, Picasso must surely have been thinking back to the series of portraits of Vollard he had created over the course of three decades. These included one of his most important Cubist paintings, of 1910, now in the Pushkin Museum, Moscow; one of the first wartime Ingres-style drawings, now in the collection of the Metropolitan Museum of Art, New York; and three prints, mostly aquatint and etching, [ills. 18, 19, 20] that Vollard commissioned from the artist in 1937 (apparently to complete a negotiation for a group of paintings by Pierre-Auguste Renoir that Picasso had acquired from the dealer).[40] As if watching a slow, stylistic striptease, we observe Picasso unburden the portrait of the myriad textures and effects by which he conveys the dealer's nearly closed

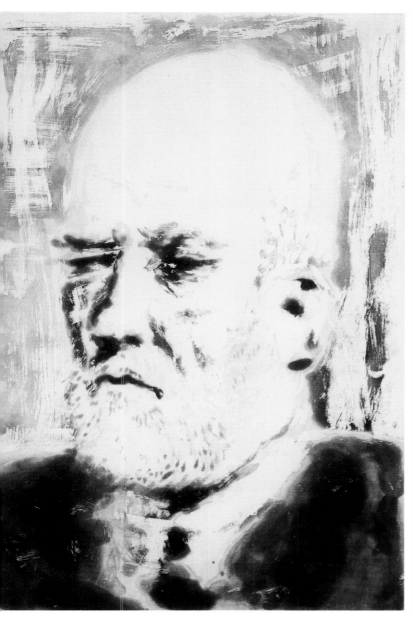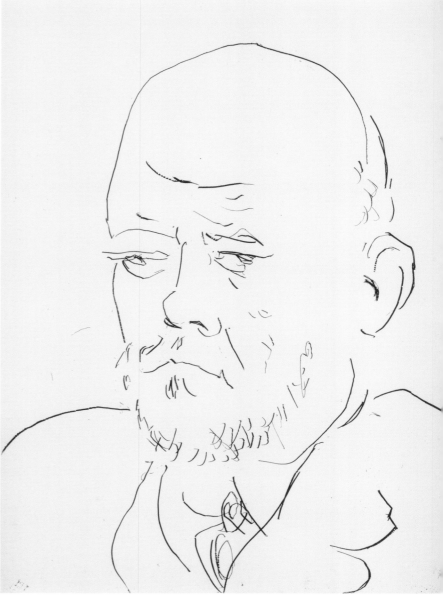

eyes, his pug nose and scowl, his gray beard, his suit jacket and tie, and the mottled background, until, by the third print—assuming that the three have been accurately put in order[41]—Vollard has become a less grizzled, younger version of himself, perhaps closer to a caricature, as Abigail D. Newman has observed, than a traditional portrait.[42]

In creating three different, contemporaneous printed likenesses, Picasso was, in effect, recapitulating Vollard's history as a serial portrait sitter. Not only had Vollard sat for major paintings by Cézanne, Renoir, and Picasso—three artists whose enormous reputations he helped establish—but he had also been the subject of works by, among others, Pierre Bonnard, Georges Rouault, and the now mostly forgotten Jean Puy [ill. 21]. Vollard became Puy's dealer immediately following the Salon d'Automne of 1905, where Puy exhibited with the Fauves in their first major group demonstration; he would be the artist's dealer for the next two decades. The man one sees in this wonderful and little-known portrait is the very embodiment of Parisian high bohemia—elegantly turned out, absorbed in his book and thus indifferent to the spectator (or, rather, to the artist who is painting him), and stretched out on a bed or couch that is draped in what looks like a Middle Eastern textile. His artful pose is one that we are likely to associate with female figures, like Ingres's odalisques or Middle Eastern male potentates, like Eugène Delacroix's

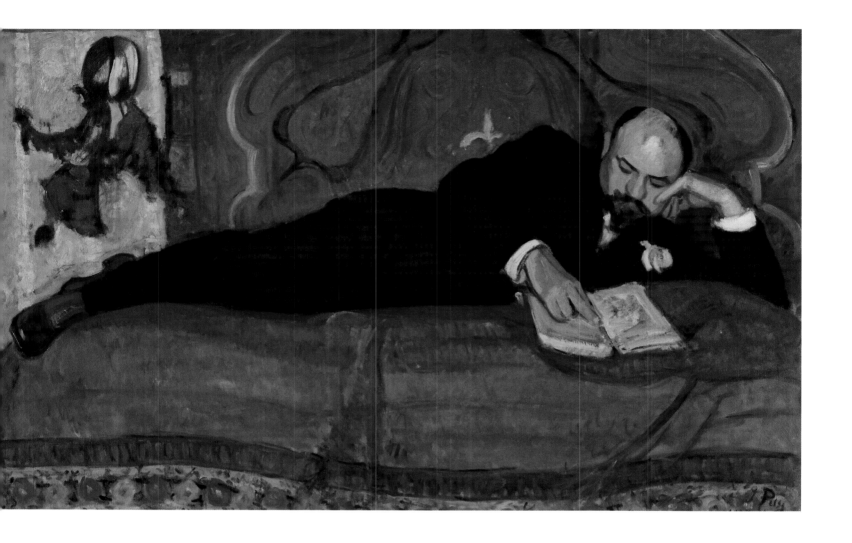

Sardanapalus.[43] In painting him thus, Puy has captured the qualities that, by all accounts, made the enigmatic Vollard such a distinctive character on the Parisian scene. Brilliant, secretive, and exotic (he was born on the island of Réunion, in the Indian Ocean), Ambroise Vollard—farsighted businessman and voluptuary—was living proof that vanity was not exclusively the prerogative of the beautiful, but the royal road to sound investments. Few sitters have been so canny in their choice of portraitists as Vollard.

Private Faces, Public Relations: Caricature and the Selling of the Avant-Garde

Vollard's was one of the faces that allowed the Parisian avant-garde to recognize itself and, in turn, made the world recognize the Parisian avant-garde. In a group caricature by Louis Touchagues, published in the August 15, 1925, issue of the important art magazine *L'Art vivant*, [ill. 22] the rotund Vollard is jogging along the bottom of the page with one of his most important artists, Georges Rouault, tagging behind. They are but two of the art world celebrities here parodied on "Vacation (around the world)," a group that also includes, at the top, the recumbent critic André Salmon, smoking his pipe beneath a tree, and in the speeding car below, the painter Maurice de Vlaminck at the wheel, the critic Florent Fel[s] riding shotgun, and the painter Moïse Kisling in the back seat. Caricatures of Vlaminck (as a hunter of "landscapes") and Rouault (amid a gaggle of streetwalkers, a subject for which the unassuming artist was renowned) [ill. 23] had appeared the previous winter in *L'Art vivant* as part of a group of "synthetic" portraits by Touchagues. Satirized here as well were Picasso (like a Cubist X-ray), Signac (a pleasure sailor, here in a skiff named *The Independent*, since he was head of the Salon des Indépendants), Bonnard ("intimate" painter of domesticity,

as a housewares merchant), and, king of the decorative modernists, Matisse, at the upper right, as an oriental rug salesman.

That they are all here implicated in the commercialization of their art is a sign of the times. This was the height of the booming Paris art market of the 1920s, when, as the critic Léon Werth commented, art galleries had become "as beautiful as the premises of car-dealers";[44] when, according to the Parisian art chronicler André Warnod, one saw and heard things in Montparnasse that had never been dreamed of in old, bohemian Montmartre: "I'm talking about the love of money and a taste for bargaining and making deals . . . as much discussion of the price of pictures as of artistic value";[45] and when Louis Marcoussis's wife, the artist Alice Halicka, asked rhetorically: "What painter didn't have or wasn't on the point of buying a car? . . . The painters carried themselves like nouveaux-riches, talked a lot about country property, makes of cars, jewels they'd given their wives, etc."[46] Indeed, the ghost of Modigliani, who had died "for his art" as a drug-addled pauper five years earlier, or so the myth went, returns "à Montparnasse" in yet another cartoon published in *L'Art vivant* that spring [ill. 24], this time by Mario Cadiz: "Now, it's no different than with the smart set," the Archangel Modigliani scolds, pointing a finger, like Savonarola, at the art world crowd partying at one of the hot nightspots, which includes, from the left, the artist Francis Picabia dancing with the model Aïcha, the model Kiki de Montparnasse, the painters Foujita and Kisling, and André Salmon. The Parisian avant-garde was, obviously, very good at laughing at itself and getting a great deal of fun out of the way it looked, always a sure sign of immense sophistication (in contradistinction, for instance, to German portraits of the Weimar period, which owe their power to brilliant, bitter, and narcissistic self-perusal).[47]

Portraiture, in other words, had neither evaporated nor diminished. To the contrary, in their myriad forms portraits were essential to the Parisian avant-garde as they had never been before—too important, one might venture to say, to be left in the hands only of society portraitists. Whether they took the form of painting, or drawing, or sculpture (Fauve or Cubist, representational or abstract), or were caricatural low-art simulacra of physiognomy, or were part of the ever-increasing inventory of photographed faces—appearing in newspapers and art magazines, lifestyle publications, and deluxe exhibition catalogues—the portraits of, by, and for the art world in Paris served mutually reinforcing functions. Making the likeness of one's artist-friends, critics, or dealers usually began in the domain of personal feeling and private connection. Once those resemblances were sent into the agora—to be seen in the art galleries of the rue La Boëtie or at the biannual salons—they took on a new life, a *second* life, as celebrity portraits. Conversely, all the images of artists and their entourage that began in the realm of mass culture became reinforcement for high cultural value: knowing what Ambroise Vollard, or Foujita, or Cocteau, or Vlaminck looked like

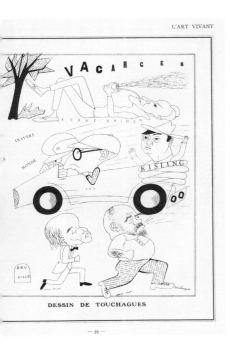

DESSIN DE TOUCHAGUES

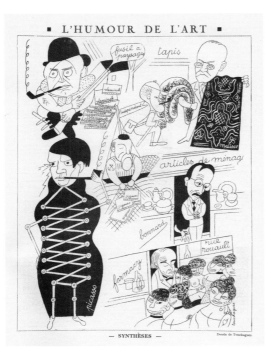

— SYNTHÈSES —

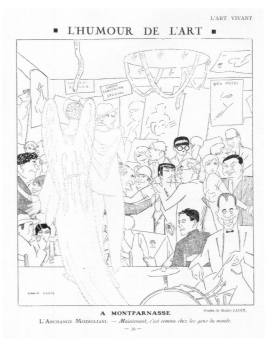

A MONTPARNASSE
L'ARCHANGE MODIGLIANI. — *Maintenant, c'est comme chez les gens du monde.*

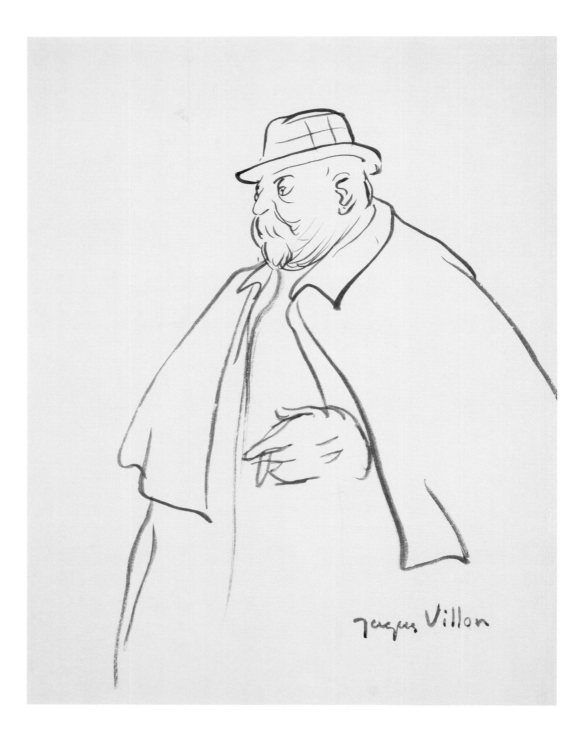

from the picture press and from caricatures meant that their representation in art, no matter how surprising or abstract, was "readable" and therefore interesting.

There was much give-and-take in Paris between the various portrait genres, in terms of style and intention. Artists like Jacques Villon, who conceptualized his father in a Cubist mode, was also capable of portraying the couturier Paul Poiret in a quickly sketched, naturalistic pen study, almost a caricature, [ill. 25] because, like so many other Parisian artists, he had made ends meet in his youth as a commercial artist, in his case an illustrator for newspapers. (Poiret, by the way, was important to the Parisian arts as more than a very gifted designer: he was also a major art collector and gallerist. In the winter of 1912 he invited Delaunay and Laurencin to exhibit together in a two-person exhibition at his Galerie Barbazanges, the "first significant showing by either artist."[48]) Adam Gopnik has written about the important links between primitivism, caricature, and Picasso's nascent Cubism, about 1906–9,[49] and there are as well links between "high" abstraction and "low" caricature that occur within individual works, like the portraits of Guillaume

Apollinaire, Francis Picabia, and (the ubiquitous) Ambroise Vollard, [ills. 26, 27, 28] by Marius De Zayas, artist, gallery owner, and transatlantic aesthetic animator (who lived in Greenwich, Connecticut, in the last years of his life). All three, plus a fourth, were published by Apollinaire in the "little magazine" *Les Soirées de Paris*, in the issue of July/August 1914, just as World War I got under way. Graphically bold black-and-white picture puzzles, these caricatures abandon resemblance almost entirely (apart from that of Apollinaire, whose small features and large face can still be recognized, as can perhaps Vollard's eyeglasses). De Zayas had followed a trajectory not unlike the one we know that Gertrude Stein would follow in her portraits—from the external or physical likeness to the internal or "intrinsic expression," as the artist put it. Embellished with mostly nonfunctional algebraic equations, these portraits were meant to convey the vitality of the complex, sophisticated, modern personalities that De Zayas had come to know in the art world of prewar Paris.[50]

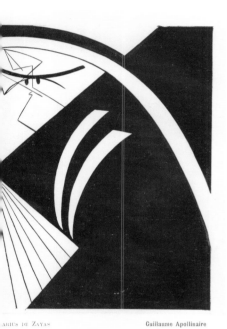

MARIUS DE ZAYAS Guillaume Apollinaire

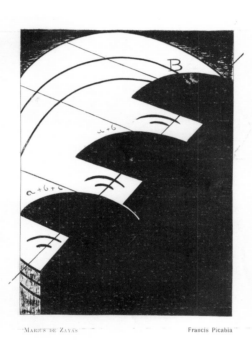

MARIUS DE ZAYAS Francis Picabia

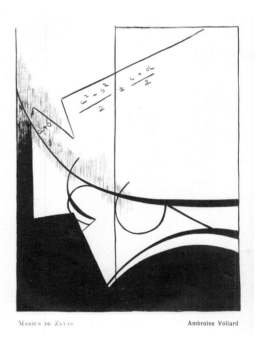

MARIUS DE ZAYAS Ambroise Vollard

Very occasionally it would occur to an artist that the Parisian vanguard was a group like any other group—classmates, hospital boards, soccer teams—and attempt to picture it, en masse. Given the rugged individualism that is required of all who would make contemporary art, these efforts at group portraiture inevitably look awkward and unnatural.[51] For instance, skilled as it is, Henri Fantin-Latour's *Un Atelier aux Batignolles* [ill. 29] lacks almost everything one would expect from a picture meant to celebrate the vitally new art that would soon be called Impressionism—intense color, brilliant daylight, adventurous composition. Included in the group gathered around Edouard Manet painting at his easel are Claude Monet, Renoir, Frédéric Bazille, and Emile Zola. Could they have imagined that they would look like undertakers rather than risk takers? A too apparent sense of its importance characterizes this lugubrious collection of artists and writers, bathed in an academic gloom that would have been all too congenial to their aesthetic antagonists, the conservative Salon painters. Despite that, Fantin-Latour referred to *Un Atelier aux Batignolles* as a mere "réunion des amis"—a meeting of friends—which perhaps is where the new Paris arrival, Max Ernst, in 1922 got the idea for *Le* (or *Au*) *Rendez-vous des amis (All Friends Together)*,

Ill. 29
Henri Fantin-Latour
(French, 1836–1904)
Un Atelier aux Batignolles
(The Atelier of the Batignolles): Manet,
Schoelderer, Renoir, Astruc, Zola, Maitre,
Bazille, and Monet
1870
Oil on canvas
204 x 273.5 cm
Musée d'Orsay, Paris, France
(Fig.12)

Ill. 30
Max Ernst
(French, born Germany, 1891–1976)
Au Rendez-vous des amis
(All Friends Together): Aragon,
Breton, Baargeld, De Chirico, Eluard,
Desnos, Soupault, Dostoyevsky, Paulhan,
Perst, Arp, Ernst, Morise, Fraenkel, and
Raphael
1922
Oil on canvas
Museum Ludwig, Cologne, Germany
(Fig. 15)

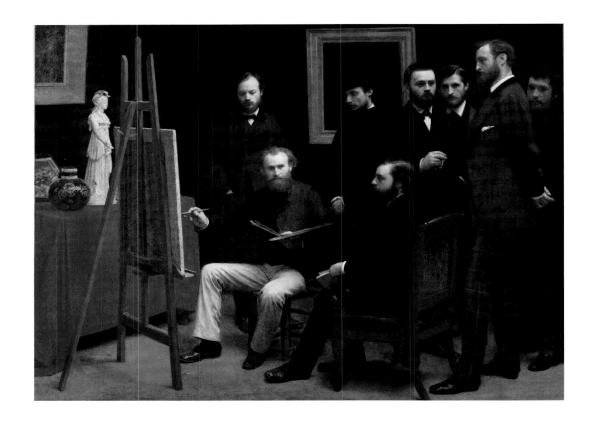

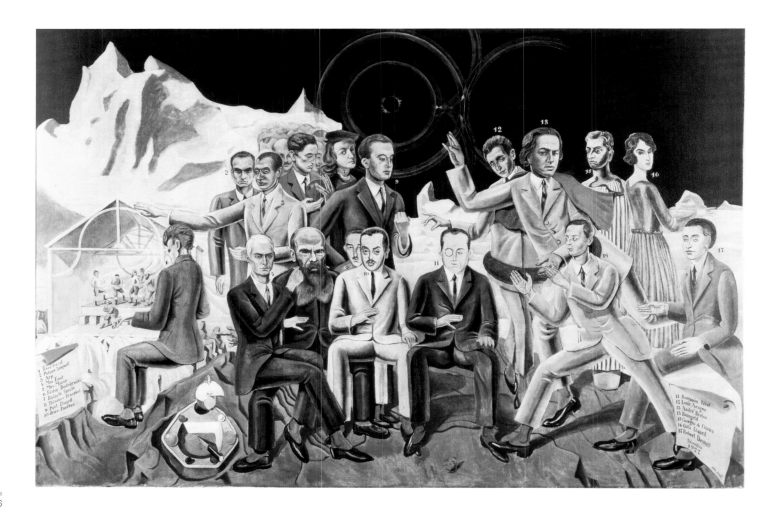

[ill. 30] which he exhibited the next year at the Salon des Indépendants. "Mid-way between visionary landscape and fairground cut-out photograph"[52] is how John Russell described the style of Ernst's high/low congregation of sympathetic friends and historical antecedents. Many of the key members of the nascent Surrealist movement are present and accounted for—André Breton, Philippe Soupault, Louis Aragon, Robert Desnos, and Paul Eluard and his wife, Gala (the lone female)—including Ernst himself, sitting on Fyodor Dostoyevsky's knee and pulling his beard, a sure sign that this group portrait is a send-up of the genre, a clever way to promote one's status in the Parisian avant-garde and deny one's status seeking at the same time.

Ill. 31
Marie Laurencin
(French, 1883–1956)
Les Invités (The Guests) or
Group of Artists
1908
Oil on canvas
64.8 x 81 cm
The Baltimore Museum of Art:
The Cone Collection,
formed by Dr. Claribel Cone and
Miss Etta Cone of Baltimore, Maryland
(BMA.1950.215)
(Fig. 9)

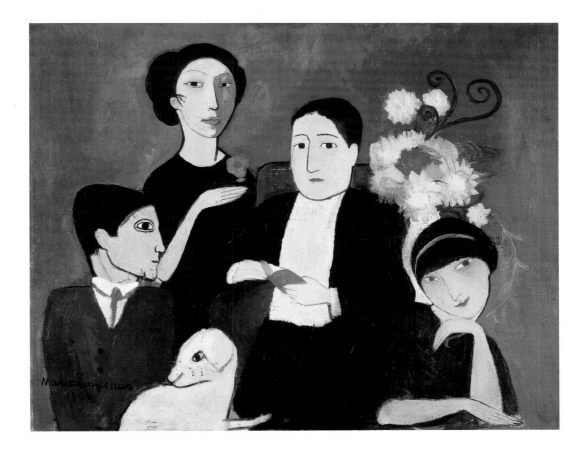

One of the few group portraits painted by a member of the avant-garde before World War I— a work whose first owner was Gertrude Stein—*Les Invités (The Guests)* by Marie Laurencin, [ill. 31] was clearly intended as a vehicle to promote herself within the Parisian inner circle, to insert herself there, permanently. With a masklike face that reveals little about what she's thinking and as the only standing figure in the picture, Laurencin asserts her role as its maker and as "hostess" of this gathering of friends, following the logic of its title. At the same time, by casting half her face in shadow, Laurencin withdraws some of that power of agency, probably in deference to her big-shot pictorial guests: to her right, her lover at the time, Guillaume Apollinaire, and at the lower left and right, Pablo Picasso and his partner, Fernande Olivier.[53] Yet, since Laurencin's work was neither incipiently Cubist in 1908, the year she painted the picture, nor would it ever be, *Les Invités* remains a curiosity rather than a proclamation of aesthetic allegiance, unlike a superb drawing of two years earlier, a work of complete artistic conviction [ill. 32]. The twenty-three-year-old artist who peruses herself in the mirror—a Sèvres-trained porcelain painter and student of the Académie Humbert—looks serious, sensual, and a bit apprehensive. Scared of herself and of her ambition, or of the spectators who will eventually look into her eyes and perhaps her heart, as she now looks into her own? This is the peculiar substitution that haunts all self-portraits from their inception. Like the crucial move away from the infantile "mirror stage" described by the French psychologist Jacques Lacan,[54] the artist must be ready to leave her (or his) self-sufficiency for the big but alienated world of adult accomplishment. If successful at attracting our interest, the self-portraitist will have to vacate her place and allow us to take it; what begins in the safe cocoon of self-regard in the artist's studio will finish as an object

Ill. 32
Marie Laurencin
(French, 1883–1956)
Self-Portrait
1906
Colored pencil and
pencil on notebook paper
19.8 x 12.5 cm
The Museum of Modern Art,
New York. Gift of Steven C.
Rockefeller, 1970, 591.1970
(Cat. 22)

Opposite:
Ill. 33
Hermann Haller
(Swiss, 1880–1950)
Head of Marie Laurencin
c. 1920
Terra cotta
25.4 x 16.5 x 17.8 cm
Collection Albright-Knox
Art Gallery, Buffalo, New York,
Bequest of A. Conger Goodyear,
1964, 1966:9.27
(Cat. 20)

p. 40:
Ill. 34
Foujita (or Fujita Tsuguharu)
(Japanese, 1886–1968)
Self-Portrait with Cat
1928
Pen, ink, and wash on paper
33 x 24 cm
William Kelly Simpson, New York
(Cat. 15)

p. 41:
Ill. 35
Foujita (or Fujita Tsuguharu)
(Japanese, 1886–1968)
Self-Portrait
c. late 1930s
Color woodblock print
33.2 x 24.8 cm
Los Angeles County Museum
of Art, Gift of Chuck Bowdlear,
Ph.D., and John Borozan, M.A.
(M.2000.105.158)
(Cat. 16)

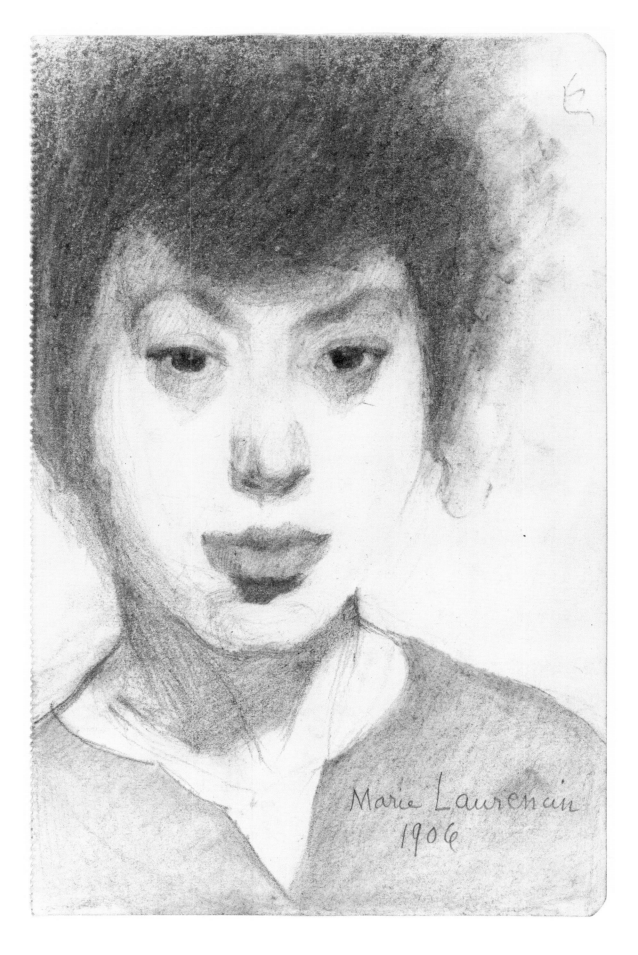

that must make its own way in the world of the art gallery. I suspect it is this impending loss that gives so many self-portraits their charged quality. The slight red and blue highlights that enliven this otherwise purely tonal study add yet another uncanny element, as if Laurencin had applied just a hint of makeup in anticipation of our eventual intrusion. Tamar Garb traces the linguistic and real slippage between painted faces, or *maquillage*, and the painting of faces—between seduction and art—in an important recent study of women and portraiture.[55]

That seeing ourselves as others see us is, alas, a struggle we are bound to lose—even if the effort is ever and always necessary to the ongoing business of life—is hinted at when we compare Laurencin's young self-portrait drawing to the terra cotta head of her by the Swiss sculptor Hermann Haller, of 1919 [ill. 33]. Laurencin may well have still felt like the woman she drew in 1906, but what she projects is utterly different: now she looks prim and a bit lost in her thoughts, which, of course, is an inevitable result of the difference between the distracted boredom of sitting for one's portrait and the engaged excitement of making one. But something else was probably on her mind. Having left her prewar Parisian identity behind, as Apollinaire's consort and would-be intimate of the *bande à Picasso*, Laurencin was about to remake her art world image. Over the next few years she would become firmly established as the one and only major woman painter in Paris, a position she would maintain for decades to come.[56] Almost to the exclusion of anything else, and apart from an occasional portrait, Marie Laurencin painted subjects that affirmed this identity and that were as unthreatening as possible: pretty girls without men (she appears to have led a lesbian life from the 1920s on), in one state or another of elegant déshabille, posed alongside gentle, companionable animals, the whole rendered in pastel tones of pink, yellow, and blue. "Blue inspires me," she told an interviewer in 1925, "it's my favorite color, I look good in it, it's nice and it creates tranquility, without which it would be impossible to isolate myself, to think."[57] Had Laurencin set her sights on becoming Paris's "woman painter," a niche artist for the elite? We can't know, but this much we can say: the art of no other woman in Paris sold as well as hers, and no other woman artist received as much critical attention.

"Tall, slender, she looks like something out of a Persian print, [but] modernized": thus was Laurencin described in *L'Art vivant* in 1925.[58] Whatever else she was, Marie Laurencin was an exotic other in the Paris art world. But no more so than the only real Asian star on the Parisian scene, Foujita (or Fujita Tsuguharu), who also figured out how to make himself an indispensable player

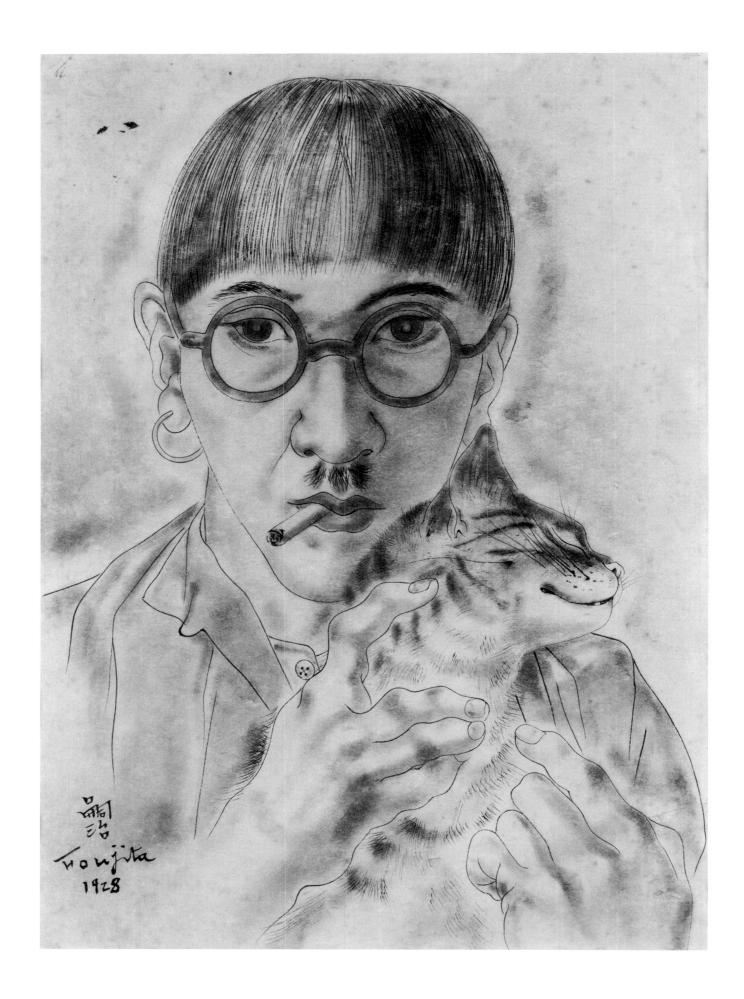

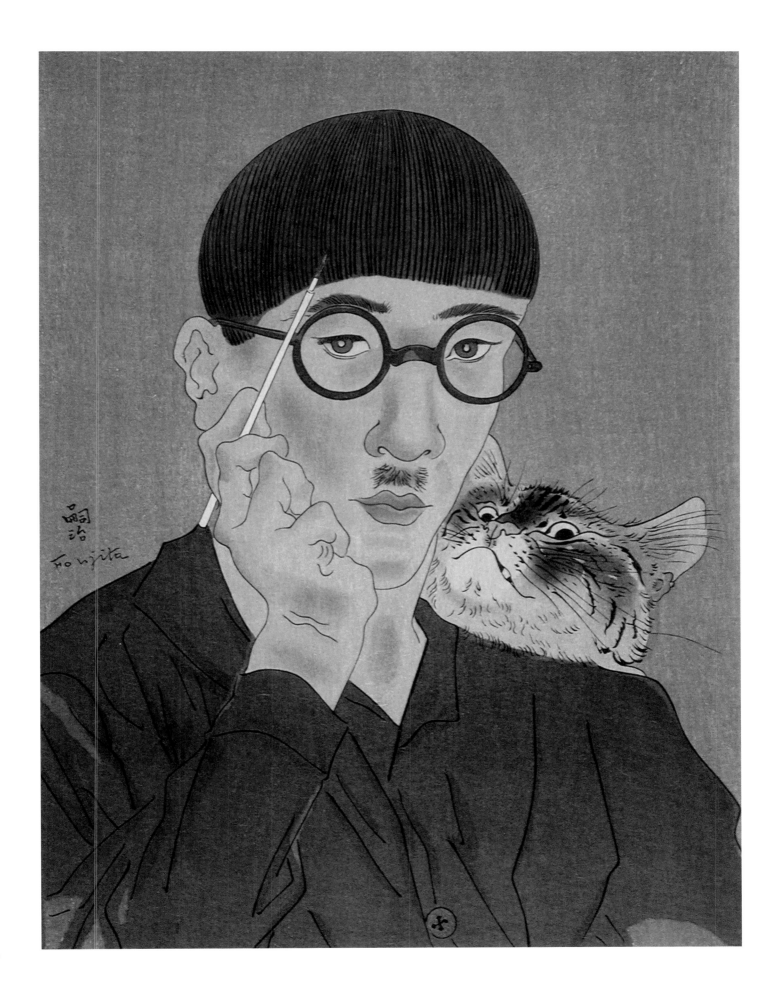

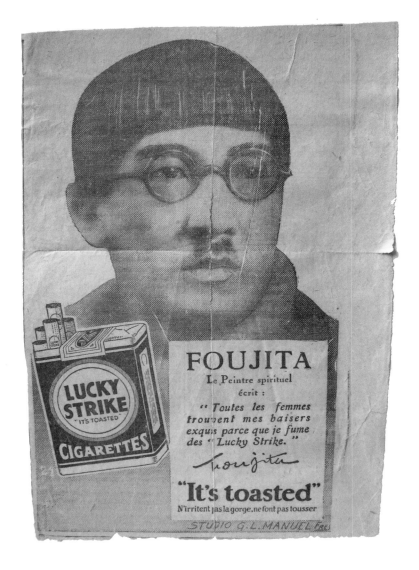

in the *comédie humaine* of contemporary art [ills. 34, 35]. Indeed, few artists were as successful in branding their "look" and their personality in the Parisian art world as he. Although certain aspects of Foujita's personal style were very much of the moment and thus shared by others in Paris—the large, perfectly round eyeglass frames were also worn by the architect Le Corbusier, and Moïse Kisling had the same *garçonne* haircut, with bangs—his earrings were, as far as I can tell, unique (especially surprising for a man who was flamingly heterosexual), just as the various elements of this eccentric vocabulary, along with his wisp of a mustache, were put together in a syntax all his own. With the addition of an adoring cat, this was the visual kit that spelled "Foujita" to an equally adoring public. Foujita's name and face appeared as advertising endorsements, [ill. 36] and there exists—as a joke about and homage to the dissemination of his eccentricity—a photograph in which the artist stands alongside a mannequin made up and dressed as his double [ill. 37]. Foujita was completely self-conscious about his use of the celebrity system of the art world, which he exploited to the full: "Those who think I became famous because of my kappa hairstyle and my earrings should compare me to the automobile company Citroën," he astutely observed. "Really, publicity is important. There's nothing that beats the combination of ability and publicity."[59] Foujita insisted on his manifest artistic ability. Famed for the suppleness of his line and his lightness of touch—traits attributed by him and the contemporary press to his Japanese background[60]—he wields what looks like a very thin, fine paintbrush, in his Japanese-inspired colored woodblock print self-portrait. He prominently displays both his hands in his self-portrait drawing of 1928, a tour de force of subtle chiaroscuro, where he also proclaims his dual geographic allegiances, by signing his name in French and Japanese. Understanding media, Foujita wants us to recognize the connection between what he looks like and what he makes—his product. That,

to the contrary, Marie Laurencin, we now realize, had suppressed her hand in her self-portrait drawing of 1906—suppressed, as it were, the "manual labor" part of the artistic enterprise—may relate to many other issues that hover around the self-identity of artists in the modern period, including class, gender, and the honest avowal of commercial ambitions, none of which seem to have troubled Foujita.

Nor did they bother Marc Chagall. In a modest self-portrait etching and aquatint of 1931 [ill. 38], he creates a kind of advertisement for the Chagall brand by reverting to a type that had been popular since the Baroque period, the artist at his easel. With a glimpse of the Eiffel Tower in the background, Chagall, palette at the ready, works at his art—we can make out a human figure on his canvas—as a horse with a

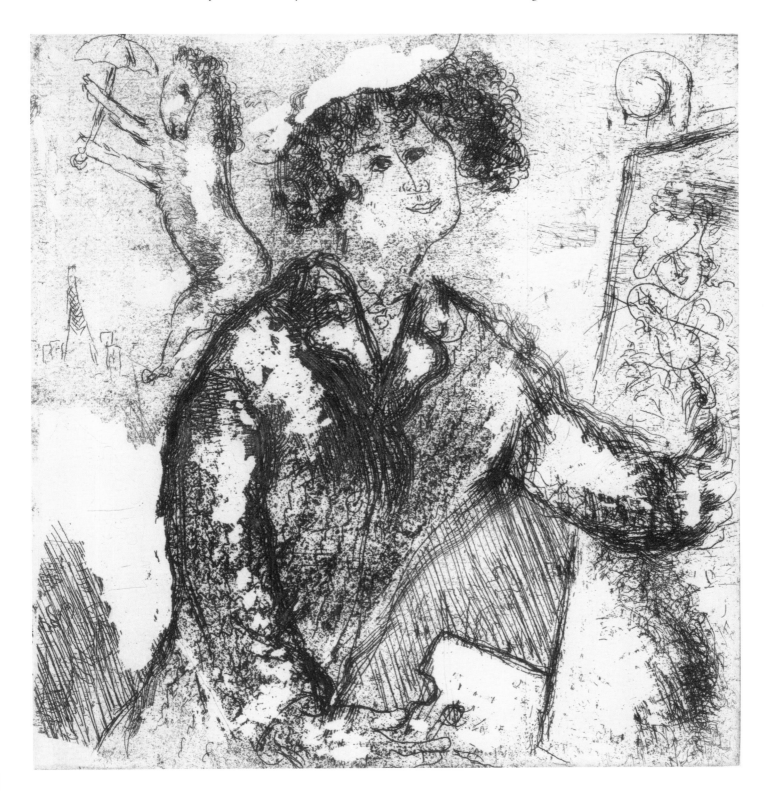

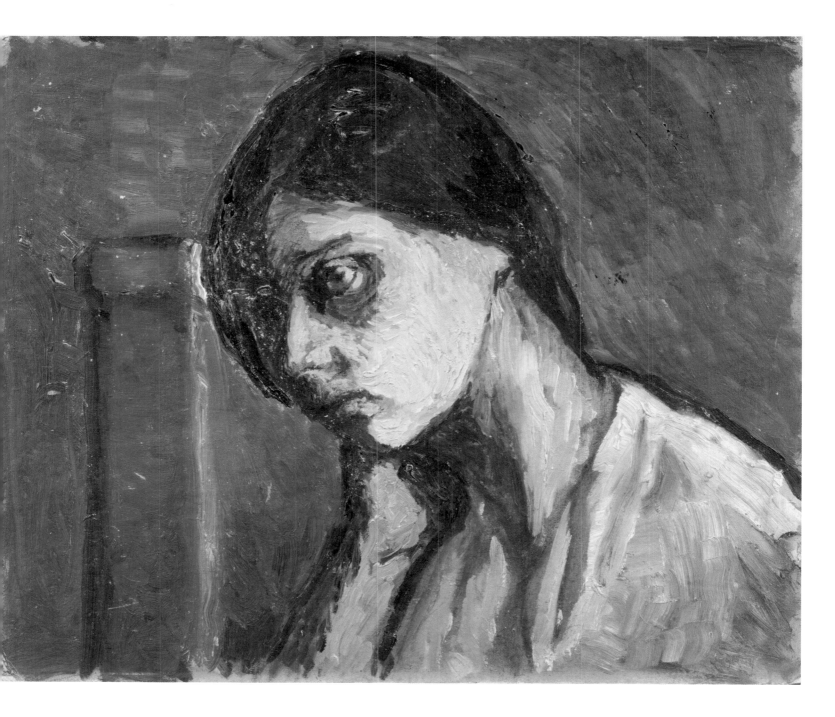

parasol dances just above his shoulder, at the upper left. If Laurencin was the Paris art world's hyperfeminine woman artist and Foujita its eccentric Far Easterner, then Chagall was its Russian-folkloric-Jew-in-residence, his childlike sensibility pure and untainted by his (enormous) success. To behave as if one were still an undiscovered talent—raw, imaginative, eccentric—was a way to keep the Parisian art world paying attention.

On the other hand, one might make a name for oneself without intending it and not necessarily owing to one's art. This was certainly the case for Margit Pogany, [ill. 39] whose self-portrait is so unassuming that she's practically lost in the half-light of her own painterly making. She reveals part of her face and a good deal of her left shoulder, as well as a hand held up to what looks to be her right cheek and neck—an element of body language that is among the most celebrated in the annals of modern art, as is her name. For she, of course, is the subject of one of Constantin Brancusi's greatest series of works, his portraits of Mademoiselle Pogany, like the dazzling polished bronze example on a limestone base of 1925 [ill. 40]. The Hungarian art student, who lived in the boardinghouse in Paris where Brancusi took his meals, sat for

Opposite:
III. 39
Margit Pogany
(Hungarian, 1879/80–1964)
Self-Portrait
1913
Oil on cardboard
37.8 x 45.9 cm
Philadelphia Museum of Art:
Purchased with the Thomas Skelton
Harrison Fund, 1966
(Cat. 41)

III. 40
Constantin Brancusi
(Romanian, 1876–1957)
Mademoiselle Pogany II
1925
Polished bronze on limestone base
43.2 x 18.4 x 23.8 cm
Norton Museum of Art,
West Palm Beach, Florida.
Bequest of R. H. Norton, 53.14
(Cat. 3)

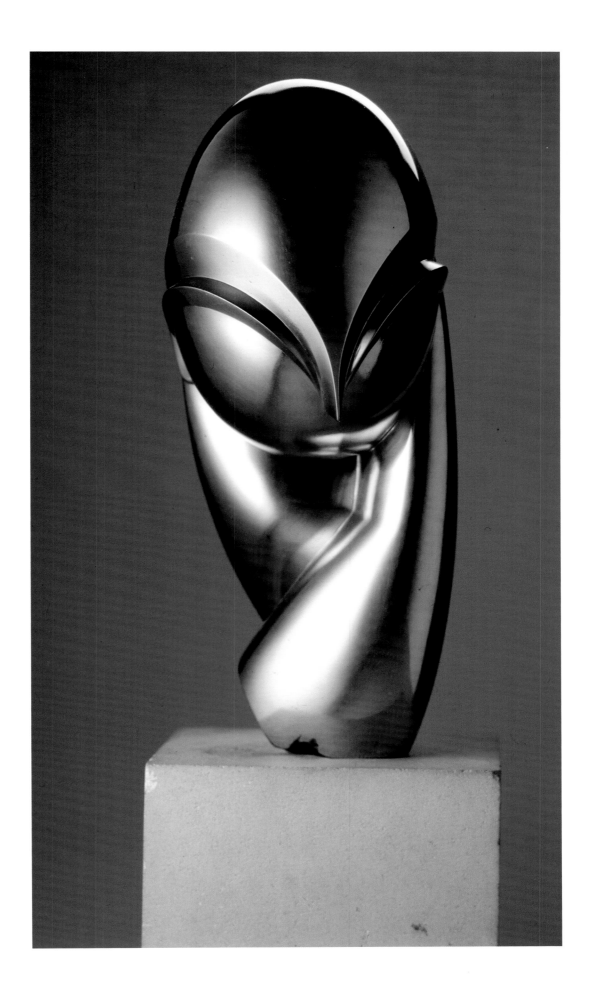

the sculptor in the winter of 1910–11; based on these sessions, he produced the celebrated group of bronze and marble busts, named for her, over the next two decades. How could we have known that the gesture of cradling her head in her hands was one that was typical of her, rather than an invention of Brancusi? If Pogany and her name have by now been completely absorbed—and made famous—by the sculptor, this is no more than the final working out of what Metzinger told us about modernism's "colonizing" of the real, to wit, that "a good portrait reminds you of its maker, not its sitter." An icon of modern beauty, *Mademoiselle Pogany* is as austere in its elegant configuration as anything Brancusi ever made.

Ill. 41
Diego Rivera
(Mexican, 1886–1957)
Angeline Beloff
December 1917
Pencil on paper
33.7 x 25.4 cm
The Museum of Modern Art, New York.
Gift of Mrs. Wolfgang Schoenborn in
honor of René d'Harnoncourt, 1975. 36.1975
(Cat. 43)

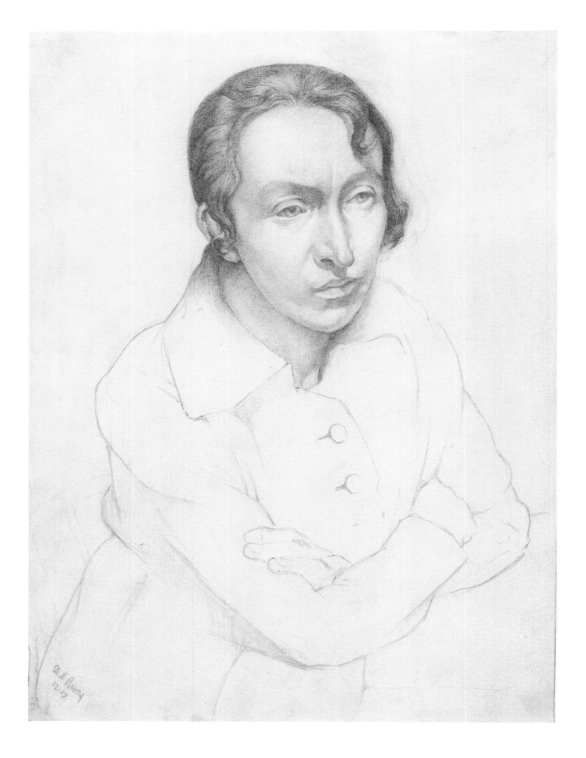

When the poet André Breton, in his first Surrealist manifesto, of 1924, gave Sigmund Freud credit for the new art and poetry movement, he was opening the doors wide to innovative portraiture. Surrealism, he wrote, was "based on the belief in the superior reality of certain forms of association heretofore neglected, in the omnipotence of the dream, and in the disinterested play of thought."[61] Although there have always been portraits where the beauty of the work of art is intended as an equivalence to the beauty of the beloved—like Diego Riviera's soigné Ingres-style pencil portrait of his Parisian lover, the artist Angeline Beloff (1917) [ill. 41]—at least since the advent of Surrealism, beauty in any standard sense has been a fairly negligible artistic virtue. Max Ernst's portrait of Gala Eluard [ill. 42] (born Helena Dmitriovna Diakonova), the wife of the poet Paul Eluard, is a visual love poem of the new Surrealist kind and one of the first and finest Surrealist portraits. Ernst here peels back, as if he were opening a sardine can, the mind of his lover and his close friend's wife. Her likeness is based on a black-and-white photograph taken of her by Man Ray,

Ill. 42
Max Ernst
(French, born Germany, 1891–1976)
Gala Éluard
1924
Oil on canvas
81.3 x 65.4 cm
The Metropolitan Museum of Art,
The Muriel Kallis Steinberg
Newman Collection,
Gift of Muriel Kallis Newman, 2006
(2006.32.15)
(Cat. 14)

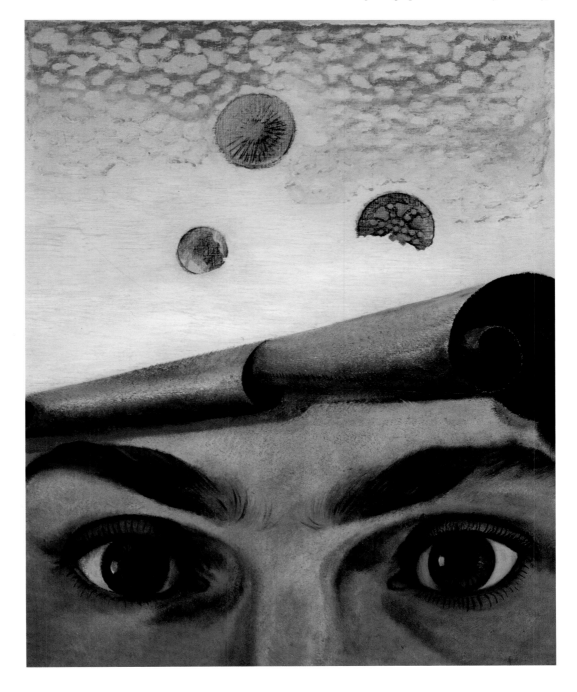

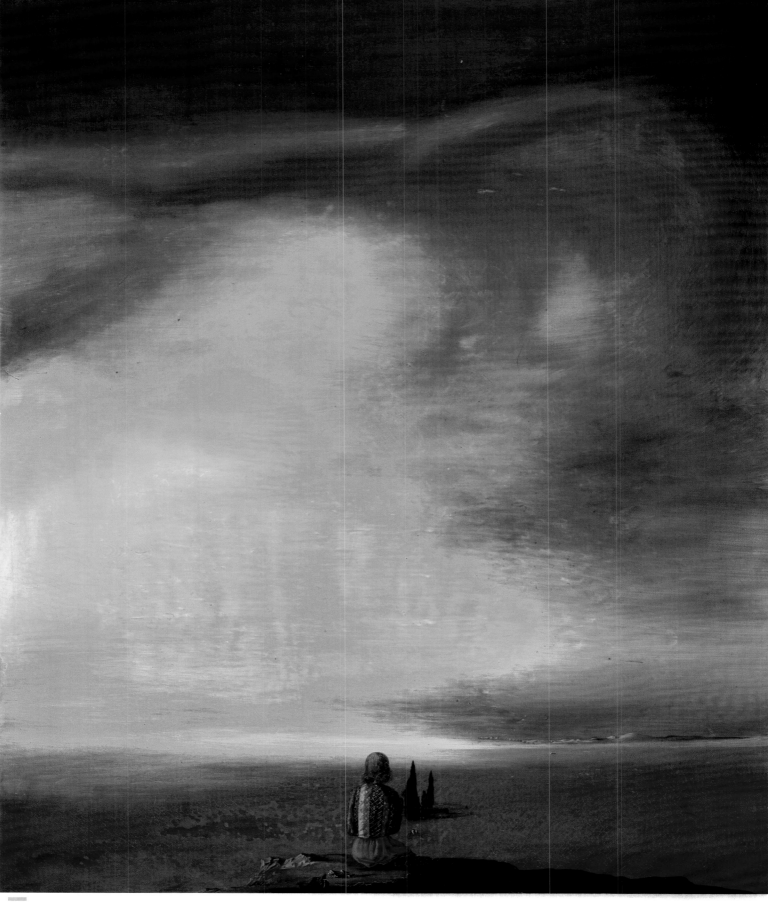

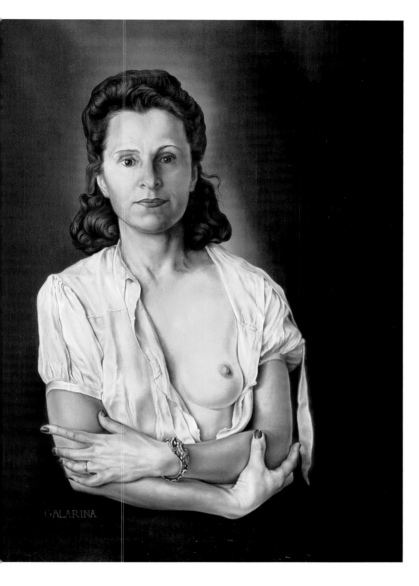

GALARINA

which is why her eyes, brows, and the bridge of her nose are rendered *en grisaille*. Floating upward from the curls of hair on her forehead are sand dollars, or echinoderms, close relatives of sea urchins, that live, feed, and reproduce on the ocean floor. Ernst has imbedded three of these primitive forms of marine life—which, like snowflakes, have unique patterns, in this case patterns of pores—in a brackish "mental landscape." Indeed, just as Ernst "borrowed" Gala Eluard's face from a photograph, his sand dollars originated elsewhere: they were made from graphite rubbings of the real things—what the French call *frottage*—a method of indexical image transfer that Ernst would henceforth regularly employ in his art. If eyes are the windows of the soul, Gala's spiritual depths appear to have been fairly chilly: the woman whose photograph by Man Ray was retrofitted for this portrait by her lover seems not the least intimidated either by their perusal or by ours.

Whether having sand dollars float out of her figurative psyche meant that Ernst thought his lover and friend's wife was a kind of mermaid, a "bottom feeder," or was merely mercenary is impossible to know—he offered no key to interpreting the picture (which would, anyway, probably have run counter to Surrealist notions of free association). Although she does seem to have had a reputation for avarice,[62] Gala was never long at the bottom of anything. By 1929 she had abandoned her marginally successful poet-husband for the up-and-coming biggest art star in Paris since Picasso—another Spaniard, and a Surrealist, Salvador Dalí. He would be devoted to Gala for the rest of his life, and she would be the object of his most persistent artistic explorations—the unfailing Gala-tea to his Pygmalion. Of course, one man's cheating wife is another man's sweet enigma. In *Sugar Sphinx* [ill. 43], we see Gala from the back and slightly from above and recognize her by the signature striped "Persian" jacket she wears in other Dalí portraits.[63] This is a case of our "looking at the looker," a doubling of the spectator's role that Dalí undoubtedly learned from German

Romantic painters like Caspar David Friedrich: we look out over the same vast plain as she and down at the same small grove of cypresses, in which the protagonists from Jean-François Millet's *Angelus*, a farmer and his wife, listen to the evening church bell, which the artist idiosyncratically interpreted as a scene of repressed sexual aggression.[64] A few years before he painted *Sugar Sphinx*, Dalí claimed that he sometimes spat on his mother's portrait (in retaliation for which his father disinherited him).[65] Perhaps that is why he so often positions Gala with her back to us, as a way to diffuse his own feelings of rage at the female love object (which does not prevent Dalí, when the mood strikes him, from having Gala, as if it were the most normal thing in the world, open her blouse to expose her naked breast to the viewer [ill. 44]). At any rate, it is significant that his mother's portrait held so much magical power for the Spanish Surrealist that Dalí turns the act of looking, in *Sugar Sphinx*, into a scopic experience shared by (at least) three—himself, Gala, and the spectator.

Matisse apparently had no adverse feelings about his mother's portrait. To the contrary, it's what made him recognize how deep-seated his feelings were for her: "The revelation of my life in the study of portraits came to me while I was thinking of my mother," Matisse recounts. "At a post-office in Picardy, I was waiting for a phone call . . . I drew without thinking. . . . And I was surprised to recognize the face of my mother with all its fine detail."[66] Richard Brilliant writes that a primary experience of the infant in arms is gazing up at its mother, whose "vitally important image" is so indelibly printed on its mind that she can be recognized "almost instantaneously and without conscious thought; spontaneous face recognition remains an important instrument of survival, separating friend from foe, that persists into adult life."[67] The intensity of the portrait experience—the normal give-and-take between artist and sitter—was, in fact, much more

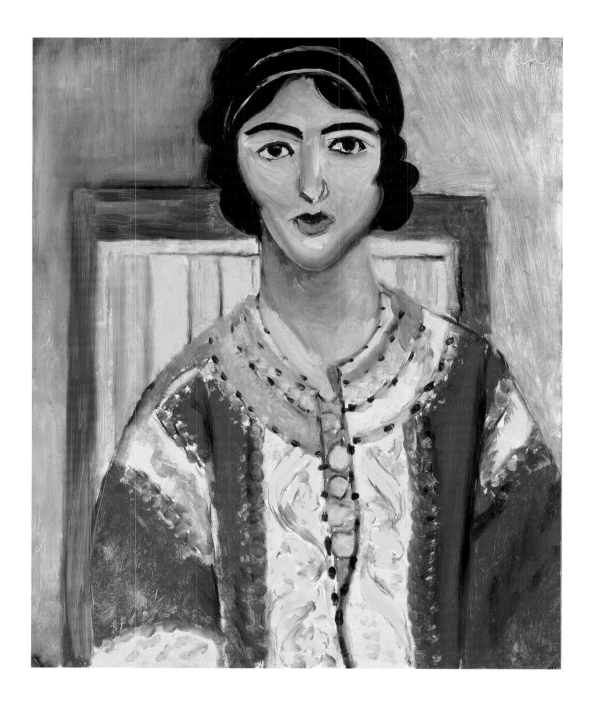

upsetting than Matisse liked. As John Klein has convincingly argued, the only way Matisse could achieve the "state of grace" necessary for "the portrait transaction" was through the "deployment of the hired model." This was, as Klein says, "portraiture the way he liked it, without demands or conflicts, a process completely in his control."[68] A curious kind of portraiture, indeed. But perhaps the painting he made of the professional model known as Lorette (or Laurette) [ill. 45], who appears in nearly fifty paintings about 1916–17, is as much the portrait of a piece of clothing as of the young woman wearing it. Probably taken from the stock of garments in which he dressed up his sitters, the vividly patterned jacket or caftan of yellow and red is clearly intended as the foil for Lorette's strikingly dark hair, eyebrows, and eyes.

No such coloristic exuberance, of course, figured in the bronze portrait heads Matisse made of Henriette Darricarrère [ills. 46, 47, 48], a model who posed for him for years and who became quite close to the artist and his family. "Matisse's models became extraordinarily important for him as the means to act out human dramas, social conventions, and artistic allegories," writes Klein.[69] As applied to these three works of the mid-1920s, perhaps they allegorize—in their movement from realism to extreme stylization—the artist's growing estrangement from the art world and from human interaction in general. Matisse by this

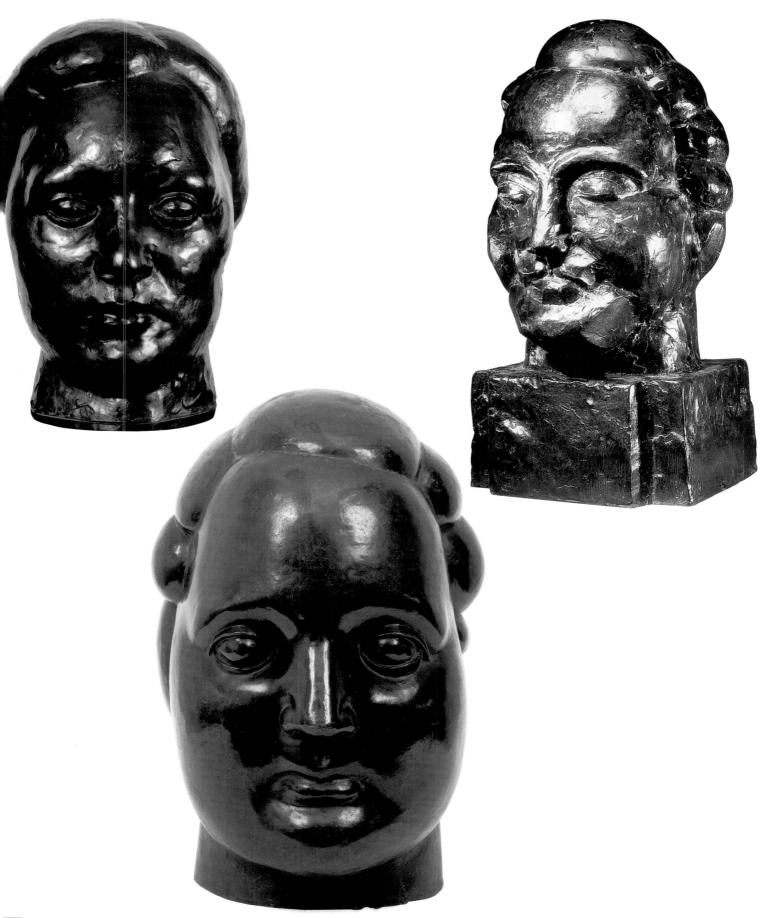

III. 49
Romaine Brooks
(American, 1874–1970)
Le Trajet (The Crossing)
c. 1911
Oil on canvas
115.2 x 191.4 cm
Smithsonian American Art Museum,
Gift of the artist
(Cat. 4)

point had taken to living almost full-time in Nice, seeing his wife, family, and friends only sporadically. The first head of Henriette is rather naturalistic, a "sensitive, nuanced study" of his model's features, according to Albert Elsen,[70] a "true portrait," according to Isabelle Monod-Fontaine.[71] *Henriette II*, while still recognizably a likeness of his model, is smooth, slick, and generalized, not unlike Lipchitz's *Gertrude Stein* of five years earlier, to which it has often been compared. Just as Lipchitz was thinking of Buddhist sculpture as a precedent for his real-life portrayal, so Elsen has noted a Baule mask from Africa and a Nice carnival mask in the photographs showing Matisse modeling *Henriette II* in his studio. He thus proposes that the artist may have been seeking "a type of self-sufficiency associated with masks when not in use. He may also have sought to fuse the portrait with the idealized head, the concentrated expression of calm."[72] The final head of the series was made after Henriette Darricarrère had ceased to model for Matisse. Based on a plaster cast of *Henriette II*, it displays on its surface a reengagement with the particularities of his model's face without restoring her physical likeness—"excavating, planning, and faceting" her features, as Michael Mezzatesta has said, "to invigorate the work sculpturally, a process indifferent to the sitter's personality."[73]

Certainly, Matisse was not generally indifferent to his models. He incorporated their look, body language, and mood into his representations of them, and he often became quite involved with them on a personal level (thus vitiating, to a certain extent, the conflict-free state he sought in hiring them in the first place). Whether that makes his painting, drawing, and sculpture of the various Lorettes, Antoinettes, Jeannettes, and Henriettes "portraits" is open to debate. Does the fact that they are paid for their services mean they have forfeited their amateur status as portrait sitters, and does that *then* mean that portraiture is a strictly social phenomenon—bespeaking a relationship of equals, that of artist and sitter—and only incidentally a matter of documentary truth or emotional engagement? What of an even more extreme case, where a famous, readily identifiable sitter—or, as here, a recumbent one—is not only unnamed but asked to function as an allegorical figure? That's what Romaine Brooks, an American painter in Paris, did when she asked the ballerina Ida Rubinstein to pose for her large grisaille painting [ill. 49] (with one thin but distinct

green line), *Le Trajet (The Crossing)*. A new star of the Ballets Russes, celebrated for her onstage near nudity, in 1909 Rubinstein had just danced the title role in the company's *Cléopâtre*, and with Vaslav Nijinsky she caused a sensation the next year in Serge Diaghilev's production of *Schéhérazade*. In 1911 she danced the title role in a ballet based on Gabriele D'Annunzio's *The Martyrdom of Saint Sebastian*, at which point she began a love affair of several years with Brooks. Rubinstein posed for other "allegorical portraits" by Brooks, including *La France croisée* (Smithsonian American Art Museum), a patriotic work of 1914, where, although dressed as a war nurse set against a burning town, she is again completely recognizable for her lithe body, angular features, and jet black hair. Brooks's friend Elisabeth de Gramont referred to Brooks as "the most penetrating of portraitists," and it may well be that *Le Trajet*, despite the high seriousness of its apparent theme—the "crossing" from life to death—is, in fact, a rather elaborate celebrity portrait. The confusion between the real, recognizable Ida Rubinstein and her painted incarnation may have been appreciated by Brooks's contemporaries for exactly what it appears to be: an excuse to put a naked superstar on canvas.

Ill. 50
Paul Colin
(French, 1892–1985)
Le Tumulte noir. Ida Rubinstein
1927
Hand-colored lithograph
47 x 31.8 cm
The Rennert Collection, New York
(Cat. 6i)

Ida Rubinstein [ill. 50] was one of the public figures celebrated enough to be parodied in Paul Colin's *Le Tumulte noir*, a deluxe, hand-colored album of lithographic caricatures, of 1927. Arms akimbo, in a pose intended to recall depictions of St. Sebastian's martyrdom by arrows, the ballerina awkwardly tries to hide the skinny naked body that made her famous. That she is deeply tanned here, in contradistinction to the stark, elongated, white form we know from Brooks's *Le Trajet*, is not accidental—all the celebrities are made dark-skinned in this "black tumult," an homage to the greatest Paris music hall star of the period, the African American Josephine Baker. "Since the La Revue Nagri [sic] came to Gai Parée, I'll say it's getting darker and darker in Paris," Baker wrote in her preface to *Le Tumulte noir*.[74] An icon of Parisian nightlife of the interwar years—who also smiles out from a poster maquette by Emile Deschler [ill. 51]—Baker wears her famous banana skirt in one of Colin's prints, which also include caricatures of the Dolly Sisters, Maurice

Ill. 51
Emile Deschler (French)
Josephine Baker
1935
Gouache, ink, and crayon maquette
44.8 x 40.6 cm
The Rennert Collection, New York
(Cat. 10)

Chevalier, the tennis champ Suzanne Lenglen, and Jean Börlin, a Ballet Suédois dancer, who waves a Swedish flag and is rendered in a Cubist style reminiscent of Léger, the company's most important stage designer. "Josephine Baker was primitivist modernism on two legs, the Cubists' *art nègre* in naked human form," write Henry Louis Gates Jr. and Karen C. C. Dalton. "Paul Colin's *Le Tumulte noir* captures a complex intercultural moment . . . [in which] we sense the delight and disorientation that Paris experienced when it first encountered African American music and dance in the persons of Josephine Baker and La Revue Nègre."[75]

Baker's look and personality were so compelling that, as if by a law of physics, she appeared to rise effortlessly into the firmament of Parisian legend (making hard work look easy is one of celebrity's tricks). Those who were able to transcend the guild system of their individual disciplines became something much bigger than painters, or entertainers, or athletes, or politicians—embodiments of Paris. They were crossover

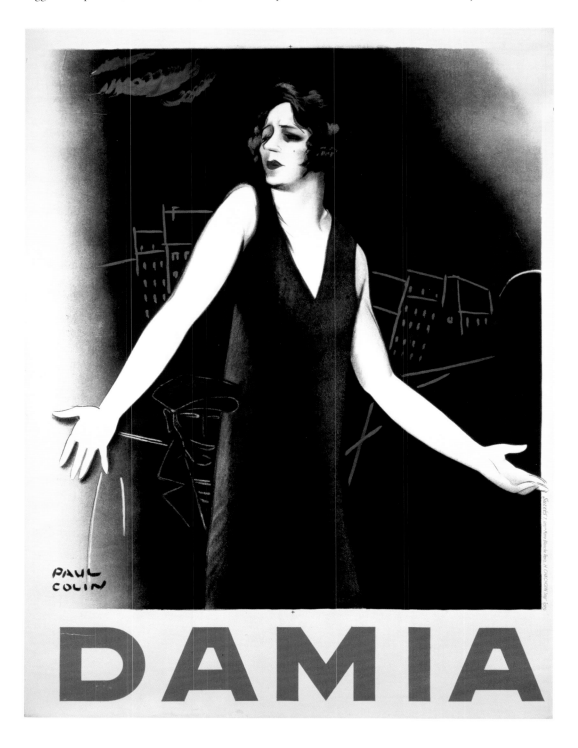

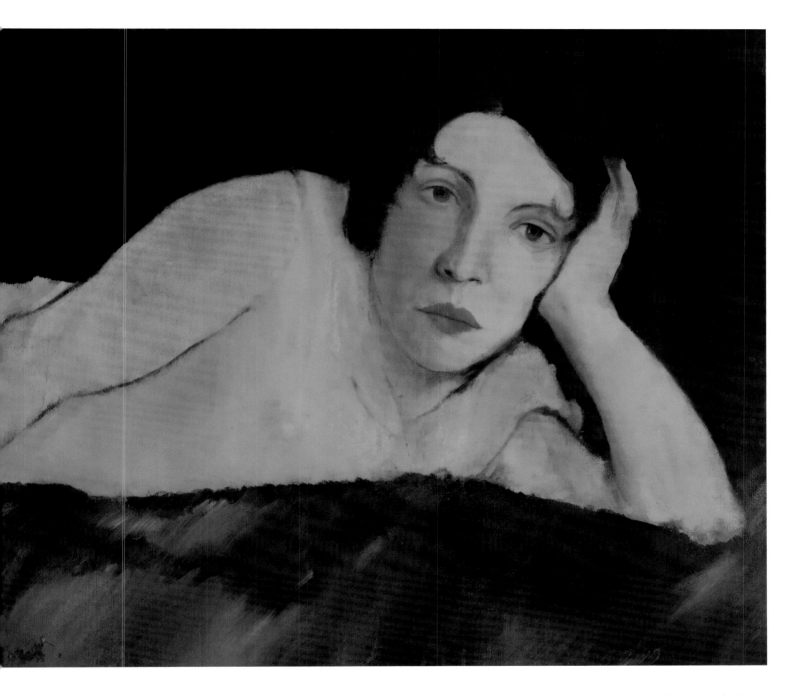

III. 53
Christian Bérard
(French, 1902–1949)
Damia
c. 1930
Oil on canvas
60 x 72 cm
John Richardson Collection, New York
(Cat. 2)

artists, types as much as individuals, larger-than-life characters who seemed Parisian to their core, whether or not they were natives. One of these was Damia, singer and occasional stage-and-screen actress (she incarnated the *Marseillaise* in Abel Gance's film *Napoléon* of 1927).[76] Colin's caricature of Damia is among those in *Le Tumulte noir*, which he also used as the basis for a Columbia Records poster in 1930 [ill. 52]. By simply reversing the blacks and whites, Marie-Louise or Maryse, Damien (her real name) is shown in the same, midsong, expressive pose. This was the working-class "Daughter of Paris" template by which, long before Edith Piaf assumed a similar identity, Damia was known to her huge, international, adoring base of fans. "[S]onorous and magnificent interpreter of the perpetual song of death," is how the critic Legrand-Chabrier described her in *Le Presse*.[77] Whatever their ostensible narrative, Damia's realist songs all painted a picture of Paris that was powerfully physical, like her post–World War I hit "Dans les fortifs," the tragic love story of a girl born in the slums of the old fortifications at the city's edges.[78] A rather different persona, more languorous but perhaps no less intense, is apparent in Christian Bérard's sensitive oil portrait of the singer [ill. 53]. This, of course, is meant to be a picture of Damia as only her intimates know her. Pushed up close to the picture plane and rendered in the most subtle shades of browns, creams, and tans, with only her full

red lips as punctuation, the singer becomes an accessible real woman, not the symbol of Paris or of France that she had become in public. Bérard was a specialist at this kind of *intime* portrait, although his sitters were usually drawn from his close circle of artistic and high society friends (like Jean Cocteau and Marie-Laure de Noailles). His neotraditional style, sometimes referred to as Neo-Humanism or Neo-Romanticism, was self-consciously anti-Cubist.[79]

 At the height of her fame, Damia was considered a front-line warrior in the newly emerging battle between indigenous French popular songs and encroaching American music. Happily, wrote Pierre Mac Orlan, despite the craze for imported "Fox-trots . . . [and] blues," Damia "was getting the better of [American] Sophie Tucker."[80] This was a subject about which few knew more than Mac Orlan, pen and stage name of Pierre Dumarchey, who had for years played the accordion to accompany the songs he himself wrote and performed at the well-known Lapin Agile cabaret. In his portrait of 1924 by Jules Pascin [ill. 54]—rendered in thin washes of oil paint and highlighted with black, a kind of colored drawing—Mac Orlan looks to be the tough but poetic Montmartre denizen of folklore, who plays the accordion as a *mégot* dangles from his Gallic lips. The painting is inscribed by Pascin, "au patron" (to the boss) Mac Orlan,

Ill. 54
Jules Pascin
(American, born Bulgaria, 1885–1930)
Pierre Mac Orlan
1924
Oil on canvas
92.1 x 73 cm
The Metropolitan Museum of Art,
The Mr. and Mrs. Klaus G.
Perls Collection, 1997 (1997.149.8)
(Cat. 35)

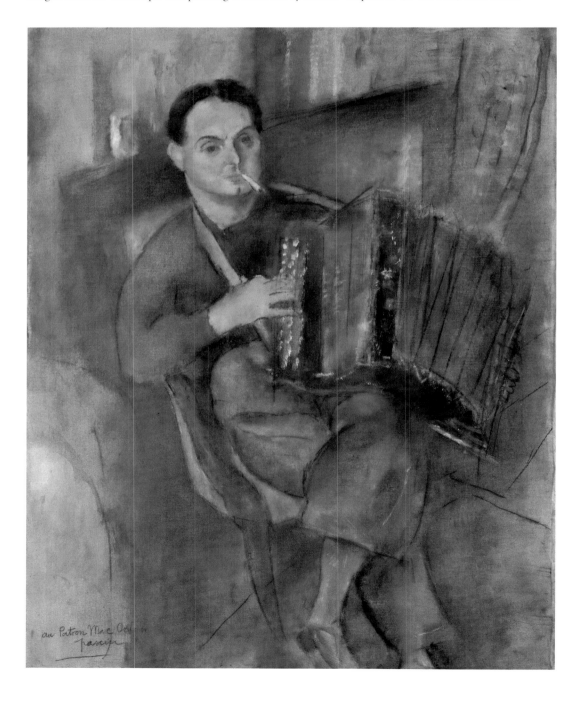

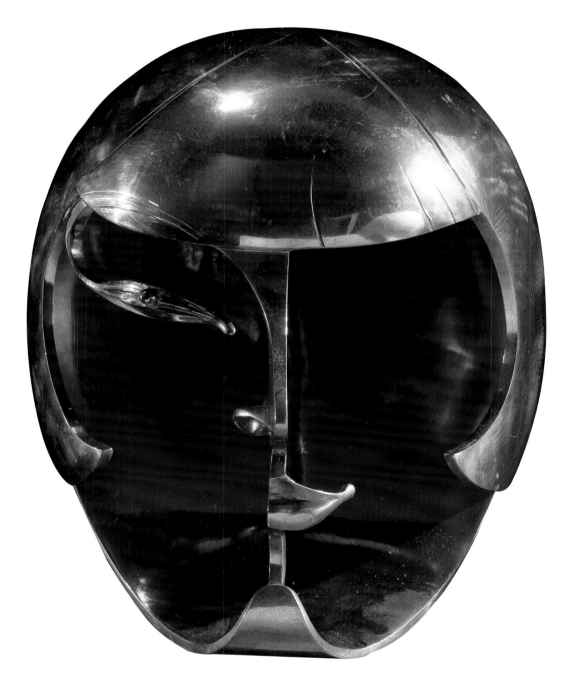

Ill. 55
Pablo Gargallo
(Spanish, 1881–1934)
Kiki de Montparnasse
1928
Polished bronze
20.2 x 16.8 x 13.1 cm
Hirshhorn Museum and Sculpture Garden,
Smithsonian Institution, Washington, D.C.,
Gift of Joseph H. Hirshhorn, 1966
(66.1989)
(Cat. 17)

altogether appropriate for a man who had mastered so many pursuits. He was a novelist (he wrote *Quai des Brumes*, on which Marcel Carné based his popular film of 1938, starring Jean Gabin); pornographer; and an art, film, and photography critic who coined the term "the social fantastic" (*le fantastique social*) to describe the extraordinary depth of feeling buried in the most ordinary facts and habits of Parisian daily life, a concept he used, in 1930, in his seminal essay on the photographer Eugène Atget.[81]

 Certainly among the most fantastic and highly social characters on the Parisian scene was Alice Prin, known universally by the nickname that attached her to the most fantastic and highly social artists' neighborhood in the world: Kiki de Montparnasse.[82] She was, before all else, an artist's model—notable for her voluptuous figure, very pale skin, dark hair with bangs, and her pert, prettily pointed nose—who posed for, among others, Kisling, Foujita, and Man Ray, who was her lover. Kiki de Montparnasse also occasionally sang in cabarets; was a self-taught painter who exhibited her work during the boom years of the art market; notoriously had her eyelids painted with wide-open eyes in *Emak Bakia* (1926), Man Ray's experimental film; and, at the age of twenty-eight, published her memoirs. The polished bronze portrait mask that Pablo Gargallo made of Kiki in 1928 [ill. 55] partakes of the distillation of form we expect of caricature but with

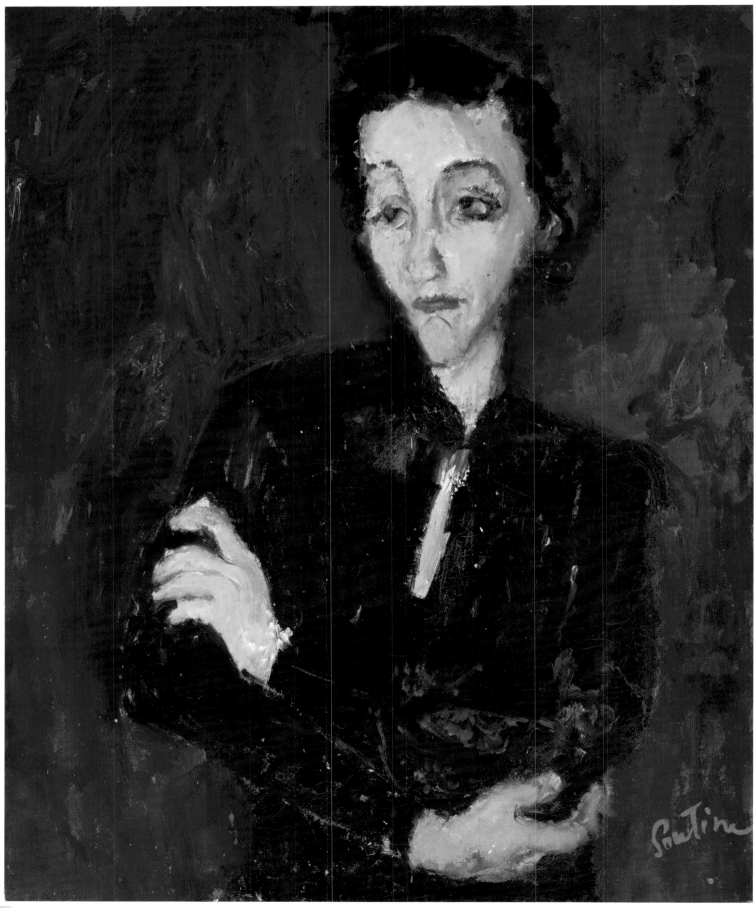

none of its ridicule or irony.[83] The swank now-you-see it, now-you-don't sculptural sleight of hand that made Gargallo's reputation—an adaptation of sheet-metal bending, whereby voids and abbreviations were made fully as expressive as his elegant, delineated forms—is the perfect vehicle for his sitter's slick, sexy, here-today, gone-tomorrow, Jazz Age glamour.

Josephine Baker, Damia, Mac Orlan, Kiki de Montparnasse: the first left St. Louis, Missouri, and crossed an ocean, when that was still a major undertaking, and the other three gave themselves new names, all in order to be reinvented as legendary figures in Paris. But how do "urban legends" get made? Everyone assumed that Maria Lani's star would never fade, inasmuch as she had been immortalized by many of the most important artists in Paris, including Bonnard, Braque, Chagall, Delaunay, Foujita, Kisling, Léger, Man Ray, Marcoussis, Picabia, Raoul Dufy, Rouault, and Kees van Dongen. Even with formidable competition like Vollard, Lani gets the prize for having been portrayed more often, by a larger group of Parisian artists, than anyone else. And she did so in about twenty months. But who was she? The "Maria Lani Story" is a

moralizing tale of beauty, fantasy, deception, greed, and fatuousness. It is also a story about art and illusion—and worth retelling.

Sometime in late 1928 the Abramovicz brothers, German motion-picture producers, arrived in Paris with their latest star, Maria Lani, who had trained for the stage in Berlin with Max Reinhardt. Word got around that the talented and very lovely thespian, a great appreciator of contemporary art, was available for portrait sittings. Before long, almost every notable artist in Paris (with a few exceptions, including Picasso) was lined up to paint, sculpt, draw, and pull prints of *la belle Lani*. According to the critic Waldemar George, these portraits of Lani would represent a triumph over the vicissitudes of time, a contemporary demonstration of Ars longa, vita brevis:

Does she want to perpetuate the memory of her body and communicate its image for centuries to come? Does the demon of eternity haunt this troubled traveler, who refuses to submit to an ineluctable fate? The destiny of those who have no other vehicle to translate their joys, their passions, their sufferings, but gesture, movement, speech—actors, mimes, and dancers—is to see the work they have created perish with their bodies, fated for decrepitude. Nothing's left of Adrienne Lecouvreur, Talma, Rachel. . . . I will never know if it is the instinct for self-preservation that spoke to her or a fear of emptiness (horror vacui) that drove her to this desire for immortality. Nonetheless Maria Lani will live on in the memory of men, and no earthly force will be able to erase her fateful image, seen through the prism of a thousand and one observers.[84]

There was, in fact, a bit of the *Arabian Nights* tale about the Lani story in Paris, as if the continued telling of it—and the continued passing on of this remarkable sitter from one studio to the next—had a momentum all its own. Of course, the number of artists involved was between 50 and 55, not 1,001, among them, the Expressionist painter Chaim Soutine, who produced, not surprisingly, a painterly "troubled traveler" who seems to wrap herself up in her graceful arms, [ill. 56] whereas Lani looks a bit more down to earth, and even willful, in Pascin's charcoal study [ill. 57]. Chagall showed Lani with an Eiffel Tower embedded in a Nefertiti hairdo, and Rouault created the kind of rough-hewn Mary Magdalen image we might expect of him. But most of the portraits of Lani—and many of them were illustrated in the album that accompanied their Paris exhibition at Galerie Georges Bernheim in 1930—were paeans to her charm and beauty, like the bronze head by Chana Orloff [ill. 58], notable for its long neck, upward tilt, and finely drawn features. Matisse distilled Maria Lani's essence down to nothing but her finely drawn features or, rather, his finely drawn rendering of what he thought she looked like [ill. 59]. Within a summarizing curve that picks up her prominent chin, high cheekbones, largish forehead, and suggestion of a chignon, he inscribes Maria Lani's face—the tip of her nose, her thin-lipped mouth, and slanting eyes—as a kind of modernist haiku in black printer's ink. "Every time you take your eyes off her she changes," wrote Jean Cocteau. "You see her in turn as a young girl, a ravaged woman, a college girl," he continues, implying that the actress before him is capable of filling an endless variety of roles and that she's the incarnation of woman's mythically mercurial "essence." This approach quickly devolves into a phantasmagoria of strangeness. For Cocteau, Maria Lani is also "a cat with thin lips, thick lips, a slender neck, a herculean neck, vanquished shoulders, broad shoulders, with Chinese eyes, with the eyes of a dog."[85] Lani's evasiveness generated a multitude of readings, from the banally misogynist to the by-now familiar sitter-as-blank-slate

interpretation: "[the artist] makes his own portrait, injecting into the living mask that reflects his own likeness the variations resulting from his inspiration," wrote one critic of the Lani portrait show in 1929.[86]

But there was one interpretation of Maria Lani's endlessly fascinating, chimerical, elusive presence that apparently never occurred to any of the immensely talented artists who portrayed her or the astute critics who discussed her: that she was a fraud. After three major exhibitions of the Lani portraits—in New York, Berlin, and Paris—the woman and the works of art, for all intents and purposes, disappeared. Jean-Paul Crespelle says that Maria Lani turned out to be a stenographer from Prague, and *les frères* Abramovicz, her brother and husband.[87] Many of the works that had not already been sold ended up in American collections, with Lani and her coconspirators presumably having made a great deal of money in the process. No one in Paris seems to have heard of her for decades. Until her demise: an obituary in the *New York Times* (March 13, 1954) noted Maria Lani's death on March 11 at the Pitié Hospital in Paris. It seems that Lani had, appropriately enough, married an art critic, come to the United States during World War II, and worked at the "Stage Door Canteen in New York, where she was a senior hostess." Thus ended the ultimate Paris portrait story, the tale not of a star but of an urban legend, whose shtick was good enough to make many of the finest artists in town dream of capturing her essential qualities, which were really nothing but what they saw in themselves. "Every man's work," wrote Samuel Butler, in *The Way of All Flesh* (1903), "whether it be literature or music or pictures or architecture or anything else, is always a portrait of himself."

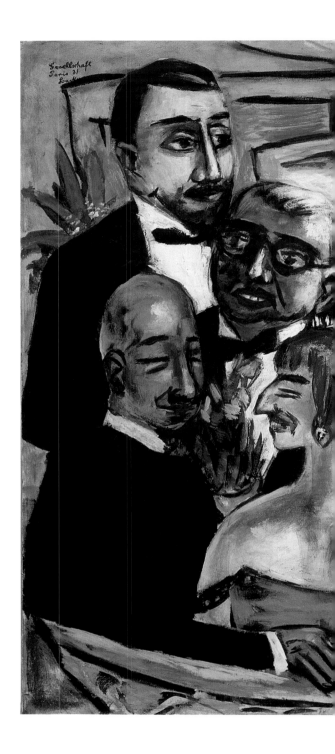

Ill. 60
Max Beckmann
(German, 1884–1950)
Paris Society (Gesellschaft Paris)
1931
Oil on canvas
109.2 x 175.6 cm
Solomon R. Guggenheim Museum, New York,
70.1927
(Cat. 1)

The impact of the American stock market crash of 1929 took several years to be felt in France, but when it was, its effects were powerful and thorough-going, not least for the Parisian art world. Few of the American collectors who had been so important to the Parisian art market were still actively buying art in Paris; galleries in New York asked for fewer and fewer French shows; and many of the Americans in Parisian residence went home to the United States once their discretionary funds dried up. The great German painter Max Beckmann bucked the tide of the Parisian exodus and went toward rather than away from the French capital. He and his second wife, Mathilde (Quappi) Beckmann-Kaulbach, lived in a series of apartments and studios, mostly in the stylish eighth and sixteenth arrondissements, from the fall of 1929 to January 1933.

Determined to be recognized in Paris, Beckmann tirelessly pursued every opportunity to make his art known to the French public. Although he was given a major one-man show at the important Galerie de la Renaissance, in the spring of 1931 his remarkable group portrait, *Paris Society* of the same year [ill. 60],

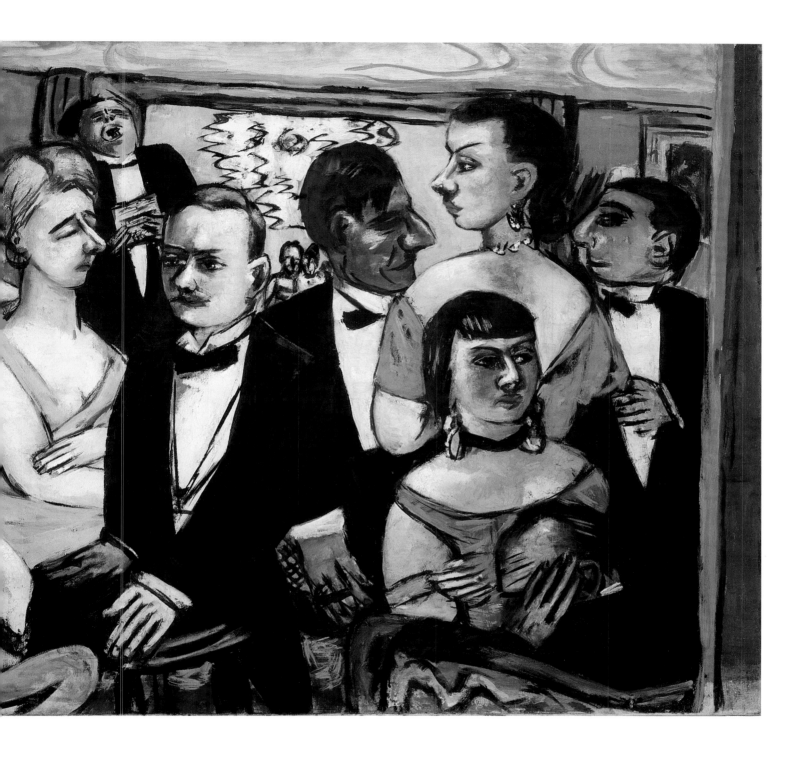

appears not to have been exhibited there.[88] This "portrait of émigrés, aristocrats, businessmen, and intellectuals . . . on the eve of the Third Reich" was apparently commissioned by the German Embassy in Paris.[89] Among those pictured are reputed to be, at the center, Prince Karl Anton Rohan, a Bohemian nobleman, pan-Germanist, Habsburg legitimist, editor of the important center-right journal *Europäische Revue*, and a key figure in all trans-European, antiprovincial interwar discourse; at the lower right, with his head in his hands, the German ambassador, Leopold von Hoesch, who, in the years following the Nazi takeover in 1933, would become a vocal opponent of Hitler; the Frankfurt banker Albert Hahn, at the extreme right; and at the lower left, in conversation with a woman to his right, Paul Hirsch, the cultivated son of a Jewish industrialist from Frankfurt, who would flee Germany for England in 1936 (his collection of historic musical manuscripts would become one of the treasures of the British Library, The Hirsch Collection).[90] We can well imagine how much preparation went into a major portrait study like *Paris Society*.

Ill. 61
Jean Dubuffet
(French, 1901–1985)
*Three Masks: René Pontier, André Claude,
Robert Polguère*
1935
Painted papier-maché
28 x 17.7 x 7.9; 23.5 x 15 x 8.3;
25.1 x 18 x 8.9 cm
Hirshhorn Museum and Sculpture Garden,
Smithsonian Institution, Washington, D.C.,
Gift of Joseph H. Hirshhorn, 1966
(66.1455.A–C)
(Cat. 11)

Opposite:
Ill. 62
Francis Picabia
(French, 1879–1953)
Portrait de Suzanne
1942
Oil on panel
63.5 x 51.7 cm
Collection Gian Enzo Sperone, New York
(Cat. 37)

According to Perry Rathbone, who knew and sat for the artist in America, when at work on a portrait, Beckmann "made it a point to see his subject at some social gathering where, as a silent observer, sitting apart from the stream of conversation, he would fix his steadfast, almost frightening, gaze upon his subject, studying him in every light, in every mood."[91] Animated, bored, nervous, snobbish, flirtatious: the guests at this official-looking cocktail party constitute a lexicon of *mondain* behavior, crammed as they are into the low, narrow, horizontal container of space. The contrast between the black-and-white formal evening clothes of the men and the pinks, oranges, mauves, and light blues of the women's gowns, as well as the range of pink and whitish flesh tones, makes *Paris Society* a percussive, exhilarating picture. Not surprisingly, given his colossal talent, Beckmann accomplishes here what almost none of his fellow artists in Paris could—he makes a group portrait that is both charming and ominous.

Many of the faces that stare out at us from Parisian portraits of the 1930s and early 1940s look unlike anything we've seen; they have the feel of hybrids, not-quite-modernist, not really old-fashioned. The masks that Jean Dubuffet made of his three close friends René Ponthier, André Claude, and Robert Polguère [ill. 61] look uncannily like human specimens, strange and familiar at the same time. Playing with our expectation for high-art sculpture—that, whether noble or beautiful, we assume to be permanent—Dubuffet fashions his friends' effigies in perishable materials (plaster and papier-mâché). Drawn from the popular culture of the European carnival, these masks represent a kind of rapprochement with the ritual African masks that, for decades at this point—at least since Picasso painted Gertrude Stein's portrait—had been radically transforming modern art. Dubuffet, we might say, turns the tables on the anthropologist in all of us: he asks us to look at his French friends, three local Parisians, with the same scholarly curiosity and rapt attention we might pay to masks from Borneo or New Guinea. In a not dissimilar fashion, the Dada pioneer Francis Picabia asks us to give serious aesthetic consideration to a kitsch, self-consciously low-brow portrait style originating in the most marginal of Parisian visual sources: "The portrait of a seemingly prim young lady in a blue dress—a portrait in fact of *Suzanne Romain* [ill. 62], the married other half of one of Picabia's

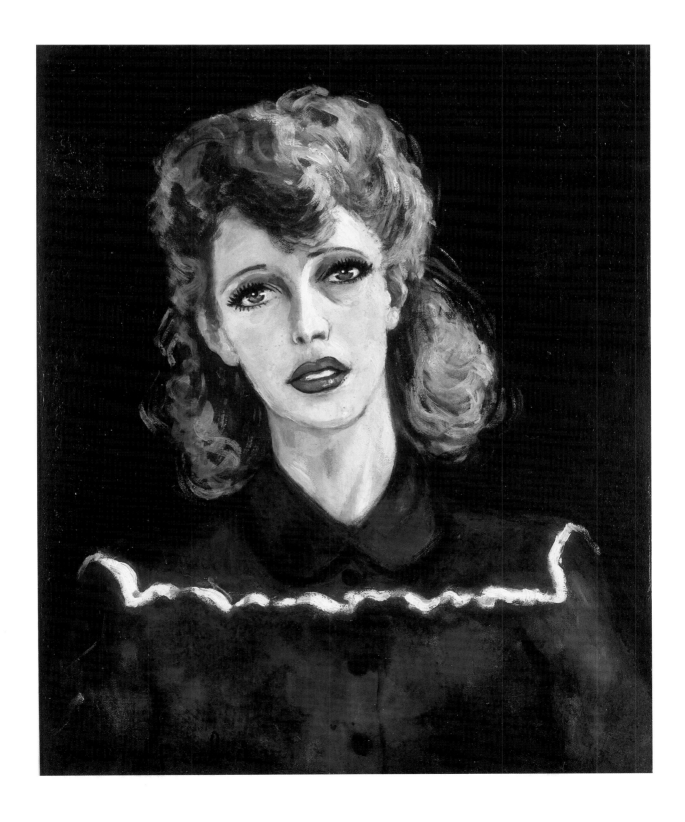

Ill. 63
Henri Matisse
(French, 1869–1954)
Self-Portrait
1945
Pencil on paper
40.5 x 52.5 cm
The Museum of Modern Art, New York.
John S. Newberry Fund, 1965, 634.1965
(Cat. 30)

own extra-marital liaisons," wrote the late, great art historian Robert Rosenblum, "looks like the work of a street-vendor portraitist on the banks of the Seine." The wife of a dentist, who by her own admission, before meeting Picabia, had been "a rather superficial creature, thinking only of my hair, my clothes, my grooming in general, like a sort of doll," Suzanne Romain eventually "came to see everything through [Picabia's] eyes."[92] Could she see that in this portrait he had turned her into a movie star of sorts, the beseeching heroine of a low-budget French melodrama? Picabia's late work is not for the faint of heart: vulgar and brilliant, it's a take-no-prisoners battle against visual decorum, waged in the name of freedom and perversity.

Of course, by this point, we are in the middle of the German occupation of France, a moment from which perverse, provocative Picabia did not exactly emerge smelling like roses.[93] It was also to be the end of Parisian dominance of modern art, although old Henri Matisse, who was still looking in his mirror to draw himself [ill. 63], was to have an extraordinary final decade ahead—creating his glorious paper cutouts and designing his chapel for the Dominican nuns at Vence. Picasso, now well into his sixties, also had great things in store, including the ceramics he would work on so remarkably at Vallauris. But Marcel Duchamp, father figure of Dada and of almost all postmodernist artistic expression (brother of Raymond Duchamp-Villon and Jacques Villon), decided he had had enough and fled for New York in 1942. He'd been planning his getaway, as it turned out, for quite a while. In 1935 Duchamp started assembling a miniature museum of his art that could fit in a box [ill. 64]: small versions of his famous ready-made urinal, *Fountain* (1917), his vial of Paris air, *Air de Paris* (1919), *The Large Glass: The Bride Stripped Bare by Her Bachelors, Even* (1915–23), and everything else he'd ever made, sixty-nine reproductions in all. "My whole life's work fits into one suitcase, literally and figuratively," he said,[94] and took that suitcase with him to New York. His

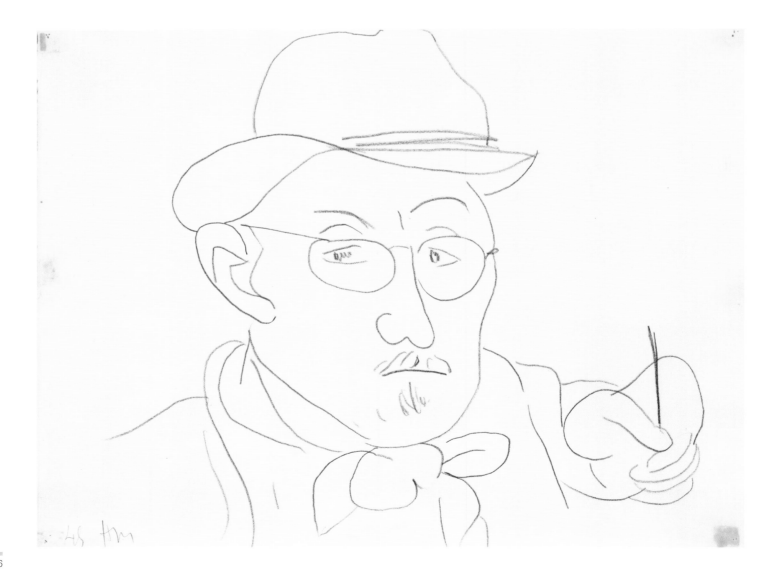

Ill. 64
Marcel Duchamp
(French, 1887–1968)
Boîte-en-valise (Box in a Valise),
1961
Mixed media, 68 items enclosed
8.9 x 37.5 x 40.6 cm
Collection of Frances Beatty and Allen Adler
(Cat. 12)

friend and devoted collector Walter Arensberg told Duchamp: "You have invented a new kind of autobiography. . . . You have become the puppeteer of your past,"[95] and we might say, as well, that he'd invented a new kind of self-portraiture, suitable for quick getaways and artistic immortality. Although Duchamp lived long enough to see the flourishing of so many of the postmodern ideas that he first launched, it seems unlikely that he could have imagined to just what an extent his subversive and salutary vision would come to dominate contemporary practice. Knowing how to miniaturize and package one's art—like a good traveling salesman—was crucial for the powerful role that Duchamp would play for posterity.

Duchamp was not alone in the westward journey out of Paris. A number of the most important artists who could manage to get to the United States as the Nazis invaded France did so—some, like Jewish Marc Chagall, at the last minute.[96] Where did they end up, and what did they do? They sat for a group portrait . . . at Pierre Matisse's New York gallery, in the Fuller Building, at 41 East Fifty-seventh Street [ill. 65]. Seated or standing in George Platt Lynes's now famous photograph of these "Artists in Exile" are, among other key figures, André Breton, Piet Mondrian, Fernand Léger, Jacques Lipchitz, Pavel Tchelitchew, Marc Chagall, and Max Ernst—all trying their best to fit in and, undoubtedly, wondering when the ordeal of sitting for their portraits, rather than making them, would be over.

Ill. 65
George Platt Lynes (American, 1907–1955)
Artists in Exile
Photograph taken on the occasion of an exhibition at
Pierre Matisse Gallery, Seligmann, Eugene Berman.
March 1942
The Museum of Modern Art, New York (PA2)

From left to right, first row: Matta Echaurren, Ossip
Zadkine, Yves Tanguy, Max Ernst, Marc Chagall, Fernand
Léger; second row, André Breton, Piet Mondrian, André
Masson, Amédee Ozenfant, Jacques Lipchitz, Pavel
Tchelitchew, Kurt Seligmann, Eugene Berman
(Fig. 16)

All translations from the French are my own unless otherwise indicated.

1. Jacques Lipchtiz with H. H. Arnason, *My Life in Sculpture* (New York, 1972), p. 23.

2. Ibid., p. 63.

3. Gertrude Stein, "Portraits and Repetition," pp. 171–72, quoted in Wendy Steiner, *Exact Resemblance to Exact Resemblance: The Literary Portraiture of Gertrude Stein* (New Haven, 1978), p. 42.

4. Gertrude Stein, "Lipschitz" (1926), *Portraits and Prayers* (New York, 1934), pp. 63–64. Stein's spelling of his name with an "s" is at variance with the artist's own spelling, although it conforms to the way most American Jews of that name spell it. In *Poetry Foundation: Online Journal* (2007), Raphael Rubinstein writes astutely of Stein's "Portrait of Lipschitz": "Interestingly, Stein begins her portrait of the sculptor with a sentence that seems to hammer away at Lipchitz's championing of 'likeness' in portraiture. 'Like and like likely and likely likely and likely like and like,' she writes, conflating, and derailing, the word's various meanings. To an attentive reader, numerous questions are raised in this opening line: Is her portrait going to be 'like' Lipchitz? Is it 'likely' that something she writes would resemble a particular person? Is the person in question someone she 'likes'? Is she thinking of her portrait, wondering if it looks 'like' her?"

5. Gertrude Stein, *The Autobiography of Alice. B. Toklas* (New York, 1961), p. 203: "Lipschitz is an excellent gossip and Gertrude Stein adores the beginning and middle and end of a story and Lipschitz was able to supply several missing parts of several stories."

6. Bert van Bork, *Jacques Lipchitz: The Artist at Work* (New York, 1966), pp. 115–16.

7. Roland Penrose, *Picasso: His Life and Work* (New York, 1962), p. 116.

8. Stein 1961, p. 203: "And then they talked about art and Gertrude Stein rather liked her portrait and they were very good friends and the sittings were over."

9. Van Gogh to Wilhelmina J. van Gogh (Auvers, first half of 1890), in *The Complete Letters of Vincent van Gogh* (Greenwich, Connecticut, 1958), vol. 3, p. 470, quoted in exh. cat. New York, Wildenstein, *Modern Portraits: The Self and Others*, 1976, cat. ed. by J. Kirk T. Varnedoe, foreword, p. XI.

10. Charles Estienne, "Des tendances de la peinture moderne: entretien avec Henri-Matisse," *Les Nouvelles*, April 12, 1909, p. 4, in *Matisse on Art*, ed. Jack D. Flam (New York, 1973), p. 48.

11. Matisse, as quoted in P. F. Althus, "Le Paysage dans la peinture et la photographie," *Caméra*, September, 1960, quoted in Pierre Schneider, *Matisse*, trans. Michael Taylor and Bridget Stevens Romer (New York, 1984), p. 98. I am grateful to Ellen McBreen for this reference.

12. Pablo Picasso, in conversation with the photographer Brassaï, September 1939, in Brassaï, *Picasso and Company*, trans. Francis Price (Garden City, New York, 1966), pp. 46–47.

13. Fernand Léger, "The Origins of Painting and Its Representative Value," in *Montjoie!* (1913), in Léger, *Functions of Painting*, trans. Alexandra Anderson (New York, 1973), pp. 9–10. In fact, Léger made very few portraits, but some of them, like his watercolor sketches of the Americans Gerald and Sara Murphy, are small masterpieces of concision and astute observation. For these, see Kenneth E. Silver, *Making Paradise: Art, Modernity, and the Myth of the French Riviera* (Cambridge, Massachusetts, 2000), p. 114.

14. Gabriel Badea-Päun, *The Society Portrait: From David to Warhol* (New York, 2007), p. 181.

15. William Rubin, "Reflections on Picasso and Portraiture," in exh. cat. New York, Museum of Modern Art, *Picasso and Portraiture: Representation and Transformation*, cat. ed. by William Rubin, 1996, p. 18.

16. Evan Charteris, *John Sargent* (London, 1927), quoted in Malcolm Warner, "Portraits about Portraiture," in exh. cat. Madrid, Museo Thyssen-Bornemisza; and Fort Worth, Kimbell Art Museum, *The Mirror and the Mask: Portraiture in the Age of Picasso*, cat. ed. by Paloma Alarcó and Malcolm Warner, 2007, p. 11. Warner's essay is one of the finest overviews of the major issues involved in modern portraiture that I know.

17. John Klein, *Matisse Portraits* (New Haven, 2001), p. 191.

18. Christopher Green, *Art in France: 1900–1940* (New Haven, 2000), p. 92.

19. Klein 2001, p. 147.

20. Shearer West, *Portraiture* (Oxford, 2004), p. 187.

21. See, for instance, a similar bohemian portrayal in Marc Chagall's *Self-Portrait with Seven Fingers*, 1913, Stedelijk Museum, Amsterdam.

22. Jean Metzinger, *Le Cubisme était né* (Paris, 1972), p. 58.

23. Bénédicte Ajac and Marie Pessiot, eds., *Duchamp-Villon: Collections Centre Georges Pompidou, Musée national d'art moderne et du Musée des beaux-arts de Rouen* (Paris, 1998), pp. 113–14.

24. Judith Zilczer, "In the Face of War: The Last Works of Raymond Duchamp-Villon," *Art Bulletin* 65, no. 1 (March 1983), pp. 138–44.

25. As these endnotes make clear, I am immensely indebted to the work of Steiner 1978, for her superb analysis of the portraiture of Gertrude Stein.

26. Gertrude Stein, "Portraits and Repetition," p. 183, in ibid., p. 43.

27. For the issue of portraiture and World War I, see Kenneth E. Silver, *Esprit de Corps: The Art of the Parisian Avant-Garde and the First World War, 1914–1925* (Princeton, 1989), pp. 110–14.

28. For Canudo, see Giovanni Dotoli, *Ricciotto Canudo: ou le cinéma comme art* (Paris, 1999). Canudo was also a close friend of Apollinaire and was the author of *Skating Rink at Tabarin*, on which the Ballet Suédois production of *Skating Rink*, with designs by Fernand Léger, was based.

29. Juan Gris to Daniel Henry Kahnweiler, September 1915, cited in Silver 1989, pp. 156–57.

30. See ibid., pp. 108–12. See also exh. cat. Paris, Centre Georges Pompidou, *Jean Cocteau: sur le fil du temps*, 2003.

31. Jeffrey Meyers, *Modigliani: A Life* (New York, 2006), p. 164.

32. Thanks to Pepe Karmel for talking with me about Picasso's "hidden" portraits of Haviland; for these see Karmel, *Picasso and the Invention of Cubism* (New Haven, 2003), pp. 133–37.

33. The Los Angeles County Museum of Art owns a similar charcoal drawing of Fabiani by Matisse, on a sheet about the same size as the present work, and the Museum of Modern Art owns one as well. See his autobiography, where he tells how the dealer Sam Salz convinced him to donate the drawing to the museum, Martin Fabiani, *Quand j'étais marchand de tableaux* (Paris, 1976), p. 78. p. 396.

34. Ibid.

35. Ibid., p. 121: "l'hydravion Matisse avait pris son vol et n'avait besoin du flotteur Fabiani."

36. Matisse prevailed and Aragon's name appeared on the book; see Hilary Spurling, *Matisse the Master* (New York, 2005), p. 408.

37. David D'Arcy, "Ambroise Vollard," *Art and Auction*, September 2006, p. 137.

38. Michèle Cone, *Artists under Vichy: A Case of Prejudice and Persecution* (Princeton, 1992), p. 148.

39. John Richardson discussed his theories with me in a phone conversation, in April 2008; his ideas are also put forth in D'Arcy 2006. For more on Fabiani, see Lynn H. Nicholas, *The Rape of Europa* (New York, 1994), pp. 92–93, 425; and Maryline Assante di Panzillo, "The Dispersal of the Vollard Estate," in exh. cat. New York, Metropolitan Museum of Art, *Cézanne to Picasso: Ambroise Vollard, Patron of the Avant-Garde*, cat. ed. by Rebecca A. Rabinow, 2006, pp. 259–62.

40. This information is contained in a letter to Malcolm Wiener from William S. Lieberman, Metropolitan Museum of Art, June 28, 1995.

41. The three prints have been put in this chronological order by Brigitte Baer, *Suite au catalogues de Bernhard Geiser, Picasso: peintre-graveur; catalogue raisonné de l'oeuvre gravé et des monotypes, 1935–1945* (Bern, 1986), vol. 3, nos. 617–20.

42. Newman makes this observation in her entry for the three works in this catalogue.

43. In fact, there is a not dissimilar portrait of Henri Matisse, also stretched out horizontally and reading on a bed (1911), by Olga Meerson. See Spurling 2005, colorpl. 7. For Jean Puy, see exh. cat. Morlaix, Museé des Jacobins, *Un Fauve en Bretagne: Jean Puy*, cat. by Marion Chatillon-Limouzi, 1995; and exh. cat. Paris, Galerie Drouot-Montaigne, *Passions Fauve: Jean Puy*, cat. by Marion Chatillon-Limouzi, 2001.

44. Léon Werth, "Chronique artistique: la peinture en province," *L'Art vivant*, June 1, 1925, p. 23, quoted in Green 2000, p. 60.

45. André Warnod, *Les Berceaux de la jeune peinture* (Paris, 1925), p. 65.

46. Alice Halicka, *Hier* (1946), p. 102, quoted in exh. cat. New York, Jewish Museum, *The Circle of Montparnasse*, cat. by Kenneth E. Silver and Romy Golan, 1985, p. 58.

47. On this, read exh. cat. New York, Metropolitan Museum of Art, *Glitter and Doom: German Portraits from the 1920s*, cat. by Sabine Rewald et al., 2006, which accompanied the excellent exhibition of the same name.

48. Nancy Troy, "Introduction: Poiret's Modernism and the Logic of Fashion," in exh. cat. New York, Metropolitan Museum of Art, *Poiret*, cat. ed. by Harold Koda and Andrew Bolton, 2007, p. 19.

49. Adam Gopnik, "High and Low: Caricature, Primitivism, and the Cubist Portrait," *Art Journal* 43, no. 1 (Winter 1983), pp. 371–76.

50. For de Zayas, see Willard Bohn, "The Abstract Vision of Marius de Zayas," *Art Bulletin* 62, no. 3 (September 1980), pp. 434–52; and Marius de Zayas, *How, When, and Why Modern Art Came to New York*, ed. Francis M. Naumann (Cambridge, Massachusetts, 1996).

51. Interesting to note, the Parisian art world, about 1900–1940, photographed itself *en groupe* continually—at studio parties, restaurants, cafés, and anywhere else they could contrive to do so. These are certainly worthy of a study all their own; for many examples of these, see Billy Klüver and Julie Martin, *Kiki's Paris: 1900–1930* (New York, 1989).

52. John Russell, *Max Ernst: Life and Work* (London, 1967), p. 67.

53. See the provocative if somewhat meandering study by the late art historian Elizabeth Louise Kahn, *Marie Laurencin: "Une Femme Inadaptée" in Feminist Histories of Art* (London, 2003) the best single work to date on Laurencin's fascinating, if often bad, art. Kahn and I both got our academic starts as students of the art of *La Grande Guerre*, and I was saddened to learn of her untimely death as I worked on the current project.

54. See Jacques Lacan, "The Mirror Stage as Formative of the Function of the I as Revealed in Psychoanalytic Experience," paper delivered at the 16th International Congress of Psychoanalysis, Zurich, July 17, 1949, in Lacan, *Ecrits: A Selection*, trans. Alan Sheridan (New York, 1977), pp. 1–7.

55. Tamar Garb, *The Painted Face: Portraits of Women in France, 1814–1914* (New Haven, 2007).

56. See Kahn 2003.

57. "Chez Marie Laurencin," *L'Art vivant* 1, no. 3 (Feburary 1, 1925), p. 9.

58. Ibid.

59. Phyllis Birnbaum, *Glory in a Line: A Life of Foujita, the Artist Caught between East and West* (New York, 2006), p. 128.

60. See my discussion of Foujita's complicated Parisian identity in "Made in Paris," in exh. cat. Paris, Musée d'Art Moderne de la Ville de Paris, *"L'Ecole de Paris, 1904–1929: la part de l'Autre,"* 2000, pp. 41–57.

61. André Breton, *Le Manifeste du surréalisme*, 1924, in Patrick Waldberg, *Surrealism* (New York, 1971), pp. 66–75.

62. John Richardson, *Sacred Monsters, Sacred Masters: Beaton, Capote, Dali, Picasso, Freud, Warhol, and More* (London, 2001).

63. See exh. cat. Philadelphia Museum of Art, *Dalí*, cat. ed. by Dawn Ades and Michael R. Taylor, 2004, p. 256.

64. Ibid.

65. See Carlos Rojas, *Salvador Dalí, or the Art of Spitting on Your Mother's Portrait* (University Park, Pennsylvania, 1993), p. 181; and Meredith Etherington-Smith, *The Persistence of Memory: A Biography of Dali* (New York, 1992), pp. 130–31, 137.

66. A. Sauret, ed., *Portraits par Henri Matisse* (Monte Carlo, 1954), p. 14, quoted in Garb 2007, p. 246.

67. Richard Brilliant, *Portraiture* (Cambridge, Massachusetts, 1991), p. 9.

68. Klein 2001, p. 21.

69. Ibid., p. 227.

70. Albert E. Elsen, *The Sculpture of Henri Matisse* (New York, 1972), p. 161.

71. Isabelle Monod-Fontaine, cited in exh. cat. Dallas Art Museum, *Matisse: Painter as Sculptor*, cat. ed. by Dorothy Kosinski, 2007, p. 208.

72. Ibid., p. 170.

73. Exh. cat. Fort Worth, Kimbell Art Museum, *Henri Matisse: Sculptor/Painter*, cat. by Michael P. Mezzatesta, 1984, p. 122.

74. Josephine Baker, "Topics of the Day," in Henry Louis Gates Jr. and Karen C. C. Dalton, *Josephine Baker and La Revue Nègre: Paul Colin's Lithographs of "Le Tumulte noir" in Paris, 1927* (New York, 1998), p. 15.

75. Ibid., p. 12.

76. Adrien Rifkin, *Street Noises: Parisian Pleasures, 1900–1940* (Manchester, U.K., 1993), pp. 185–86.

77. Legrand-Chabrier, "Pistes et plateaux," *La Presse*, November 13, 1924, cited in Charles Rearick, *The French in Love and War: Popular Culture in the Era of the World Wars* (New Haven, 1997), p. 103.

78. Ibid.

79. See Kenneth E. Silver, "Neo-Romantics," in exh. cat. Museum of the City of New York, *Paris/New York: Design, Fashion, and Culture, 1925–40*, cat. ed. by Donald Albrecht, forthcoming.

80. Pierre Mac Orlan, "Disques," *La Crapouillot*, May 1930, p. 43, quoted in Rearick 1997, p. 129.

81. *Atget: photographe de Paris*, preface by Pierre Mac Orlan (Paris, 1930). There is an amusing portrait bust of Mac Orlan by Sébastien Tamari (1900–1991), composed of wooden found objects, in the collection of the Musée des Années Trente, Boulogne-Billancourt, France.

82. See Klüver and Martin 1989.

83. That the face of Kiki de Montparnasse, much photographed, was associated with masks is testified to by Man Ray's famous photograph, *Noire et blanche* (1926), where Kiki's made-up, Caucasian face is compared and contrasted to the face on the dark wooden African mask she holds upright. See exh. cat. Lausanne, Musée cantonal des Beaux-Arts, *La Femme et le surréalisme*, cat. ed. by Erika Billeter and José Pierre, 1987, pp. 351–53.

84. Jean Cocteau, Mac Ramo, and Waldemar George, *Maria Lani* (Paris, 1929), p. 15.

85. Jean Cocteau, in ibid., p. 7. This translation from Clare Vincent, "In Search of a Likeness: Some European Portrait Sculpture," *Metropolitan Museum of Art Bulletin*, n.s., 24, no. 8 (April 1966), p. 255.

86. Ruth Green Harris, "C'est pas la Même Chose: How the Many Look at Maria Lani—Artists Offer Pictures in Various Galleries," *New York Times*, November 3, 1929.

87. Jean-Paul Crespelle, *La Folle Epoque* (Paris, 1968), pp. 280–82.

88. There is a list of all the Beckmann works exhibited at the Galerie de la Renaissance, and many photos of the show, in exh. cat. Saint Louis Art Museum *Max Beckmann and Paris*, cat. ed. by Tobia Bezzola and Cornelia Homburg (also shown at Zurich, Kunsthaus), 1998, pp. 189–91.

89. Information regarding this painting comes primarily from Cornelia Lauf's discussion of it in exh. cat. New York, Solomon R. Guggenheim Museum, *From Picasso to Pollock: Classics of Modern Art*, 2003, p. 130.

90. Lauf, in ibid., writes that this information comes from Beckmann's widow; but its reliability seems to me in question, since Mrs. Beckmann also tentatively identified the bearded man at the extreme left as Paul Poiret, which is certainly incorrect—the man pictured looks nothing like the French fashion designer, and he is clearly much too young (Poiret was already fifty-two years old at this point).

91. Perry T. Rathbone, "Max Beckmann in America: A Personal Reminiscence," in exh. cat. New York, Museum of Modern Art, *Max Beckmann*, cat. ed. by Peter Selz, 1964, pp. 130–31.

92. Exh. cat. New York, Sperone Westwater, *Giorgio de Chirico, Francis Picabia, Andy Warhol: A Triple Alliance*, cat. ed. by Gian Enzo Sperone with an essay by Robert Rosenblum, 2004, p. 8; Maria Lluïsa Borràs, *Picabia*, trans. Kenneth Lyons (New York, 1985), p. 424.

93. On Picabia's pro-Pétainist wartime views and postwar problems, see Yve-Alain Bois, "Francis Picabia: From Dada Pétain," *October* 30 (Fall 1984), pp. 121–27.

94. Marcel Duchamp, quoted in Ecke Bonk, *Marcel Duchamp, The Box in a Valise: De ou par Marcel Duchamp or Rrose Sélavy; Inventory of an Edition*, trans. David Britt (New York, 1989), p. 174.

95. Ibid., p. 167.

96. Chagall was arrested in a Vichy round-up of foreigners in the spring of 1941, but thanks to the efforts of the American Varian Fry, of the Emergency Rescue Committee, he was released. Chagall and his wife, Bella, crossed the border into Spain on May 7, 1941, and arrived in New York, by steamship from Lisbon, on June 23.

CATALOGUE

Entries by Abigail D. Newman

Max Beckmann
(German, 1884–1950)
Paris Society (Gesellschaft Paris)
1931
Oil on canvas
109.2 x 175.6 cm
Solomon R. Guggenheim Museum,
New York, 70.1927

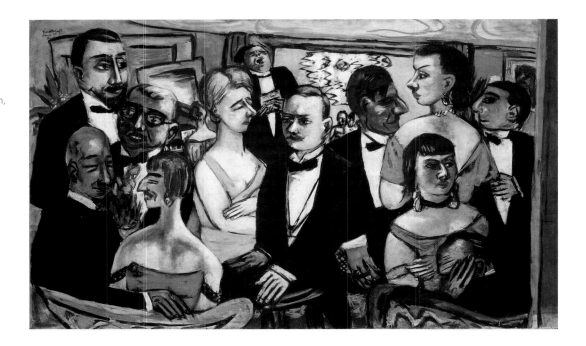

When Max Beckmann (1884–1950) rented a studio in Paris in 1929, it marked the beginning of a three-year period during which he would spend his winters in the French capital. He had already made his name in his native Germany, and he hoped to challenge the hegemony of Pablo Picasso (cats. 38–40)—as a recent exhibition about Beckmann's time in Paris has suggested (exh. cat. Saint Louis 1998–99)—and execute a savvy infiltration of the Parisian art world.

After a childhood in Leipzig, Falkenburg, and Brunswick, in 1900 Beckmann entered the Grand Ducal Art Academy in Weimar, where he studied first with Otto Rasch (1862–1952) and later with Frithjof Smith (1859–1917). Concluding his three years of study in Weimar, Beckmann moved to Paris in October 1903, where he lived until the following April, studying at the Académies Julian and Colarossi. Soon after, he traveled to Geneva to visit the studio of Ferdinand Hodler (1853–1918), whose work impressed him greatly. A fellowship sent Beckmann and his first wife, Minna Tube (1881–1964), to Florence in 1906, and from 1907 until World War I, Beckmann, his wife, and his son (b. 1908) lived in Berlin. Beckmann served in various military capacities during the war until the fall of 1915, when he took a leave of absence. Working in Frankfurt and elsewhere through the end of the war and into the 1920s, Beckmann met Mathilde von Kaulbach (1903/4–1986), called Quappi, in 1924, who became his wife the next year, after he and Minna divorced.

According to some sources, Beckmann began to work on *Paris Society*, at least in the form of sketches, soon after he met Prince Karl Anton Rohan in 1925 (exh. cat. London 2002–3, p. 159; Spector 2001, p. 46). Most of it was evidently painted in 1931, supposedly in response to a commission from the German embassy in Paris (exh. cat. Saint Louis 1984–85, p. 246; Spector 2001, p. 46). Another recounting of the painting's creation suggests that Beckmann produced *Paris Society* largely in response to the opening reception for his exhibition at the Galerie de la Renaissance in Paris in 1931. In any event, Beckmann initially completed the painting in 1931 and later retouched it in Amsterdam in 1947, before leaving for the United States.

In the present group portrait of his fellow countrymen, Beckmann produces a scathing critique of the upper echelons of Parisian society. With a caricaturist's eye for vanities, Beckmann captures something distinctive about each of his subjects, presenting them as human individuals who border on the monstrous. Beckmann described his task as the need "to find the Ego . . . to find it in animals and men" (Beckmann 2003, p. 12). In *Paris Society*, it is as though he has searched inside his subjects to bring to the surface the most unappealing aspects of their psyches, which take physical form. The exaggerated lines around the mouth of the woman in the orange strapless gown underscore the insincerity of her grin; the pointed nose and minute mouth of the lady at left center suggest a prim arrogance; the gray flesh, deeply lined brow, and rigid fingers hiding his face evoke the despair of the man at lower right, whose tuxedoed body fades pitifully into the suit of the man at back. The figures' proportions within the claustrophobic space also seem to suggest internal qualities: the woman shown in profile at right towers proudly above the figures around her; two men on the left have enormous heads, emphasizing by contrast the comparatively small

figure of the man seated on a stool at center, who stares plaintively out of the picture, perhaps seeking escape from the society in which he is so centrally placed. Throughout, the decked-out company fails to engage with one another and, moreover, seems completely oblivious to the concert taking place behind them: the man at top center, his face raised dramatically to the ceiling, likely sings an operatic number while being accompanied by a female pianist—just visible above the shoulder of the stuffy blond woman.

The melancholy figure at center was identified by Beckmann's widow as Prince Karl Anton Rohan. After their first meeting in June 1925, Beckmann wrote about Rohan to Quappi, suggesting that he had impressed Rohan and hoped this contact would prove valuable. Rohan was at the center of various plans that would, it was hoped, spread culture across the different European countries in the wake of World War I to create a pan-European cultural elite. He was part of the European Cultural Union from 1923 and cofounder in 1925 of the journal *Europäische Revue*, to which Beckmann contributed an article in 1927. Although Rohan leaned politically to the right and his cultural projects were eventually funded by the Nazis, he was a strong supporter of Beckmann's exhibition at the Galerie de la Renaissance in 1931, which was condemned by the National Socialist and fascist press.

In addition to Rohan, Quappi identified the desperate man at lower right as Leopold von Hoesch (1881–1936), the German ambassador in Paris; the figure above him as Albert Hahn, a Frankfurt banker; and the balding man at lower left as Paul Hirsch, a music historian from Frankfurt.

On the eve of Hitler's ascension to power and with Beckmann already receiving harsh criticism from certain quarters, the painting—at least in retrospect—seems perfectly to capture a sense of foreboding across Europe, shabbily and unconvincingly concealed by garish elegance and aristocratic abandon.

Selected bibliography: Erhard and Barbara Göpel, *Max Beckmann: Katalog der Gemälde*, 2 vols. (Bern, 1976), no. 346, pl. 119; Stephen Lackner, *Max Beckmann* (New York, 1977), no. 20, ill.; exh. cat. Saint Louis Art Museum, *Max Beckmann, Retrospective*, cat. ed. by Carla Schulz-Hoffmann and Judith C. Weiss (also shown at Munich, Haus der Kunst; Berlin, Nationalgalerie; Los Angeles County Museum of Art), 1984–85, pp. 443–72, no. 60, ill.; Max Beckmann, *Self-Portrait in Words: Collected Writings and Statements, 1903–1950*, ed. and annotated by Barbara Copeland Buenger (Chicago, 1997), pp. 286–87, 392 n. 11; exh. cat. Saint Louis Art Museum, *Max Beckmann and Paris: Matisse, Picasso, Braque, Léger, Rouault*, cat. ed. by Tobia Bezzola and Cornelia Homburg (also shown at Kunsthaus, Zurich), 1998–99, pp. 22–25, 163–65, no. 26, ill.; Nancy Spector, ed., *Guggenheim Museum Collection, A to Z* (New York, 2001), pp. 46–47, ill.; exh. cat. Paris, Centre Georges Pompidou, *Max Beckmann, un peintre dans l'histoire* (also shown at London, Tate Modern; New York, Museum of Modern Art, Queens), 2002–3, p. 218, ill.; exh. cat. London, Tate Modern, *Max Beckmann*, cat. ed. by Sean Rainbird (also shown at Paris, Centre Georges Pompidou; New York, Museum of Modern Art, Queens), 2002–3, pp. 157–64, 261–83, no. 91, p. 162, ill.; Max Beckmann, *On My Painting* (London, 2003); exh. cat. New York, Solomon R. Guggenheim Museum, *From Picasso to Pollock: Classics of Modern Art*, 2003, pp. 130–31, ill.

Christian Bérard
(French, 1902–1949)
Damia
c. 1930
Oil on canvas
60 x 72 cm
John Richardson Collection, New York

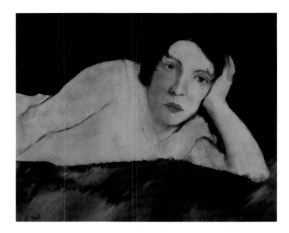

In this intimate portrait, the painter of the elites encounters the singer of the people. Yet the versatile artist Christian Bérard (1902–1949) and the musical tragedienne Damia (1892–1978) inhabited the same theatrical world of 1920s and 1930s Paris.

Born Marie-Louise Damien and often using the stage name Maryse Damia, the subject of the present portrait has generally been referred to simply as Damia, or Mlle Damia. Beginning in 1922, she was the lover of Eileen Gray (1878–1976), the Irish architect and designer who spent most of her long life in Paris. Sometime after 1928, Damia was involved with Gabrielle Bloch (b. c. 1878), who oversaw Gray's shop and was also the manager for the American dancer Loïe Fuller (1862–1928). Gray, and presumably Damia, moved to some extent in the various lesbian circles in Paris between the wars. Damia sang in music halls in Paris and also on at least one visit to New York, in 1926, and she acted in a number of films.

Bérard was the son of a Parisian architect and his wife and studied first at the Académie Ranson with the Nabi painters Edouard Vuillard (1868–1948) and Maurice Denis (1870–1943) and later at the Académie Julian. As one of the exhibitors in 1926 at the Galerie Drouot with Pavel Tchelitchew (cat. 45), Bérard became known as a Neo-Romantic or Neo-Humanist painter, with works that, with their traditional representations and subjects, challenged the Parisian avant-garde. Bérard met Serge Diaghilev (1872–1929) in 1927, initiating a period of numerous theatrical projects, including designing scenery and costumes for ballets and films and working with Bérard's close friends Jean Cocteau (cat. 33) and Boris Kochno (1904–1990); the latter was Bérard's lover for many years. In addition to his theatrical work, Bérard continued to paint, began illustrating books, worked with the interior decorator Jean-Michel Frank (1895–1941), and became heavily involved in the world of fashion—creating the decorations and advertising for Coco Chanel (1883–1971), among others, and even encouraging Christian Dior (1905–1957) to try his hand at fashion. He was prolific throughout the 1930s and 1940s until his death in 1949.

Bérard's depiction of Damia from about 1930 differs drastically from the posters of her also on view (cats. 6d, 7). Here, Damia is not depicted onstage, midsong, arms tensely stretched outward with emotive power displaying their legendary pantomimic ability. Instead of a striking evening gown, she wears a pale dress so subtly rendered and similar in color to her skin that at first glance she appears nude. The sense of a public figure stripped bare prevails; the thick red lips, short dark hair, and melancholy eyes remain, but they no longer appear to be part of her act but rather part of her essence.

Two articles from around the time Bérard painted Damia suggest how his work was received by his contemporaries, especially alongside the more avant-garde styles of painting. Waldemar George wrote in *Formes* in 1929 that Bérard, although aware of the paintings of his peers, "denies their aesthetic." He went on to say, "Bérard has rediscovered the lost faculty of expressing a subject in a craftsmanlike way, without localising it, giving it situation" (George 1929, p. 8). He seems to see Bérard as a sort of redeemer for the traditional art of painting. In another article in *Formes*, Paul Fierens wrote of the modernist practice of treating the human face the same way one would treat any other object: as a theme on which to impose the artist's vision. By contrast, he writes of Bérard's "luminous faces where the likeness is an *intrinsic* quality (not merely a relation between one known thing and another)" (Fierens 1932, p. 274). Indeed, Bérard's painting is in the minority in the context of this exhibition for his devotion to a straightforward presentation of his sitter's likeness. The viewer does not focus on the style of this painting so much as the sitter's appearance and intensity: the dark background and proximity of the subject to the picture plane make her appear extremely close to the viewer and heighten her immediacy; her eyes seem at once to meet the viewer and to look beyond; and the hardness of Damia's features—firm jaw, strong nose, and large arms, the latter frequently referred to in reviews (Rifkin 1987, p. 138)—contrast sharply with the luscious lips and soft tendrils that curl onto her forehead.

Selected bibliography: J. Brooks Atkinson, "The Play: Diseuse a la Francaise," *New York Times*, September 25, 1926; Waldemar George, "Call of the Occident: Christian Bérard," *Formes* 1 (December 1929), pp. 6–9; Paul Fierens, "Eyes and the Man . . . Some Portraits by Christian Bérard," *Formes* 25 (May 1932), pp. 274–75, ill.; exh. cat. London, Arts Council, *Christian Bérard: An Exhibition of Paintings and Décors*, introduction by Cecil Beaton, 1950; exh. cat. Boston, Institute of Contemporary Art, *Christian Bérard: Painter Decorator Designer*, cat. by Baird Hastings with an introduction by Louis Jouvet (also shown at Houston, Contemporary Arts Association; San Francisco, California Palace of the Legion of Honor; Santa Barbara Museum of Art; Colorado Springs Fine Arts Center; New York, M. Knoedler & Company), 1950; Boris Kochno, *Christian Bérard* (Paris, 1987), no. 45, ill.; Adrian Rifkin, "Musical Moments," *Yale French Studies*, no. 73, Everyday Life (1987), pp. 121–55; Caroline Constant, *Eileen Gray* (London, 2000), pp. 9, 197 n. 8; Tee A. Corinne, "Gray, Eileen," *glbtq: An Encyclopedia of Gay, Lesbian, Bisexual, Trangender, and Queer Culture* (Chicago, 2002), at www.glbtq.com/arts/gray_e.html; Fiona MacCarthy, "Future Worlds: As Visionary as She Was Contrary, Eileen Gray Ranks among the Giants of Modernism, Thanks to Just Two Buildings," *Guardian*, September 10, 2005.

Constantin Brancusi
(Romanian, 1876–1957)
Mademoiselle Pogany II
1925
Polished bronze on limestone base
43.2 x 18.4 x 23.8 cm
Norton Museum of Art,
West Palm Beach, Florida.
Bequest of R. H. Norton, 53.14

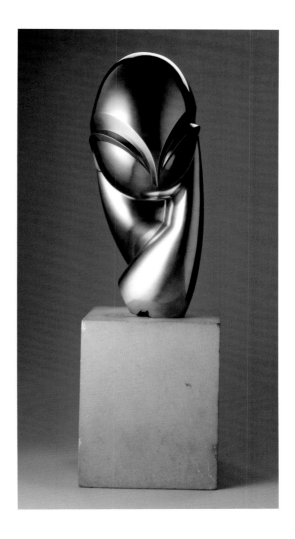

Constantin Brancusi's (1876–1957) legendary series of sculptures, *Mademoiselle Pogany I, II,* and *III,* each of which he produced in both bronze and marble, fundamentally challenge preconceptions about portraiture. At first glance, the present sculpture, *Mademoiselle Pogany II,* appears to be an abstract form, or perhaps it is reminiscent of an animated but otherworldly being. Yet repeated viewings reveal an introspective young woman, her head bent forward, with a round face, pronounced brows, and delicate eyes. This exhibition provides the exciting opportunity to consider Brancusi's unique perception of this woman and his radical execution of her portrait alongside her own expression of self-analysis (cat. 41).

 Both Brancusi and his subject, Margit Pogany (1879/80–1964), were foreigners in Paris. Brancusi was born in the agricultural town of Hobita, Romania. As a child, he apparently tried to run away several times before finally leaving home in 1887. While working as a waiter in Craiova, he began attending the School of Arts and Crafts, finally enrolling as a full-time student in 1894. The following year, he began specializing in wood sculpture, and he spent the summer of 1897 apprenticed to a furniture maker in Vienna. He concluded his studies in Craiova the following fall and immediately enrolled in the National School of Fine Arts in Bucharest, where he trained with Ion Georgescu (1856–1898) and subsequently with Wladimir C. Hegel. After winning various grants and awards and receiving further training at the School of Medicine and at the Museum of Comparative Anatomy, Brancusi traveled to Paris in 1904. He then studied at the Ecole des Beaux-Arts under Antonin Mercié (1845–1916), and when four of his plasters were shown at the Salon d'Automne of 1906, Auguste Rodin (1840–1917), the reigning patriarch of French sculpture, was impressed with his work. He soon became a studio assistant to Rodin, but he retained this position for just a month, deciding that working so closely with a master sculptor would hinder his development. Brancusi rented a studio in Montparnasse, and by 1908 he had become friendly with a number of artists, including Henri (Douanier) Rousseau (1844–1910), Henri Matisse (cats. 26–30), and Amedeo Modigliani (cats. 32, 33). Two years later, probably in July 1910, he met Margit Pogany.

 Pogany was a young Hungarian painter, evidently of Romanian roots. In 1910 she showed two of her paintings at the Salon d'Automne. Brancusi saw her frequently at the boardinghouse where she was staying in Paris. Pogany recalled her first visit to Brancusi's studio

and, in particular, her reaction to a marble head: "I felt it was me, although it had none of my features. It was all eyes. I looked at Brancusi and noticed that, while he was speaking to my friends all the time, he was slyly observing me. He was awfully pleased that I had recognized myself" (quoted in Geist 1968, p. 190). Exactly which sculpture she saw has been debated—many scholars have assumed it to have been an early version of *Danaïde* (c. 1913)—but the recollection nonetheless reflects Brancusi's ability to capture certain qualities and retain something of their essence, and even their recognizability, while entirely transforming their outward appearances. Pogany formally asked Brancusi to do a portrait of her, and, according to her memory, she sat for him during December 1910 and the following January. She left Paris for Lausanne soon thereafter (Miller 1995, p. 135).

They evidently became quite close. Pogany translated several lines of Goethe for Brancusi, and soon after she left Paris, she wrote to the sculptor, "I thought of you the whole time, how very kind and affectionate you have been toward me. It's a little as if you had come along with me. I should like to give you as much joy as you are giving me" (quoted in Hultén, Dumitresco, and Istrati 1987, p. 86). They continued to correspond until as late as 1937, and Pogany purchased a bronze cast of Brancusi's portrait of her, which she evidently planned to sell (ibid., p. 86). She wrote with delight that she was pleased Brancusi had sent her the bronze rather than the marble (ibid., p. 86). Although she received the portrait in 1914, she did not sell it until the 1950s, when it was purchased by the Museum of Modern Art in New York.

While she was in the process of selling the portrait, she wrote two letters to the museum that described Brancusi's process in sculpting her. He began by modeling her in clay in a comparatively traditional, realistic style. After completing each of these models, he discarded them, throwing the clay back in his box (Miller 1995, p. 135). He also made several drawings of her, but she did not mention these in her recollections, and it is possible that, like the final sculptures, he completed them in her absence.

Brancusi finished the first surviving version of the portrait in 1912 in white marble. (At New York's Armory Show of 1913, he exhibited a plaster version, which is now lost.) Although Pogany's features are distilled to their essential forms, the sculpture nonetheless reads relatively clearly as a portrait of a woman with a sharp nose, large eyes, a layered bun at the nape of her neck, and her face resting against her hands. When Brancusi produced four bronze casts of *Mademoiselle Pogany I*, he polished the entire surface except for the hair, to which he gave a black patina, adding to the sculpture's recognizability as a human, and female, figure. He sent this version to Pogany. Brancusi said of the first portrait, "the face has been generalized almost to the obliteration of the features, except for the eyes and the arching sweep of the eyebrows" (quoted in Jianou 1963, n.p.).

In 1919 Brancusi sculpted a second version of *Mademoiselle Pogany*, which he produced first in veined marble and later in bronze, with two casts done in 1920 and two more in 1925. For this second interpretation of his subject, he seemingly stretched his original conception of her hair as a tightly wrapped, representational chignon into a series of repeating curves that arc from the sitter's neck down to the sculpture's base. In keeping with the integration of her hair into the overall form of the portrait, he left its surface polished, increasing the appearance of unified forms. In addition, the sitter's two arms are now merged into one; the eyes no longer bulge but are merely suggested by strong brows; and no mouth is indicated (exh. cat. Philadelphia 1995, p. 176). For his third consideration of this subject—which he sculpted in white marble in 1931 and cast in two bronze versions in 1933—Brancusi extended the curves of hair even more fully over the back of the sculpture.

Although Brancusi's three versions increasingly move away from a traditional representation of a portrait subject, he retained the title, indicating the works' portrait status throughout the series. Yet when pressed by a reporter in 1926 about his title for a different work, *Blonde Negress*, Brancusi evasively replied, "But a name means nothing. . . . A statue must have a name so I give it, but I am not a professor and you must interpret it as you see fit. It is the same in music, the title does not mean anything" (quoted in Miller 1995, p. 151). Yet the title in the Pogany series clearly is important to an interpretation of the sculpture. Its spare modernist lines, glistening surface, and temptingly tactile forms are endowed with arguably greater intensity when one must search within them for an individual. Various scholars have suggested that *Danaïde*—perhaps the work Pogany saw in Brancusi's studio—is also derived from his perception of Margit Pogany, but, significantly, he presented that work not as a portrait but as a subject from Greek mythology (exh. cat. Philadelphia 1995, p. 124).

A comparison of *Mademoiselle Pogany II* with Margit Pogany's self-portrait reveals certain shared qualities: pronounced brows, a tendency of the sitter to incline her head forward, a habit of resting her face and neck against her hand, and the smooth shape of her skull, which is clear even when her hair is realistically depicted, as in her portrait, since it lies flat against her head. Brancusi has captured anecdotal and essential characteristics about his sitter and shaped them into a startling modern portrayal.

Selected bibliography: Ionel Jianou, *Brancusi* (New York, 1963), pp. 77–78, 97–98, 113, text on unpaginated page; Sidney Geist, *Brancusi: A Study of the Sculpture* (New York, 1968), pp. 42, 44, 69–70, 109–11, 190–91; exh. cat. New York, Solomon R. Guggenheim Foundation, *Constantin Brancusi, 1876–1957; A Retrospective Exhibition*, cat. by Sidney Geist (also shown at Philadelphia Museum of Art; Art Institute of Chicago), 1969, pp. 58–59, 62–63, 96–99, 129, 137; Pontus Hultén, Natalia Dumitresco, and Alexandre Istrati, *Brancusi* (New York, 1987), pp. 84, 86, 88, 254, 286, 287, 294, 295, 311, 312, no. 114d; Eric Shanes, *Constantin Brancusi* (New York, 1989), pp. 61–63, 117–19; exh. cat. Philadelphia Museum of Art, *Constantin Brancusi: 1876–1957*, cat. by Friedrich Teja Bach, Margit Rowell, and Ann Temkin (also shown at Paris, Musée national d'Art Moderne, Centre Georges Pompidou), 1995, pp. 108, 120–25, 176–77, 258–61, 293–94, 372–86; Sanda Miller, *Constantin Brancusi: A Survey of His Work* (Oxford, 1995), pp. 134–38, 144, 149, 151; Pierre Cabanne, *Constantin Brancusi* (Paris, 2002), pp. 79–83, 204–7; exh. cat. New York, Solomon R. Guggenheim Museum, *Constantin Brancusi: The Essence of Things*, cat. ed. by Carmen Giménez and Matthew Gale (also shown at London, Tate Modern), 2004, pp. 57, 134–39; Sanda Miller, "Brancusi's Women," *Apollo* 165, no. 541 (March 2007), pp. 56–63.

Romaine Brooks
(American, 1874–1970)
Le Trajet (The Crossing)
c. 1911
Oil on canvas
115.2 x 191.4 cm
Smithsonian American Art Museum,
Gift of the artist

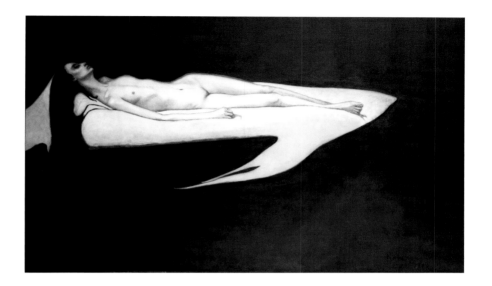

After a tumultuous childhood spent in various locations across Europe and the United States with a volatile mother and an emotionally disturbed brother, Romaine Brooks (1874–1970), née Goddard, embarked on what would prove an abortive singing career. She first moved to Paris in 1896, but when in 1898 she abandoned her singing for painting, she settled in Rome. Studying primarily at La Scuola Nazionale with night classes at the Circolo Artistico, she returned to Paris the next year and attended the Académie Colarossi. By 1905 she had married and deserted John Ellingham Brooks, her mother and brother had died, leaving Romaine an heiress, and she had settled in Paris with a studio on the Left Bank.

The wealthy and eccentric Russian dancer and sometime actress Ida Rubinstein (1885–1960) arrived in Paris in the spring of 1909 with Serge Diaghilev's (1872–1929) Ballets Russes to star in *Cléopâtre*. By all accounts, the ensuing relationship between Brooks and Rubinstein, which lasted from about 1911 to 1915, involved a surprising romantic triangle. Brooks sustained a long friendship and a short love affair with the Italian poet and playwright Gabriele D'Annunzio (1863–1938). They shared a villa during the summer of 1910 at Arcachon in southwestern France, where Brooks began a portrait of D'Annunzio while he worked on a new play about the martyrdom of St. Sebastian. Although the idea had been haunting him for years, it was not until he saw Rubinstein perform as Schéhérazade in 1910 that he believed he had found someone to play the lead role: he fixated on the appropriateness of her body for the part, particularly her notably long, slender legs. Jean Cocteau (cat. 33) was also dazzled by Rubinstein.

When Brooks and D'Annunzio's summer together was dramatically halted by the arrival of one of his former mistresses, supposedly brandishing pistols, Brooks turned her attention on D'Annunzio's current artistic obsession: Ida Rubinstein. It is not clear exactly when Brooks and Rubinstein first met, but it was likely on the opening night of *The Martyrdom of St. Sebastian*, May 22, 1911 (Chadwick in exh. cat. Washington, D.C., 2000–2001, p. 23; Lucchesi in ibid., p. 79, suggests that they may have met as early as 1909, at the social events hosted by their mutual patron and supporter Robert de Montesquieu; Meryle Secrest 1974, p. 241, writes that they "probably" met in June 1910). Brooks was attracted to Rubinstein's coloring—pale skin and dark hair—which matched Brooks's own aesthetic (see below), as well as to Rubinstein's body, which was seen by many at the time as an intriguing, almost androgynous form.

Although *Le Trajet (The Crossing)* is dated 1900, scholars have surmised that Brooks must have mistakenly added that date much later, an error she made on several other occasions; the painting is almost certainly from about 1911, since it is clearly an image of Ida Rubinstein. A figure with the angular nose and jaw, long neck, jet black hair, and narrow proportions of Rubinstein lies on a meticulously delineated white form in the shape of a wing. Her flesh, nearly as pale as the wing, is faintly modeled and bordered by delicate lines. Her head is slightly elevated and facing upward, with eyes closed, dark hair streaming down, and several strands forming stylized curves toward her shoulder. Although we see the figure in profile, her left hip is lifted, presenting the lower half of her body to the viewer. Darkness surrounds this luminous odalisque on her wing, and the viewer seems to encounter her in transit, as the title suggests, from one realm to another.

Various titles have hinted at Brooks's intended meaning in this work. It is possible that this was the work described as *La Femme couchée (Woman Reclining)* in an exhibition at the Goupil gallery in London in 1911. Brooks displayed the painting as *Femme morte (Dead Woman)* at the Alpine Club Gallery in London in June 1925, and as *Death* at Wildenstein Galleries in New York later that year.

Such titles and the deathly pallor of the figure against such a dark void raise questions about the work's status as a portrait. Brooks produced a number of images of Rubinstein, which range from traditional portraits—a sketch of 1912 and a painting of 1917 (both, Smithsonian American Art Museum, Washington, D.C.)—to works with allegorical titles or allusions that nonetheless present the highly distinctive physical characteristics of Rubinstein. Brooks's allegorical portraits of Rubinstein include the present painting; *The Masked Archer* (1910–11; ill. in exh. cat. Washington, D.C., 2000–2001, p. 79), in which Rubinstein appears with blond hair as a captive maiden, attacked by a small figure resembling D'Annunzio; a work generally referred to as *Spring* from about 1912 (Collection Lucile Audouy, Paris), in which Rubinstein stands nude, partially draped in a black cloak and fingering a seemingly paradisiacal chain of flowers, before a verdant landscape; a patriotic *La France croisée (The Cross of France)* of 1914 (Smithsonian American Art Museum, Washington, D.C.), presenting Rubinstein as a war nurse against a watery gray backdrop and distant burning city; and *La Vénus triste (The Weeping Venus)* (1916–17; Musée Sainte-Croix, Poitiers), a painting similar in composition and scale to *Le Trajet*, in which a fully nude Rubinstein again wears a ghostly pallor as she lies on a structure that is part couch, part balcony, overlooking a dark sky.

These seemingly allegorical works could arguably be excluded from the portrait genre, since they remove Rubinstein from everyday life, placing her in otherworldly roles and settings. Yet it is important to note that Brooks was above all a portraitist; although her financial prosperity allowed her to eschew subjects that did not interest her, and she rarely accepted commissions, the bulk of her painted oeuvre consists of traditional portraits, and her vast production of drawings has been described as a form of self-portraiture (see Latimer 2005, p. 163; Chastain 1996–97, p. 9). When she paints identifiable figures as her subjects, even in fantastical surroundings, their portrait nature often becomes an integral part of their meaning. For Brooks, Rubinstein, with her distinctive body, was an ideal vehicle for a variety of roles and ideas. Here, it seems that Rubinstein's willowy body and inherent gracefulness, combined with her role as a martyr in D'Annunzio's play, made her the perfect figure to send on a mysterious, deathly passage.

In exploring the themes of death and transition in an imagined, stylized setting, Brooks engaged with the ideas of fin de siècle symbolism. It was in part this tendency in her work that makes a painting like this one seem out of date by 1911, for, as Brooks looked back toward Symbolism, Pablo Picasso (cats. 38–40), Robert Delaunay (cat. 9), Jean Metzinger (cats. 9, 31), and Albert Gleizes (cat. 18) were developing Cubism. Indeed, it may be a fitting setting for Rubinstein, whose aesthetic decadence and Sarah Bernhardt–inspired acting style harkened to an earlier epoch.

The color scheme or lack thereof in *Le Trajet* and many of Brooks's other works, was certainly influenced in part by James McNeill Whistler's (1834–1903) restrained palette; Brooks acknowledged this influence, which was also noted by many of her contemporaries. Yet for Brooks, a devotion to blacks and grays was in some sense part of a systematic effort in identity molding. She wrote about discovering grays (see Breeskin 1986, p. 22), and most of her paintings feature monochromatic palettes—leading D'Annunzio to give her the nickname Cinerina (little gray one). Such dark colors set her apart from female colleagues, such as Marie Laurencin (cats. 20, 22), whose pastel palette was viewed as distinctly feminine. When Brooks's affair with D'Annunzio had ended, she wrote to him, "I shall withdraw once again into the shadows and become a vague image, enveloped in the color of distances, gray" (quoted in Secrest 1974, p. 238). Brooks's forays into the then burgeoning field of interior decoration were rigorous essays in blacks, whites, and grays. Significantly, Brooks used black-and-white photography as a medium of self-promotion—various photo shoots present her in striking male costume—and also took photographs closely related to her art. When Rubinstein tired of posing nude for Brooks, Brooks shot a number of photographs, probably about 1911–12, of Rubinstein in the artist's studio on the Trocadéro. One of these contains *Le Trajet* in the background, which Joe Lucchesi noted has a lighter background (in exh. cat. Washington, D.C., 2000–2001, p. 82). He has suggested that the original background was pale green—the color of the thin strip outlining the figure's body—and that *Le Trajet* might have been a pendant of sorts to *Spring*. If Brooks was uninterested in the many developments affecting painting in early-twentieth-century Paris, photography was a medium that clearly appealed to her aesthetic and that she used, in dialogue with her painting and drawing, as a tool. Interestingly, in *Le Trajet*, Brooks completely ignored the eccentric, luxury-centered persona that Rubinstein developed around herself.

The wing on which the figure lies, in addition to its significance as a means of transport, seems to have special resonance here. Brooks signed some of her paintings with a symbol of a wing chained to the earth.

Selected bibliography: Meryle Secrest, *Between Me and Life: A Biography of Romaine Brooks* (Garden City, N.Y., 1974), pp. 238–39, 242, 326; Adelyn D. Breeskin, *Romaine Brooks* (Washington, D.C., 1986), no. 12, ill., pp. 9, 17, 21, 23, 28–29, 44 n. 12, 47–49, 53, 66; Michael de Cossart, *Ida Rubinstein (1885–1960): A Theatrical Life* (Liverpool, 1987), pp. 15, 20, 27, 30–31; Catherine McNickle Chastain, "Romaine Brooks: A New Look at Her Drawings," *Woman's Art Journal* 17, no. 2 (Autumn 1996–Winter 1997), pp. 9, 14; exh. cat. Washington, D.C., National Museum of Women in the Arts, *Amazons in the Drawing Room: The Art of Romaine Brooks,* cat. by Whitney Chadwick, with an essay by Joe Lucchesi (also shown at Berkeley Art Museum), 2000–2001, pp. 10, 12, 17, 22–23, 36, 73, 78, 80, 86 n. 28; Tirza True Latimer, *Women Together/Women Apart: Portraits of Lesbian Paris* (New Brunswick, N.J., 2005), pp. 43, 56–59, 163 n. 80, 159 n. 45; Diana Souhami, *Wild Girls: Paris, Sappho, and Art: The Lives and Loves of Natalie Barney and Romaine Brooks* (New York, 2005), pp. 125, 130.

Marc Chagall
(French, born Russia, 1887–1985)
Self-Portrait with Easel
1931
Etching and aquatint
16 x 14.8 cm
The Metropolitan Museum of Art,
Bequest of William S. Lieberman,
2005 (2007.49.591)

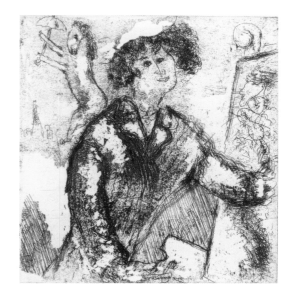

In Marc Chagall's (1887–1985) work, animals float in air and physical space seems to follow an otherworldly logic. In the present self-portrait, Chagall takes many liberties with conventional representation: he presents an elongated version of himself; his face appears askew, in that the outline of the right side of his face makes it seem as if he is looking toward the viewer's right, whereas his eyes, nose, and mouth suggest that he is looking directly out at the viewer; and the hand that works on the canvas dissolves into an unreadable mass of lines, as though we are somehow seeing this picture in the process of creation. The lines drawn on the canvas may suggest another self-portrait—note the curls again escaping from a beret—but this time the figure holds a violin rather than a palette.

Other fantastical elements abound. A rearing horse holds a parasol and floats above—or perhaps rests on—Chagall's right shoulder. Areas in the foreground hatched with parallel lines present small figures, seen as though through a veil; where exactly they are relative to Chagall is a mystery. Finally, at back left, Chagall has vaguely sketched a cityscape, emerging above a white void; the city is identifiable as Paris by the central building, that icon of the French capital, the Eiffel Tower.

France was Chagall's adopted home—he was granted official French citizenship in 1937—but his art never abandoned the folkloric imagery inspired by his Russian-Jewish beginnings. The first of nine children, Chagall was born in Vitebsk, where he lived throughout his childhood and where he attended college beginning in the fall of 1900. He studied wood turning and carpentry, and after concluding his studies in 1906, he trained with Yury (Yehuda) Pen (1854–1937). Thereafter, Chagall left for St. Petersburg, where he enrolled in a decorative drawing class at the Imperial Society for the Protection of Fine Arts. Through various connections, probably stemming from Chagall's association with Pen, Baron David Ginzburg became his patron in 1908. The following year, Chagall entered the Zvantseva School, where he studied with Léon Bakst (1866–1924), through whom he became involved in designing sets for the Ballets Russes in 1910, inaugurating an involvement with the theater that would extend throughout much of his career.

In 1911 Chagall moved to Paris, where he remained until 1914, when, after a trip to Vitebsk, he was unable to return to Paris due to the outbreak of war. Until 1923, when he finally settled again in Paris, Chagall and his wife, Bella, lived in Vitebsk, St. Petersburg, Moscow, and Berlin, during which time Chagall's work became increasingly recognized. On his return to Paris, Chagall began the first of several collaborations with the dealer and publisher Ambroise Vollard (cats. 39, 42), and in 1926, Chagall worked with, among others, Pierre Mac Orlan (cat. 35) and Max Jacob (cat. 19), to illustrate *The Seven Deadly Sins*.

The year that Chagall etched this self-portrait, 1931, he traveled to Palestine and Egypt and also worked on biblical illustrations for a project commissioned by Vollard the previous year. In addition, 1931 marked the publication in Paris of his autobiography, *My Life*, which he had begun about 1915 or 1916 and finished writing in 1922. Although Chagall produced self-portraits throughout his career, it seems especially appropriate that in the year of the long-awaited publication of his written memoirs, he would again consider his own image and his personal process of artistic creation.

Selected bibliography: Jacob Baal-Teshuva, ed., *Chagall: A Retrospective* (Westport, Connecticut, 1995), pp. 1–15; exh. cat. San Francisco Museum of Modern Art, *Marc Chagall*, 2003, pp. 23–59.

Paul Colin
(French, 1892–1985)
Le Tumulte noir.
Josephine Baker (6a)
Jean Börlin (6b)
Maurice Chevalier (6c)
Damia (6d)
1927
Hand-colored lithographs
47 x 31.8 cm each
The Rennert Collection, New York

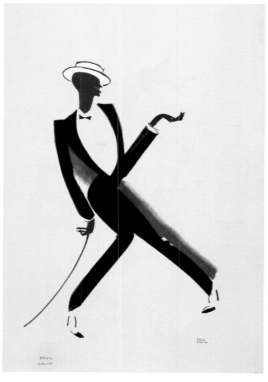

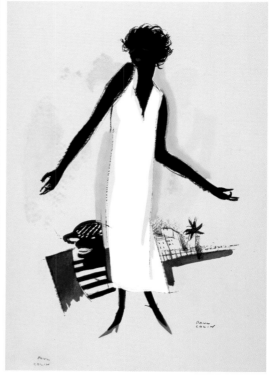

Paul Colin
(French, 1892–1985)
Le Tumulte noir.
Max Dearly (6e)
The Dolly Sisters (6f)
Josephine Baker (6g)
Suzanne Lenglen (6h)
Ida Rubinstein (6i)
1927
Hand-colored lithographs
47 x 31.8 cm each
The Rennert Collection, New York

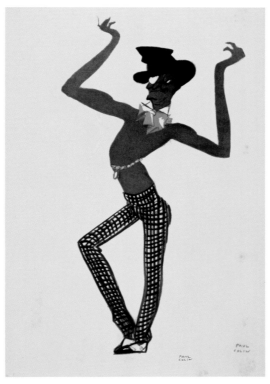

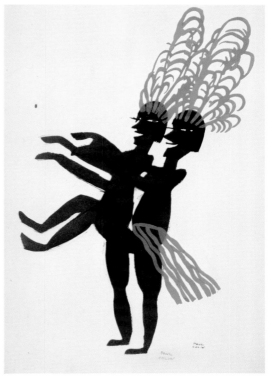

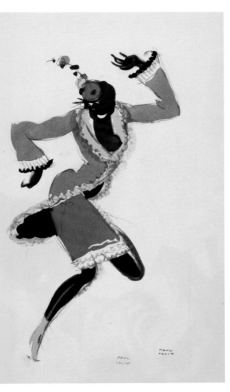

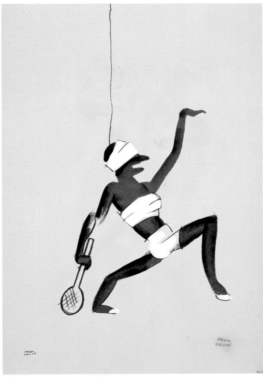

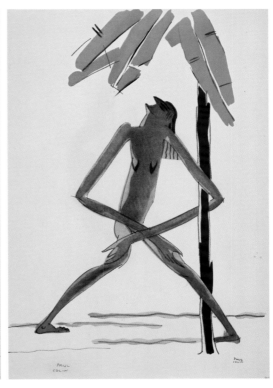

Paul Colin
(French, 1892–1985)
Le Tumulte noir.
Preface by Josephine Baker (6j)
1927
Hand-colored lithograph
47 x 31.8 cm
The Rennert Collection, New York

Topic of the Day.

When the rage was in New York of colored people
Monsieur Siegfied of Ziegfied Follies said its getting
darker and darker on old broadway"
Since the "Revue Nagri" came to Gay Pareé,
All say its getting darker and darker in Paris
In a little while it shall be so dark untill one shall
light a match then light another to see if the first
is lit are not,
As the old saying is I may be a dark horse but you"will
never be a black mare,
By the way we cant forget the "charleston" that maddance
a friend ask me to pay them a visite,
But when I went to there home, people were in front of
the house, and dogs were barking, I dident know what to think
but on the second thought I desided to inter,
on intering the cat was hanging on the clandlier the birds cage
turned over, dishes were broken and the two people looked as
if a terrible storm had happened, of course with this sight
I did know again what to do, go in or out, but by me being
so curous I intered, When they saw me, both stoped
the wife saying witch is right josephine this way or that
then the husband said, no it isent I tell you this the
right way, isent it josephine!? as a matter of fact I dident
know what to say, so I ask if they would try to cool down
a bit, I would try to see, All this time I dident know what they
were talking about, on this idear they stopped, told me they were
dancing the charleston, and to make peace in the family
I said both were right,
 Its not saft to walk in the streets now,
When the driver says, Hey" Hey" to make his horse
stop, the people think he means "Charleston" and
start Dancing, dont stop untill each fall out and
faint.
 The new way of meeting a friend
Marcel. Hey" Hey"
Jocky. Charleston
Marcel, Did you hear the scandle that happens
yesterday?
Jock -- Why no, What happened?
Marcel My fathers secretary and foreman
was, cought in the office
Jocky doing what???,?????
Marcel The Charleston of course idiot"
 Josephine Baker

84

In the autumn of 1925, a nineteen-year-old Josephine Baker (1906–1975) arrived in Paris, where she became an overnight phenomenon. Born Freda Josephine McDonald (Baker was the surname of her second husband) to an impoverished family in St. Louis, Baker joined the black vaudeville circuit, finally securing a job as a dressing assistant for the successful show *Shuffle Along*, which positioned her to join the cast when a chorus girl left and subsequently to star in *The Chocolate Dandies*. Noticed by the young socialite Caroline Dudley Reagan, who was assembling a troupe of black performers to bring to the Paris stage, Baker was soon on her way to Paris. The show, *La Revue nègre*, was planned in New York but was totally reconceived in Paris for a French audience; among the additions was the soon-to-be-famous *Danse sauvage*, danced by Baker and Joe Alex in sparse clothing to exotic music.

A young artist from Nancy in eastern France, Paul Colin (1892–1985) was at the theater when the troupe arrived, fresh from New York, to rehearse. Colin had apprenticed with a painter and trained at the Ecole des Beaux-Arts in Nancy before arriving in Paris in 1912 to begin his career. After two unsuccessful years as a struggling artist and four years of decorated military service, Colin returned to civilian life to try again. A mural commission and stints as an illustrator enabled him to keep a studio and continue to paint, but his real break came when he encountered an old friend, André Daven, on the street. Daven hired Colin to work in set design and publicity for the Théâtre des Champs-Elysées, where Daven was a producer. Thus, Colin was asked to produce the publicity poster for *La Revue nègre*.

Years later, he recalled seeing Baker perform for the first time: "She contorted her limbs and body, crossed her eyes, shimmied, puffed out her cheeks, and crossed the stage on all fours, her kinetic rear end becoming the mobile center of her outlandish maneuvers. . . . I still see her, frenzied, undulating, moved by the saxophones' wail. Did her South Carolina dances foretell the era of a new civilization, finally relieved of fetters centuries old?" (quoted in Gates and Dalton 1998, p. 9). Almost immediately, he asked Baker to go to his studio to pose for numerous sketches, and a close friendship—possibly even a brief affair (Wood 2000, p. 86)—developed. Baker wrote of Colin in the last of her books of memoirs, "Under his eyes, for the first time in my life I felt beautiful" (quoted in Gates and Dalton 1998, p. 10). In addition to his role in spreading Baker's image throughout Paris, Colin escorted her to Parisian events and introduced her, according to one version of the story, to the couturier Paul Poiret (cat. 47) (Jules-Rosette 2007, p. 142). Poiret took great interest in Baker, frequently outfitting her and only sometimes charging her for the clothing he supplied.

For part of the run of *La Revue nègre*, the singing star Damia (cats. 2, 7) performed as the first act on the program. Years later, Damia remembered Baker's attention to her performances: "Extraordinary, that little girl . . . each night, between two scene supports, Joséphine, who did not then know a word of French, would watch me with her big eyes, with a grave, attentive expression, not missing a word" (quoted in Wood 2000, p. 93).

In 1927 Colin and Baker collaborated on two projects: he supplied several illustrations for her first book, *Les Mémoires de Joséphine Baker*, and she wrote a preface, which appeared in her own handwriting, for Colin's collection of forty-five hand-colored lithographs, or pochoirs, *Le Tumulte noir*. In it, she discussed the contemporary Parisian enthusiasm for the Charleston and the phenomenon of Paris becoming "darker and darker." The printer Henri Chachoin published an unnumbered edition of five hundred wove paper copies, as well as ten numbered volumes on Japan paper and another ten on Madagascar paper. In the pochoir process, color is applied to prints by hand using stencils, and for *Le Tumulte noir*, the colors were stenciled in by J. Saudé. The pochoirs presented here are from Baker's personal copy of *Le Tumulte noir*.

In *Le Tumulte noir*, Colin displayed his talents in extending the bounds of caricature. On the surface, the images represent Parisian personalities—singers, dancers, even a tennis star—their flesh darkened and their bodies rhythmically contorted, seemingly overcome by the black invasion of Paris, which Baker described in her preface. Colin capitalizes on something distinctive about each figure to render them easily recognizable to the Parisian public who knew them so well: the Swedish dancer and choreographer Jean Börlin (1893–1930), who collaborated with Fernand Léger (1881–1955), as a Cubist figure in a top hat, waving his nation's flag; the elegant French singer Maurice Chevalier (1888–1972), sporting his famed boater; Damia's urban, larger-than-life appeal and signature costume, here in reverse colors; the music hall regular Max Dearly, shirtless and with a drooping top hat, wild bow tie, checkered pants, and two-tone shoes; the Hungarian-born twin Dolly Sisters, a traveling singing and dancing team, as identical cutouts; the tennis star Suzanne Lenglen (1899–1938), who won numerous championships in the years just before *Le Tumulte noir* was published, with her classic headband and a rather abbreviated sporting outfit; Ida Rubinstein's (cat. 4) emaciated body, flat chest, and vastly elongated limbs; and two of the many images of Baker. She appears in one, of course, in her celebrated banana skirt, probably conceived by Jean Cocteau (cat. 33) and executed by Colin, which she first wore in *La Folie du jour* (1926) (Jules-Rosette 2007, pp. 3, 49; Wood 2000, pp. 104–5). Contrary to the frenetic movements suggested by so many of the figures, Colin captures a frozen image of Baker poised gracefully on tiptoe, her slender body elegantly controlled, the light glistening off her chic, close-cropped hair. The other image of Baker presents her in a bright colored suit and floral-embellished hat, dancing a lively Charleston.

Although the images of Parisian celebrities function as convincing caricatures, they are all, in a sense, also imprinted with the likeness—in flesh tone and in pose—of Baker, who seemed to epitomize the craze for all things black. To that end, Chevalier and Rubinstein's caricatures strike Baker's famed knock-kneed pose, and Börlin, Lenglen, and Dearly flex wrists, hips, and knees in ways that recall Baker's energized, stylized movements.

A month after publishing *Le Tumulte noir*, Colin held a gala *Bal nègre* at the same theater where *La Revue négre* had debuted; Parisian personalities attended in the guise of various black stars. Josephine Baker, through her own acumen and with the aid of those around her, particularly Colin, became as much a celebrated performer as a brand—much like the artist Foujita (cats. 15, 16)—with dolls, clothing, and accessories promoting her adored image.

Selected bibliography: Paul Colin, *Josephine Baker and La Revue Nègre: Paul Colin's Lithographs of Le Tumulte noir in Paris, 1927*, intro. by Henry Louis Gates Jr. and Karen C. C. Dalton (New York, 1998), pp. 4–12; "Börlin, Jean," *The Oxford Dictionary of Dance,* by Debra Craine and Judith Mackrell (Oxford, 2000), *Oxford Reference Online* (accessed June 5, 2008); Ean Wood, *The Josephine Baker Story* (London, 2000), pp. 75–77, 79–80, 86–88, 93, 104–5, 116–17; "Dolly Sisters," *The Oxford Companion to American Theatre,* ed. Gerald Bordman and Thomas S. Hischak, 3rd ed. (Oxford, 2004), *Oxford Reference Online* (accessed June 5, 2008); Bennetta Jules-Rosette, *Josephine Baker in Art and Life: The Icon and the Image* (Urbana, Illinois, 2007), pp. 130–31, 134–35, 142–43, 287–95.

Paul Colin
(French, 1892–1985)
Damia
1930
Poster
37 x 59 cm
The Rennert Collection, New York

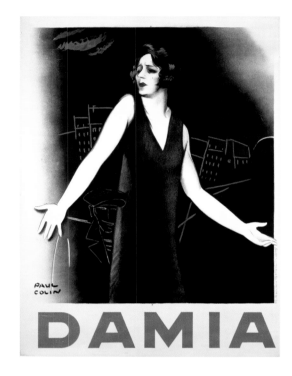

In 1930 Paul Colin (1892–1985) produced this poster of the singer Damia (1892–1978) for the Columbia record label. Odéon also used this image for its label in France, and Damia promoted some of her theatrical performances with the poster. Colin recalled that Damia wore a black, sleeveless evening gown for her performances and sang against the backdrop of a black velvet curtain, which had been his suggestion (Rennert 1977, p. 9). He portrayed her here against this dark background, and the only hints of color in the poster are the touch of blue evening clouds in the upper left corner and the red of Damia's lips; this red is repeated in the block letters proclaiming her name below.

Inscribed in the darkness behind the proportionately giant figure of Damia is a stylized skyline of Parisian buildings and a male figure in a beret and jacket. Thus Colin sets Damia, as a larger-than-life figure, against the city about which she would say, a decade later, "I am a daughter of Paris" (quoted in Rifkin 1987, p. 138).

It seems likely that Colin based his design of this poster on his earlier pochoir of Damia that he included in his *Tumulte noir* series of 1927 (cat. 6d), since the figure's pose and the position of her arms are extremely similar. The earlier image also uses the structure of placing a large-scale Damia against a comparatively small vista. Colin produced another poster of Damia for Columbia in 1941 in which her face appears wider and somewhat older and in which she strikes a different, more static pose and wears a dress with a higher neckline.

Selected bibliography: Adrian Rifkin, "Musical Moments," *Yale French Studies*, no. 73, Everyday Life (1987), pp. 121–55; Jack Rennert, *100 Posters of Paul Colin* (New York, 1977), pp. 9, 11, no. 55, ill.

Salvador Dalí
(Spanish, 1904–1989)
Sugar Sphinx
1933
Oil on canvas
72.7 x 59.7 cm
Salvador Dalí Museum,
St. Petersburg, Florida

As in so many paintings by Salvador Dalí (1904–1989), the present work contains the figure of Gala, who became his wife the year after he produced this picture. The view of the sitter from the back combined with the various layers of meaning Dalí imposed on the painting certainly challenge the interpretation of this work as a portrait. Yet the undeniable identification of the figure as Gala and Dalí's integration of Gala into the literary theories that inform this painting justify a consideration of the status of the work as a portrait.

Born in Figueres in Catalonia, Dalí received his first oil painting set in 1914 but did not embark on a formal study of art until three years later, when he entered the Municipal School of Drawing under Juan Nuñez (1877–1963). After a teaching course at the Academy of Fine Arts in Madrid, he remained in the city to train at the Academy of San Fernando, where he studied from 1921 until he was expelled because of his involvement in a student protest in 1923, and then again from 1925 until his second expulsion, for refusal to take an exam, the following year. Between his stints at the Academy of San Fernando, he took drawing classes at the Free Academy. During this period, he befriended the poet Federico García Lorca (1898–1936) and the filmmaker Luis Buñuel (1900–1983). He had visited Pablo Picasso (cats. 38–40) and Joan Miró (1893–1983) in Paris in 1926, and on his return there in 1928, he met many of the Dada and Surrealist artists then in Paris. He met Gala in Spain the following year, which resulted in her abandoning her husband Paul Eluard (1895–1952) for the second time; she had already had a brief affair with Max Ernst (see cat. 14 for further discussion of Gala's relationship with Ernst and her life before she became the infamous Gala Dalí).

After cycling through a variety of styles—including Impressionism, Pointillism, and abstraction—Dalí arrived at the highly detailed depictions and polished surfaces that characterize his style. As James Thrall Soby observed, Dalí essentially used the techniques of realism to present fantastical images, thereby making a claim for their legitimacy (exh. cat. New York 1941, p. 15). When he created *Sugar Sphinx*, he was working according to a theory that he had devised: the Paranoiac-Critical Method, in which he perceived concealed meanings in, for example, myths and paintings (ibid., p. 16); moreover, the method involved seeing forms in decidedly different ways.

In particular, Dalí fixated on Jean-François Millet's (1814–1875) *Angelus* (1857–59; Musée d'Orsay, Paris), a painting that depicts a man and a woman—beside a wheelbarrow and a pitchfork—pausing from their work in the field to bow their heads; the title refers to a particular prayer said thrice daily, and the evocative lighting of Millet's work suggests that the workers are praying at sunset. Motifs from this painting recur in a number of Dalí's works from the early 1930s: in *Imperial Monument to the Child Woman* (1929; Museo Nacional Centro de Arte Reina Sofía, Madrid) he placed the two figures from Millet's *Angelus* at back right; *Gala and the Angelus of Millet Immediately Preceding the Arrival of the Conic Anamorphoses* (c. 1933; National Gallery of Canada, Ottawa) includes a smiling figure of Gala set back in a room in which a reproduction of Millet's painting hangs above a doorway; *Atavism at Twilight* (c. 1933–34; Kunstmuseum, Bern) presents Millet's man as a

skeletal figure in a rocky landscape, the wheelbarrow from the original painting floating in the sky and melting into the man's hat; Dalí's drawing *Homage to Millet* (1934; Salvador Dalí Museum, St. Petersburg, Florida) depicts Millet's workers without flesh, their skeletal structures only roughly resembling the human anatomy; *Archaeological Reminiscence of Millet's Angelus* (1933–35; Salvador Dalí Museum, St. Petersburg, Florida) shows the figures as the ruins of brick towers on a beach, around which grow cypress trees—also present in *Sugar Sphinx*; and, finally, *Portrait of Gala* (1935; Museum of Modern Art, New York) displays Gala seated on a wheelbarrow in the background, with a reworked interpretation of Millet's *Angelus* framed behind her head, while in the foreground, another Gala sits on a cube with her back to the viewer.

Dalí produced his repeated reimaginings of *The Angelus* in the 1930s, and he wrote a preface to an exhibition of his drawings in 1934 entitled "Millet's *L'Angélus*." In this preface, he describes Millet's painting as "the unmoving presence, the expectant encounter, of two beings in a desolate, crepuscular environment" (quoted in Finkelstein 1998, p. 280). Almost three decades later, Dalí published a longer literary explication of the subject and its significance to him, *The Tragic Myth of Millet's L'Angélus: Paranoiac-Critical Interpretation*, which he claimed to have written in the 1930s, lost during World War II, recovered in 1962, and then published without any revisions. Haim Finkelstein has challenged Dalí's story, suggesting that the work may have been greatly altered in the 1960s (ibid., p. 274). In the later text, Dalí reports that he had a vision in 1932 in which *The Angelus* appeared to him: "although everything in my vision of the aforesaid image 'corresponds' exactly to reproductions of this painting known to me before, it nevertheless 'appears to me' completely modified and charged with such latent intentionality that Millet's *L'Angélus* becomes for me 'all of a sudden' the pictorial work that is the most disturbing, the most enigmatic, the most dense, and the richest in unconscious thoughts ever to have existed" (quoted in ibid., p. 283). What follows is an at times erotic and highly bizarre discussion of the painting; Gala is a recurring character in Dalí's musings and daydreams about the painting. Fiona Bradley has written that in Dalí's interpretation of *The Angelus*, the woman stands for a "mother and a sphinx: interrogatory, threatening, but ultimately offering a clue to the hero's identity. This maternal sphinx is inevitably for Dalí, Gala" (exh. cat. Liverpool 1998–99, p. 64).

In *Sugar Sphinx*, Gala sits on a rock formation, her back to the viewer, facing a wheelbarrow and two figures in the poses of Millet's couple, against a swirling, luminous sky. The sphinx referenced in the title and perhaps embodied in Gala is presented as a celestial golden silhouette of the Great Sphinx at Giza. The cypress trees beside the figures from *The Angelus* likely carry their traditional associations with death; yet it is also significant that Dalí's memories of the school in which he became acquainted with Millet's painting—in a reproduction that hung in a hallway—also include viewing two cypress trees out the window of his classroom (Ades 1982, p. 11).

In the Millet-inspired paintings mentioned above in which Gala appears, she wears the same distinctive, quilted, brightly patterned jacket. Since Gala faces the viewer in the paintings in Ottawa and New York, the jacket indicates that the sitter here is Gala. Dalí also painted *Geodesic Portrait of Gala* (1936; ill. in Descharnes 1984, p. 190), in which Gala is shown at close range from the back, the colorful "Persian" jacket just slipping off her left shoulder. This image in particular seems to weave together three threads of Dalí's preoccupations: his persistent interest in presenting figures viewed from the back, his appreciation of the beauty of Gala's back, and the idea of the jacket, particularly as seen from behind, as a feature that identifies Gala. Figures presented from behind appear early in Dalí's work, such as the depictions of his sister Anna María from the mid-1920s. It is not surprising that Kenneth Wach has suggested that Dalí may have been influenced by paintings by Caspar David Friedrich (1774–1840) showing lone figures, seen from the back, generally against massive natural vistas (Wach 1996, p. 68). Dalí wrote of how the sight of Gala's back revealed her importance to him: "Gala, Eluard's wife. It was she! Galuchka Rediviva! I had just recognized her by her bare back" (quoted in exh. cat. Liverpool 1998–99, p. 54). Although Gala appears often in Dalí's oeuvre, identifying her by means of this distinctive jacket seems to draw particular attention to her role, enigmatic though it may be, in this group of related paintings.

As James Thrall Soby noted, Dalí set himself apart from many of his fellow modernists in his eagerness to incorporate literature and history into his paintings as well as in his own practice of writing extensively (exh. cat. New York 1941, pp. 9, 29). Dalí's integration of Gala into his interpretation of Millet's *Angelus*, and his insistence on the personal significance and relevance of his ideas about the nineteenth-century work, suggest that this painting's elusive meanings are probably just as much about Gala—rendering this an unusual portrait—as about Dalí himself and Millet's *Angelus*.

Selected bibliography: exh. cat. New York, Museum of Modern Art, *Paintings, Drawings, Prints, Salvador Dali*, cat. by James Thrall Soby, 1941; Dawn Ades, *Dalí and Surrealism* (New York, 1982); Robert Descharnes, *Salvador Dali: The Work, the Man*, trans. Eleanor R. Morse (New York, 1984), p. 139, ill.; A. Reynolds Morse, foreword, and Robert S. Lubar, intro., *Dali: The Salvador Dali Museum Collection* (Boston, 1991), no. 48, ill., pp. 181–84; Robert Descharnes and Gilles Néret, *Salvador Dali, 1904–1989: The Paintings*, vol. 1, *1904–1946* (Cologne, 1994), no. 444, ill.; Kenneth Wach, *Salvador Dali: Masterpieces from the Collection of the Salvador Dali Museum* (New York, 1996), pp. 112–22, 68, ill.; Haim Finkelstein, ed. and trans., *The Collected Writings of Salvador Dalí* (New York, 1998), pp. 273–97; exh. cat. Liverpool, Tate Gallery, *Salvador Dali: A Mythology*, cat. by Dawn Ades and Fiona Bradley (also shown at St. Petersburg, Florida, Salvador Dalí Museum), 1998–99, no. 25, ill.; Marco Di Capua, *Salvador Dali: su vida, su obra* (Barcelona, 2003), p. 144, ill.

Robert Delaunay
(French, 1885–1941)
Jean Metzinger or
The Man with the Tulip
1906
Oil on canvas
72.4 x 48.5 cm
Private collection

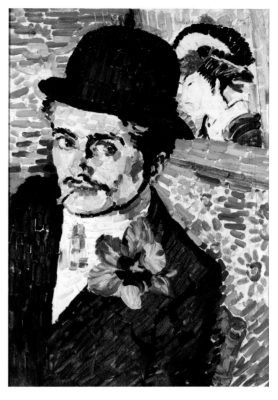

When Robert Delaunay (1885–1941) and Jean Metzinger (1883–1956) painted each other's portrait in 1906, the results were so similar in style that they serve not only as depictions of individuals but testaments to the intimate and collaborative friendship they shared. Both works were shown at the Salon d'Automne of 1906.

Here, Delaunay has pictured his friend and fellow artist in a suave bowler, dark jacket, and collared shirt. An oversize, bright flower sprawls across Metzinger's lapel, and a cigarette emerges jauntily from his lips. Although his body and chair are angled toward the left, Metzinger turns slightly to the right and up to face the viewer, and he is set against a backdrop of vivid floral wallpaper and a framed Japanese print. Likewise, Metzinger's portrait of Delaunay (ill. in exh. cat. Paris 1999, p. 24) displays a fashionably clad man with a walking stick in a debonair pose. Beyond the similarities in aura, these works share many technical qualities and display their creators' joint experimentation in new artistic styles.

After his parents separated, Delaunay was raised by his prosperous aunt and uncle who exposed him to the arts. From 1902 to 1904 he served an apprenticeship at the theater decoration studio of Ronsin in Belleville. The year he left the studio, he began exhibiting his paintings, and his early efforts explored Impressionism, Neo-Impressionism, Fauvism, and Divisionism, before he arrived at his personal style of simultaneity or Orphism—the critic Guillaume Apollinaire's (cat. 25) term for a type of Cubism focused mainly on light effects. As Sherry A. Buckberrough has noted, Delaunay was concerned with matters of color throughout his career (Buckberrough 1982, p. 1). Delaunay was clearly influenced by the bright colors of the Fauves, whose major showing at the Salon d'Automne of 1905 occurred the year before Delaunay painted this portrait. The other movement from which Delaunay draws here is Divisionism. Espoused by Georges Seurat (1859–1891) and Paul Signac (1863–1935), Divisionism, derived from the color theories of Michel-Eugène Chevreul (1786–1889) and Ogden Rood (1831–1902), is characterized by the principle of applying colors in discrete touches. Delaunay and Metzinger had met at the Salon des Indépendants in March 1906, and their letters from this period discuss Divisionism (ibid., p. 9). Delaunay painted three portraits of Metzinger, all of which experiment with Divisionist principles, and this version is dated May 1906, just a few months into their friendship. Delaunay's *Portrait of Jean Metzinger* (1906; Museum of Fine Arts, Houston) takes the Divisionist techniques further—which are visible in the present painting but not in so extreme a fashion—using clearly delineated rectangular brushstrokes to depict the sitter.

In this work, Delaunay uses the principles of Divisionism to varying degrees. His depiction of Metzinger's coat and hat is comparatively traditional for the time: the brushstrokes are closely joined, and the gradations of color are subtle. Likewise, the depiction of the woman in the Japanese print behind Metzinger lacks the bold differentiation of colors and brushstrokes that Delaunay uses in his evocation of the floral wallpaper and in his friend's face. The inclusion of the Japanese print reflects Delaunay's interest in such works, which was shared by many of his contemporaries and by French painters of the preceding generations.

Selected bibliography: exh. cat. New York, Wildenstein, *Modern Portraits: The Self and Others*, cat. ed. by J. Kirk T. Varnedoe, 1976, pp. 37–38; Sherry A. Buckberrough, *Robert Delaunay: The Discovery of Simultaneity* (Ann Arbor, Michigan, 1982), pp. 1–20, no. 8, ill.; exh. cat. New York, Solomon R. Guggenheim Museum, *Visions of Paris: Robert Delaunay's Series* (also shown at Deutsche Guggenheim Berlin), 1997–98; exh. cat. Paris, Centre Georges Pompidou, *Robert Delaunay: 1906–1914, de l'impressionnisme à l'abstraction*, 1999, pp. 24–25, 94–95, ill.; Christie's, London, *Impressionist and Post-Impressionist Art*, June 28, 2000, lot 26, ill., pp. 64–67; exh. cat. Valencia, Fundación Bancaja, *Robert y Sonia Delaunay: Exposición Internacional de Artes y Técnicas de París, 1937*, cat. by Javier Riaõno, 2002, p. 199; Christie's, London, *Impressionist and Modern Art Evening Sale*, February 2, 2004, lot 23, ill., pp. 74–77; Christie's, New York, *Impressionist and Modern Art*, May 9, 2007, lot 33, ill., pp. 112–15.

Emile Deschler (French)
Josephine Baker
1935
Gouache, ink, and crayon maquette
44.8 x 40.6 cm
The Rennert Collection, New York

The remarkable Josephine Baker (1906–1975) rose from an impoverished St. Louis childhood to be a star of the Parisian stage. Stunning audiences first in *La Revue nègre*, which opened in 1925, and *La Folie du jour,* which ran the following year, Baker went on to have a successful and glowing career, recording music, opening her own nightclub, Chez Joséphine, appearing in films, and performing throughout much of her life. She also became an impassioned political advocate for numerous causes: she worked for the French Resistance during World War II, fought for desegregation in the United States, and adopted children of varied ethnicities to form a Rainbow Tribe.

Immortalized by Paul Colin in countless posters and in his collection of lithographs, *Le Tumulte noir* (cat. 6), Baker also served as portrait subject for such artists as Alexander Calder (1898–1976), who created several wire sculptures of her, and the creator of the present work, Emile Deschler. Deschler, who was born in Epinal and showed at the Salon d'Automne, created this poster maquette in gouache, ink, and crayon. Against a dreamy blue backdrop, Baker seems electric, the spiky white halo around her body echoing the black and white feathered boas draped over her shoulders; she famously appeared in feathers and little else.

In Deschler's stylized presentation—perhaps a study for a poster—blue highlights delineate the waves in Baker's hair and capture the shadows around her eyes and lips and on the tops of the white feathers. Deschler emphasizes her glowing smile and warm eyes, which were captured in many photos of Baker throughout her life.

Selected bibliography: E. Bénézit, *Dictionnaire critique et documentaire des peintres, sculpteurs, dessinateurs et graveurs*, new ed. (Paris, 1976), vol. 3, p. 513; Ean Wood, *The Josephine Baker Story* (London, 2000); Bennetta Jules-Rosette, *Josephine Baker in Art and Life: The Icon and the Image* (Urbana, Illinois, 2007).

Jean Dubuffet
(French, 1901–1985)
*Three Masks: René Pontier,
André Claude, Robert Polguère*
1935
Painted papier-maché
28 x 17.7 x 7.9; 23.5 x 15 x 8.3;
25.1 x 18 x 8.9 cm
Hirshhorn Museum and Sculpture
Garden, Smithsonian Institution,
Washington, D.C.,
Gift of Joseph H. Hirshhorn, 1966
(66.1455.A–C)

Although Jean Dubuffet (1901–1985) came from a comfortable family in Le Havre and trained at the city's Ecole des Beaux-Arts and subsequently at the stodgily renowned Académie Julian in Paris, he soon rejected academic art and its institutions. Yet his sporadic approach to his art in his early years—his artistic endeavors ceased from 1925 to 1932 and again from 1937 to 1939 while he managed his family's wine business—did not slow his evolving art theories. His discovery, in 1924, of Hans Prinzhorn's *Bildnerei der Geisteskranken (Art of the Mentally Ill)* (1922) seems to have nurtured his belief that the most authentic art is produced outside the established art world.

Dubuffet produced these masks in 1935, soon after the dissolution of his first marriage and with the collaboration of the woman who would become his second wife, Emilie Marie Augustine Carlu, whom he called Lili. Freed from an unhappy marriage and a seemingly bourgeois lifestyle, Dubuffet relished his relationship with Lili, admiring her liberated social attitude, and, significantly, her humble origins. Seeking inspiration and artistic forms from the so-called common people, he embarked on a series of works inspired by carnival art: he made masks out of plaster and papier-mâché as well as wooden marionettes, using friends as his subjects. Embracing the ritualistic nature of carnival art, he staged puppet shows and played the accordion for friends in his studio.

The masks here depict three of Dubuffet's friends. André Claude—whose mask presents him as bald with thick eyebrows, solemn green eyes in plaintively arcing cavities, and two visible teeth—managed Dubuffet's wine business in the mid-1930s. The mask with the thick head of hair, fleshy face, and pursed red lips depicts René Pontier, a musician and acquaintance. Robert Polguère, who apparently sold antiques, seems to be the oldest of the three men whose masks appear here: his representation is marked by pronounced ears, dark eyebrows, red eyes, and a double chin.

Pepe Karmel, in line with the ideas of the Russian literary theorist Mikhail Bakhtin, has noted the implicit power of carnival masks to toy with both personal and class identities, for example, allowing common people to assume the identities of royalty during the carnival (Karmel 2002, p. 16). Perhaps Dubuffet intended to invert both the traditional functions of carnival masks and entrenched ideas about portraiture that expect it to be the depiction of aristocratic and celebrated people. These masks do not present stock characters but individuals; moreover, they present the sitters as decidedly mundane, inelegant, and even caricatured, with their infelicities underscored and all their noses reddened. Dubuffet completely disregards the traditional practice of artists to stray toward idealization when producing portraits, instead providing the viewer with playful caricatured effigies.

Selected bibliography: Georges Limbour, *Tableau bon levain à vous de cuire la pâte: L'Art brut de Jean Dubuffet* (Paris, 1953), p. 17; exh. cat. New York, Museum of Modern Art, *The Work of Jean Dubuffet, with Texts by the Artist* (also shown at Art Institute of Chicago; Los Angeles County Museum of Art), 1962, p. 11, ill.; Pepe Karmel, "Jean Dubuffet: The Would-Be Barbarian," *Apollo* 156, no. 488 (October 2002), pp. 12–20, fig. 12; exh. cat. Salzburg, Museum der Moderne, Rupertinum, *Jean Dubuffet: Spur eines Abenteuers/Trace of an Adventure*, cat. by Agnes Husslein-Arco et al. (also shown at Guggenheim Museum Bilbao), 2003–4, pp. 274–88; Valérie Da Costa and Fabrice Hergott, *Jean Dubuffet: Works, Writings and Interviews* (Barcelona, 2006), p. 157; Julien Dieudonné and Marianne Jakobi, *Dubuffet* (Paris, 2007), pp. 91–98.

Marcel Duchamp
(French, 1887–1968)
Boîte-en-valise (Box in a Valise)
1961
Mixed media, 68 items enclosed
8.9 x 37.5 x 40.6 cm
Collection of Frances Beatty and
Allen Adler

The younger brother of Jacques Villon (cats. 46, 47) and Raymond Duchamp-Villon (cat. 13), Marcel Duchamp (1887–1968) followed his brothers into the arts, joining them in Paris in 1904, where he studied briefly at the Académie Julian and made cartoons for Parisian magazines. His radical Cubist painting *Nude Descending a Staircase* of 1912 (Philadelphia Museum of Art) was first displayed in Paris that year and created a tremendous stir the following year when it was exhibited at the Armory Show in New York. After dealing this striking blow to traditional painting, Duchamp began experimenting in other media, producing the first box consisting of reproductions of his work, the *Box of 1914*, and creating what he would soon call "ready-mades"—found objects, some of which he altered and to which he affixed his name. He also devoted himself increasingly to chess, playing in numerous tournaments.

He began work on the *Boîte-en-Valise (Box in a Valise)* in 1935, the year in which he wrote to his Connecticut friend and patron Katherine Dreier on March 5, "I want to make, sometime, an album of approximately all the things I produced" (quoted in Bonk 1989, p. 147). He started assembling photographs of his work; each time a work was to be reproduced in a book or magazine, he would request three hundred additional copies of the photographic reproduction. He then hand-colored one photograph of each work that would serve as the guide for the coloring of the other reproductions, which would be performed by the printing firm of Vigier et Brunissen using the pochoir method. Because many of Duchamp's works were owned by his close friends and patrons Louise and Walter Arensberg and hence in the United States, Duchamp traveled there in 1936 and made detailed color notes. In 1938 Duchamp arranged for a replica to be made of his infamous *Fountain* (1917), a ready-made urinal, which by that time existed only in photographs. Two years later, he ordered cardboard that would serve as the display case for the miniature reproductions of his work and began producing identifying labels, listing media, dimensions, and the collections in which his works resided. When he discovered that the cardboard container was too flimsy, he designed an exterior container composed of wood covered in leather.

Originally, each box was to contain sixty-nine reproductions of his work, with seventeen affixed to the box and the remainder in detachable folders stored within the box. In December 1940 the reproductions were complete; construction and assembly of the boxes took place over the next three decades. The first copy was dated January 1, 1941, and the edition was planned for twenty-four deluxe copies, each officially called *Boîte-en-Valise*, and three hundred additional copies, each referred to as *Boîte*. The deluxe edition copies were housed in valises and each contained one "original" hand-colored by Duchamp; the artist assembled these. For the remainder, many changes were made to different aspects of the box, and different people supervised their assembly and distribution. The bulletin announcing the boxes declared that they would initially sell for five thousand francs and subsequently be reduced to four thousand francs. The bulletin also announced the box's alternative name: *de ou par MARCEL DUCHAMP ou RROSE SELAVY (from or by Marcel Duchamp or Rrose Sélavy)*; Rrose Sélavy was Duchamp's female alter ego, whom he had created in 1920 (see p. 139).

The present context allows examination of the *Boîte* as an innovative conception of the self-portrait, created toward the end of the period considered in the exhibition. After receiving a copy of the *Boîte-en-Valise*, Walter Arensberg wrote to Duchamp on May 6, 1943, "You have invented a new kind of autobiography. It is a kind of autobiography in a performance of marionettes. You have become the puppeteer of your past" (quoted in Bonk 1989, p. 167). Indeed, portraits always involve, to some extent, the role of puppeteer for the artist, choosing which features to play up and which to deemphasize, manipulating the sitter as he chooses. As Arensberg notes, Duchamp has assembled his

past, creating a presentation of himself—an autobiography or, more aptly here, a self-portrait. The art dealer and writer Sidney Janis described the work similarly in 1944: "The *Boîte* is a device which when manipulated, retrospectively unfolds the work of Duchamp before the spectator in such a way that it constitutes virtually a composite portrait of the artist's personality" (Janis 1944, pp. 126–27). The collection of reproductions of almost his entire oeuvre—a catalogue raisonné, as Ecke Bonk describes it (Bonk 1989, p. 21)—makes for a compelling self-portrait in itself.

During an interview in 1954, Duchamp quipped, "My whole life's work fits into one suitcase, literally and figuratively: that's where the precise miniature replicas of my most important works are collected" (quoted in Bonk 1989, p. 174). An interesting parallel to Duchamp's assemblage of his oeuvre in the *Boîte* is his skill at herding most of his work into the hands of the Arensbergs, who in turn donated their extensive collection of works by Duchamp to the Philadelphia Museum of Art in 1950. The idea of the suitcase is especially significant, at least in retrospect, since Duchamp embarked in 1942 for his new home in the United States. With Duchamp's departure—and that of so many artists fleeing war-torn Europe—the art world's center shifted from Paris, where it had been for several centuries, to New York. Thus, the suitcase seems to enable its creator and subject to tidily pack up his oeuvre and, thereby, himself, for a new life in America.

The present work was assembled in 1961, as part of what Bonk has classified as Series D (Bonk 1989, p. 320). Thirty copies, of which this is one, were assembled in Paris in 1961 using pale green linen for the exterior of the box and similarly colored paper for lining the interior. The copies in Series D contained sixty-eight reproductions and were assembled by Duchamp's stepdaughter—incidentally also Henri Matisse's (cats. 26–30) granddaughter—Jackie Matisse Monnier (b. 1931).

Selected bibliography: Sidney Janis, *Abstract and Surrealist Art in America* (New York, 1944), pp. 126–27, no. 91, ill.; exh. cat. Philadelphia Museum of Art, *Marcel Duchamp*, cat. ed. by Anne d'Harnoncourt and Kynaston McShine (also shown at New York, Museum of Modern Art; Art Institute of Chicago), 1973, pp. 12–31, 304; Ecke Bonk, *Marcel Duchamp, the Box in a Valise: De ou par Marcel Duchamp ou Rrose Sélavy; Inventory of an Edition*, trans. David Britt (New York, 1989); Francis M. Naumann, "The Valise and Box in a Valise: A Brief History of Marcel Duchamp's Portable Museum," in exh. cat. London, Entwistle, *The Portable Museums of Marcel Duchamp: de ou par Marcel Duchamp ou Rrose Sélavy*, cat. by Ronny Van de Velde and Jessy Van de Velde, 1996.

Raymond Duchamp-Villon
(French, 1876–1918) /
Marcel Duchamp
(French, 1887–1968)
Portrait of Professor Gosset
Edition: 6/8, 1917–18
Bronze; cast posthumously by
Marcel Duchamp and Louis Carré
29.8 x 22.2 cm
Indiana University Art Museum:
Jane and Roger Wolcott Memorial,
Gift of Thomas T. Solley, 76.31.1

Works by three brothers from Rouen, Jacques Villon (cats. 46, 47), Raymond Duchamp-Villon (1876–1918), and Marcel Duchamp (cat. 12), appear in this exhibition. The differences in their names result from the decision of the eldest, born Gaston Duchamp, to assume the name Jacques Villon for his artistic career, due in part to his father's reticence about the son's chosen profession. His younger brother Raymond affixed the assumed name to his own in tribute to his brother.

Duchamp-Villon originally intended to become a doctor and studied medicine at the University of Paris. However, he terminated his studies when he developed rheumatic fever. During his recovery, he nurtured his interest in sculpture and in 1907 opened a studio next to his elder brother's in the Parisian suburb of Puteaux. By 1911 the brothers were regularly receiving visits from such members of the avant-garde as Robert Delaunay (cat. 9), Albert Gleizes (cat. 18), Jean Metzinger (cats. 9, 31), and Francis Picabia (cat. 37), among others.

As soon as World War I began, Duchamp-Villon enlisted, serving as a medical officer. During his first post, he was able to return to Puteaux intermittently to work, but this became impossible when he was sent to the front in 1915. He caught typhoid fever at the end of the next year and died in the fall of 1918. The plaster head that was the model for this posthumous cast was Duchamp-Villon's final work. In May 1918 he wrote to his friend Walter Pach, the American artist and champion of the French avant-garde, "I have, however, progressed rather far with a portrait of one of the surgeons who cared for me and with which I am not dissatisfied as a point of departure. But it is still necessary to finish it and I am counting on the weeks of my convalescence to accomplish it" (quoted in Zilczer 1980, p. 21).

The noted surgeon and urologist Antonin Gosset (1872–1944), who was also portrayed by Edouard Vuillard (1868–1940) (*The Surgeons*, 1912–14, reworked 1925, 1937; ill. in exh. cat. Washington, D.C., 2003–4, no. 306) and Marie Laurencin (cats. 20, 22) (*Le Professeur Antonin Gosset, membre de l'Académie de Médecine de Paris,* 1929; ill. in Marchesseau 1986, no. 481), treated Duchamp-Villon at Corbineau Hospital at Châlons and inspired this portrait. Gosset had a celebrated career as a surgeon and medical professor at the Salpêtrière Hospital in Paris and was elected president of the French Congress of Surgery in 1927. A *Time* magazine article of December 30, 1929, described him as the "famed remover of the prostate glands of Georges Clémenceau (1912) and Raymond Poincaré" and ascribed to him the "first operating-room-ambulance," devised in 1915 ("Gosset," 1929). In 1934 he was elected to the Académie de Sciences.

On the path toward the essentializing abstraction of this work and his other late sculptures, Duchamp-Villon experimented with various styles, including forays into Art Nouveau and the naturalistic territory of Auguste Rodin (1840–1917). His time at Puteaux, in frequent conversation with Cubist painters, profoundly affected his work. Collaborating with André Mare (1885/87–1932), Villon, Laurencin, and Roger de la Fresnaye (1885–1925), Duchamp-Villon designed a facade and interior for the Maison Cubiste of 1912, a facade and suite of

decorated rooms at the Salon d'Automne the same year. The following year, he expressed his interest in modern machinery in a letter to Pach (quoted in Zilczer 1998, p. 15).

Several drawings and related sculptures reveal some of Duchamp-Villon's concerns as he worked on this portrait. In envisioning a portrait of Professor Gosset, Duchamp-Villon began in 1917 with a naturalistic wax head (Musée des beaux-arts, Rouen). A sheet of drawings from 1917–18 (Musée national d'art moderne, Paris) contains numerous images of Professor Gosset from different angles; many appear more identifiably human and flesh-covered than the final result. Another sheet (Musée national d'art moderne, Paris) features far more abstracted heads, and in several cases the heads emerge out of column capitals, reflecting Duchamp-Villon's interest in sculpture fully integrated into the surrounding architecture. Duchamp-Villon also produced a caricature in polychrome plaster of Professor Gosset in 1918 for a play that was performed during the war (ill. in Ajac and Pessiot 1998, p. 36). In this caricature the facial structure bears a strong resemblance to the final sculpture, albeit appearing playful rather than ominous. A bronze head from 1917–18 (ill. in Ajac and Pessiot 1998, no. 55), has a nose that is similar to, though more elongated than, the nose in the present work. That head has been related to the gas masks that French soldiers wore beginning in 1915 (Zilczer 1983, p. 142). It seems likely that Duchamp-Villon's interest in machinery and his preoccupation with war and death in 1917–18 shaped his depiction of his doctor.

Duchamp-Villon's representation of Professor Gosset pares down any surface features of the subject. Concentrating on Gosset's anatomical structure, which he stylizes, prompting associations with skulls and death, Duchamp-Villon sacrifices the recognizability of his sitter for a presentation that perhaps strives for a more universal, bleak message about the ultimate fate of individuals in a highly mechanized, violent world.

Interestingly, both Pach and Villon later wrote that Duchamp-Villon had drawn a number of "caricatures" in the final years of his life (Zilczer 1980, p. 21; Zilczer 1983, p. 140). This head displays the efficient use of lines and forms associated with caricature.

Selected bibliography: *Science*, n.s., 61, no. 1589 (June 12, 1925), p. 601; *Science*, n.s., 66, no. 1722 (December 30, 1927), p. 648; "Gosset," *Time*, December 30, 1929; *Science*, n.s., 84, no. 2187 (November 27, 1936), p. 481; Judith Zilczer, "Raymond Duchamp-Villon: Pioneer of Modern Sculpture," *Philadelphia Museum of Art Bulletin* 76, no. 330 (Autumn 1980), pp. 3, 5, 9, 15, 21; Judith Zilczer, "In the Face of War: The Last Works of Raymond Duchamp-Villon," *Art Bulletin* 65, no. 1 (March 1983), pp. 139–40, 142, 144; Daniel Marchesseau, *Marie Laurencin, 1883–1956: catalogue raisonné de l'oeuvre peint* (Toyko, 1986), no. 481; Bénédicte Ajac and Marie Pessiot, eds., *Duchamp-Villon: Collections Centre Georges Pompidou, Musée national d'art moderne et du Musée des beaux-arts de Rouen* (Paris, 1998), pp. 34–41, 112–13, 150; Judith K. Zilczer, "Raymond Duchamp-Villon and the American Avant-Garde," *Archives of American Art Journal* 38, nos. 1–2 (1998), pp. 14, 15, 21–22, 24 n. 2; exh. cat. Washington, D.C., National Gallery of Art, *Edouard Vuillard*, cat. by Guy Cogeval et al., 2003–4, pp. 40, 372–74.

Max Ernst
(French, born Germany, 1891–1976)
Gala Eluard
1924
Oil on canvas
81.3 x 65.4 cm
The Metropolitan Museum of Art,
The Muriel Kallis Steinberg Newman
Collection, Gift of Muriel Kallis
Newman, 2006 (2006.32.15)

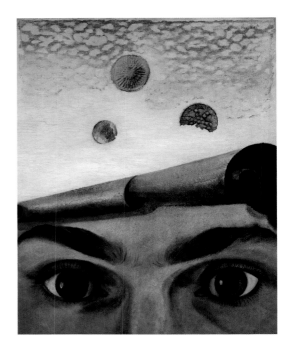

Before Helena Dmitriovna Diakonova (1894–1982), called Gala, became the infamously eccentric wife of Salvador Dalí (cat. 8), she was married to the French poet Paul Eluard (1895–1962). During that marriage, she was simultaneously the lover and muse of Max Ernst (1891–1976) while Eluard, Ernst, and Gala lived together in St.-Brice, a suburb of Paris.

The son of an amateur painter, Ernst was born in Germany, where he studied art history, literature, philosophy, and psychology at the University of Bonn. During his military service in World War I, he became involved with the group of Dadaists in Cologne. Eluard and Gala, who were among the Dadaists in Paris, met Ernst in November 1921. Eluard and Ernst rapidly began a friendship that would prove to be life long—they collaborated on several books, including *Répétitions* (1922) and *Les Malheurs des immortels* (1922)—and Ernst and Gala were also drawn to each other. On another visit, in 1922, this mutual attraction became clear to all concerned; in August 1922 Ernst deserted his wife and son and moved in with Eluard and Gala. This complicated romantic arrangement endured until March 24, 1924, when Eluard left unannounced for Southeast Asia, to be followed that summer, first by Gala, and then by Ernst. In the fall of 1924 Eluard and Gala returned together to France; Ernst followed soon after but no longer lived with them, and his relationship with Gala ceased.

Ernst was a master of collage; he incorporated images from disparate sources into his compositions, manipulating them, erasing the evidence of their previous contexts, and creating new, unified images. The present portrait was based on a photograph of Gala's eyes by Man Ray (1890–1976), which Ernst had acquired and on which he had made a small modification: the addition of a minute landscape beneath her eyes (*The Visible Woman*, 1925, photographic enlargement [after Man Ray] and pencil; ill. in exh. cat. New York 2007–8, fig. 12). Here, Ernst has closely followed the Man Ray photograph in presenting Gala's eyes, but instead of adding a traditional landscape vista below her eyes, he adds an otherworldly mental landscape above them, revealed by the elegantly rolled golden scroll of flesh. This scroll is richly textured, with visible impasto and a scored line separating the scroll from the scene above.

Although the upper half of the painting is usually described as a sky, it is clearly not a scene from nature. Ernst seems to present the mind of his subject as tranquil, arid terrain, with gray disks, one partially submerged in the sand. The greenish sky, recalling a mosaic of cumulus clouds, rises above the mind's desert. Many of Ernst's figures of this period are set in barren or otherwise strange landscapes (for example, *Ubu imperator*, 1923–24; Musée national d'Art Moderne, Centre Georges Pompidou, Paris, or *Castor and Pollution*, 1923; ill. in exh. cat. New York 2005, no. 44), and so the idea seemingly presented here—that such a landscape represents the environment of the mind—may reveal much about the bizarre landscapes in some of Ernst's other paintings.

The odd relationship among Gala, Eluard, and Ernst prompted Ernst to draw *Double Portrait of Ernst and Eluard* (1922; Bibliothèque littéraire Jacques Doucet, Paris), in which the subjects' heads have merged. In contrast, Ernst's depiction of Gala here accords her complete individuality and autonomy.

By his own account, Ernst developed a technique in the summer of 1925 that he called *frottage*, in which he laid paper or canvas atop a textured surface and rubbed it with pencil, charcoal, or paint; the resulting image served as a starting point for his drawn manipulations. The three disks in the sky were made using that technique, evidently with charcoal that has been fixed, and so either Ernst may have invented the technique earlier than he claimed or this picture is later than the 1924 date currently ascribed to it. The images in the sky here, which appear to be sand dollars (*Echinoidea*), can be compared with Ernst's collage of gouache and pencil on print, mounted on cardboard, *The Sand Fleas* (1920; ill. in exh. cat. New York 2005, no. 20). Although the disks here do not perfectly resemble any of the creatures in *The Sand Fleas*, they are reminiscent of them in shape, texture, and the way they emerge from the sand. Sand fleas (*Siphonaptera*) are parasitic insects, and sand dollars are invertebrate animals, related to sea urchins. Ernst's inclusion of these creatures in his work reflects his broader interest in the natural sciences as subject matter for his art; his collages often include nineteenth-century scientific illustrations.

Eluard was the first owner of this painting, followed by the founder of Surrealism, André Breton (1896–1966).

Selected bibliography: exh. cat. New York, Solomon R. Guggenheim Museum, *Max Ernst: A Retrospective*, 1975, pp. 253–55; Charlotte Stokes, "The Scientific Methods of Max Ernst: His Use of Scientific Subjects from *La Nature*," *Art Bulletin* 62, no. 3 (September 1980), pp. 453–65; exh. cat, New York, Metropolitan Museum of Art, *An American Choice: The Muriel Kallis Steinberg Newman Collection*, cat. ed. by William S. Lieberman, 1981, pp. 26–27, ill.; Gaston Diehl, *Max Ernst* (New York, 1991), pp. 89–90; exh. cat. Houston, Menil Collection, *Max Ernst: Dada and the Dawn of Surrealism*, cat. by William A. Camfield et al. (also shown at New York, Museum of Modern Art; Art Institute of Chicago), 1993, no. 182, pl. 169; exh. cat. New York, Metropolitan Museum of Art, *Painters in Paris, 1895–1950*, 2000, pp. 123, 98, ill.; exh. cat. New York, Metropolitan Museum of Art, *Max Ernst: A Retrospective*, cat. ed. by Werner Spies and Sabine Rewald, 2005; exh. cat. New York, Metropolitan Museum of Art, *Abstract Expressionism and Other Modern Works: The Muriel Kallis Steinberg Newman Collection in The Metropolitan Museum of Art*, cat. ed. by Gary Tinterow et al., 2007–8, no. 5, ill.; "Echinoidea," *A Dictionary of Zoology*, ed. Michael Allaby (Oxford, 1999), *Oxford Reference Online* (accessed April 4, 2008); "Siphonaptera," *A Dictionary of Zoology*, ed. Michael Allaby (Oxford, 1999), *Oxford Reference Online* (accessed April 4, 2008).

Foujita (or Fujita Tsuguharu)
(Japanese, 1886–1968)
Self-Portrait with Cat
1928
Pen, ink, and wash on paper
33 x 24 cm
William Kelly Simpson, New York

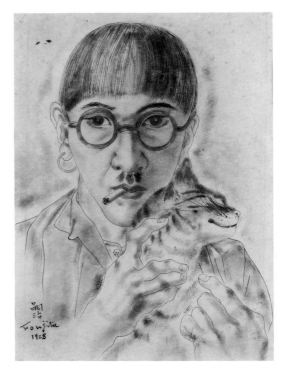

Tsuguharu Fujita (1886–1968), better known as Foujita, entered the Parisian art world in 1913. The son of a Japanese medical officer, Foujita had studied at the Tokyo College of Fine Arts in 1905. Shortly after his arrival in Paris—where he settled in Montparnasse, like so many others—he met Pablo Picasso (cats. 38–40), and his Parisian friends would also include Amedeo Modigliani (cats. 32, 33), Chaim Soutine (cat. 44), and the singer Damia (cats. 2, 6d, 7), who apparently frequented his Sunday soirées (Selz 1981, p. 73). Although he toyed briefly with Cubism, Foujita developed his own distinctive style. Merging elements of Japanese and French art, he concocted a formula for white paint, consisting of powdered seashell, gum, and eggwhite, over which he drew with Sumi ink using a fine brush. His dedication to line, as scholars have noted, was also no doubt inspired by Japanese art (Selz 1981, pp. 8, 91). His indebtedness to Western art is evident in his often naturalistic—if quite stylized—portrayals of people, cats, and objects.

A wild dresser and an imaginative self-promoter, Foujita at times wore the robes of a Japanese courtesan, a mauve coat, a suit made of floral curtains, or Greek-inspired creations, many of which he sewed himself. Despite his frequent appearances in bizarre and attention-drawing paraphernalia, certain characteristics—his round-rimmed glasses, small mustache, earrings, and bowl-like, banged hairstyle, which he first assumed in 1915—came to define him so strongly that his varied costumes did not detract from the essential "brand" that Foujita created. It was this branded image of himself, rather than one of the exotically attired versions, that Foujita portrayed endlessly, in countless portraits and varied media, throughout his career.

It is not as anachronistic as it might seem to speak of Foujita as branding himself. He was extremely savvy about self-promotion, announcing, "Those who think I became famous because of my kappa hairstyle and my earrings should compare me to the automobile company Citroën, which spent a fortune to advertise on the Eiffel Tower with the biggest electrical device in the world. Can't you say that my way gives me clever publicity for free? Really, publicity is important. There's nothing that beats the combination of ability and publicity" (quoted in Birnbaum 2006, p. 128). Foujita's branding was a huge success, as his appearance in countless caricatures, advertisements, and even in the form of mannequins dressed and sculpted to represent him all attest (see Silver essay, ills. 24, 36, 37).

Despite his many stunts, the identity he molded and presented was remarkably consistent. In this drawing, Foujita demonstrates his skill as a draftsman, his features carefully delineated and the whole subtly modeled with wash, giving the appearance of light flickering over his stylized fingers. He holds a cat, one of his signature motifs, whose striped fur seems to blend seamlessly into the artist's shirt. The cat turns away from the viewer, but the artist gazes outward.

Foujita gave this drawing to his friend Jules Pascin (cats. 35, 36), who in turn gave it to his model and lover, Lucy Krohg.

Selected bibliography: Jean Selz, *Foujita*, trans. Shirley Jennings (New York, 1981); Christie's, London, *Impressionist and 20th Century Works on Paper*, February 8, 2001, lot 432, ill.; exh. cat. Valencia, Centro Cultural Bancaja, *Foujita: Entre Oriente y Occidente/Between East and West* (also shown at Museu Diocesà de Barcelona), 2005, pp. 242–56; Phyllis Birnbaum, *Glory in a Line: A Life of Foujita; The Artist Caught between East and West* (New York, 2006), pp. 19, 30, 66, 69, 78.

Foujita (or Fujita Tsuguharu)
(Japanese, 1886–1968)
Self-Portrait
c. late 1930s
Color woodblock print
33.2 x 24.8 cm
Los Angeles County Museum of Art,
Gift of Chuck Bowdlear, Ph.D.,
and John Borozan, M.A.
(M.2000.105.158)

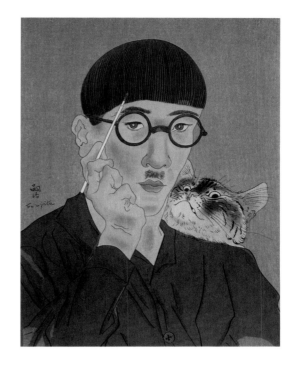

As noted in catalogue number 15, Foujita (1886–1968) portrayed himself repeatedly over the course of a long career. The similarities between Foujita's two self-portraits, presented in this exhibition, are striking, although their media are different: *Self-Portrait with Cat* (cat. 15) is a drawing in pen and ink with wash, whereas the present work is a color woodblock print. Foujita's life and artistic style reflect his desire to absorb elements of both Europe and Japan, and his interest in the color woodblock probably derived from its traditional role in Japanese art. Here, the image Foujita presents of himself is extremely close to that in his drawing. His rigid, banged haircut, round glasses, collared shirt, and short mustache remain the same. Instead of a cigarette emerging from his mouth, he holds what appears to be a thin paintbrush. Here too is a cat, gazing upward at Foujita from behind. Both this print and the drawing relate closely to other works by Foujita; the respective poses of the cat in each work appear in many of Foujita's other self-portraits. Despite the large blocks of color—the nature of the woodblock medium—Foujita still conveys subtle shading on his skin and around the wrinkles in his shirt. This print has been dated to the late 1930s, about a decade after the previous work, yet Foujita's appearance and demeanor remain remarkably unchanged.

Selected bibliography: Sylvie Buisson and Dominique Buisson, *La Vie et l'oeuvre de Léonard-Tsuguharu Foujita*, 2 vols. (Paris, 1987–2001).

Pablo Gargallo
(Spanish, 1881–1934)
Kiki de Montparnasse
1928
Polished bronze
20.2 x 16.8 x 13.1 cm
Hirshhorn Museum and Sculpture
Garden, Smithsonian Institution,
Washington, D.C., Gift of Joseph H.
Hirshhorn, 1966 (66.1989)

One of the many foreigners associated with the School of Paris, the Spaniard Pablo Gargallo (1881–1934) was born in Saragossa and subsequently lived in Barcelona, where he worked as an apprentice for the sculptor Eusebio Arnau y Mascort (1864–1933) and later entered the Ecole des Beaux-Arts "La Lonja." He also spent time at Barcelona's avant-garde café Els Quatres Gats, along with Pablo Picasso (cats. 38–40), among others, before arriving in Paris on a scholarship in 1903. Returning to Paris for varying lengths of time over the next two decades, he did not settle there permanently until 1924. His friends included Juan Gris (cat. 19), Max Jacob (cat. 19), and Amedeo Modigliani (cats. 32, 33).

In Barcelona Gargallo had learned the techniques of decorative art. He began working with sheet metal about 1911, which enabled him to develop a distinctive style. He created a number of masks, both portraits and types, in which what is absent seems to add to, rather than detract from, the image he presents. Relying increasingly on concave forms, Gargallo also included cardboard templates in his process, beginning about 1925. Although *Kiki de Montparnasse* was made from a plaster model and cast in bronze, rather than composed of individual sheets of metal, its aesthetic is clearly informed by his work with sheet metal, and as Rafael Ordóñez Fernández has suggested, Gargallo was evidently experimenting with a new medium for this kind of sculpture (in exh. cat. Valencia 2004, p. 31).

In contrast to some abstracting modernist works, the economy and asymmetry of Gargallo's *Kiki* are striking in that they do not compromise her recognizability. Ordóñez Fernández and Alejandro J. Ratia have both noted the automatic tendency of the viewer to supply the missing parts—an eye as well as the other half of her nose and lips (ibid., pp. 31, 47). Yet the satisfaction in viewing *Kiki de Montparnasse* derives not from mentally filling in what is missing, but from noting the recesses and voids and still seeing a woman's face. Clearly part of Gargallo's skill at retaining Kiki's identity stems from his selection of distinctive traits, such as her short, banged haircut and her pronounced nose. Gargallo's distillation and stylized presentation of these features bears some resemblance, as Ratia has pointed out, to the practices of caricaturists (ibid., p. 47).

Kiki did not sit for Gargallo, but she was hard to miss in the Montparnasse artists' quarter of Paris. An impoverished and illegitimate child from a town in Burgundy, Kiki was born Alice Ernestine Prin (1901–1954) and moved to Paris to join her mother when she was thirteen. Finding her niche among the bohemians in Montparnasse, she painted a bit, even holding several exhibitions of her work; modeled for many artists, including Moïse Kisling (1891–1953), Man Ray (1890–1976), and Foujita (cats. 15, 16); appeared in avant-garde films, famously sporting eyes painted on her eyelids in Man Ray's *Emak Bakia* (1926); and published her memoirs at the youthful age of twenty-eight. Accounts of Kiki often describe her radiance, and Gargallo's mask conveys this quality in slick, sharply delineated forms and a brilliant surface.

Selected bibliography: Pierre Courthion, *Pablo Gargallo*, with a catalogue raisonné by Pierrette Anguera-Gargallo (Paris, 1973), p. 177, no. 113, ill.; Billy Klüver and Julie Martin, *Kiki's Paris: Artists and Lovers, 1900–1930* (New York, 1989); Pierrette Gargallo-Anguera, *Pablo Gargallo, catalogue raisonné* (Paris, 1998), no. 158, ill., p. 13; exh. cat. Monnaie de Paris, *Pablo Gargallo*, 2001, p. 51; exh. cat. Institut Valencia d'Art Modern, *Pablo Gargallo*, cat. by Rafael Ordóñez Fernández et al. (also shown at Biarritz, Centre Le Bellevue, Salles Les Rhunes et Les Vagues), 2004.

Albert Gleizes
(French, 1881–1953)
Man on a Balcony
(Portrait of Doctor Morinaud)
1912
Oil on canvas
195.6 x 114.9 cm
Philadelphia Museum of Art:
The Louise and Walter Arensberg
Collection, 1950

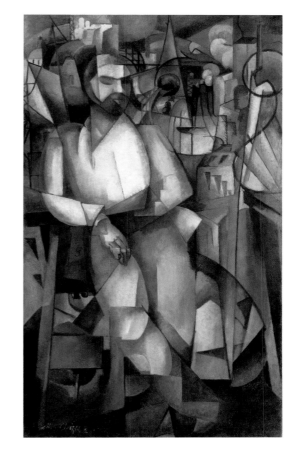

Despite his lack of formal art training, Albert Gleizes's (1881–1953) decision to pursue painting is not surprising in the context of his family. His father oversaw an industrial design workshop and painted in his spare time, and two of Gleizes's uncles were painters: Léon Comerre (1850–1916), winner of the Grand Rome Prize in 1875, and Honoré Gleizes. Gleizes took drawing courses in school and apprenticed in his father's studio, where he designed fabrics. He began studying theater in about 1899, but by 1901 he was focused on painting. In 1905 Gleizes helped found the Ernest-Renan Association, the first of several socially conscious organizations in which he was involved. The following year, he and several friends established a fraternal order whose members bought a printing press, rented land in the Parisian suburb of Créteil, and hoped to support themselves through their printing while simultaneously each dedicating himself to his art. Financial troubles put an end to the experiment in 1908. In 1910 Gleizes met Robert Delaunay (cat. 9) and Jean Metzinger (cats. 9, 31), and the three, along with Fernand Léger (1881–1955) and Henri Le Fauconnier (1881–1946), began to meet regularly. When these artists exhibited together in the Salon des Indépendants of 1911, their works created a great stir, and later that year they became friendly with the Duchamp brothers (cats. 12, 13, 46, 47), whose studios in Puteaux they frequented.

The year in which Gleizes produced this work, 1912, was momentous: Gleizes and his fellow Puteaux artists mounted the Section d'Or exhibition, and Gleizes and Metzinger published their treatise *Du cubisme*. Although Gleizes was at the center of one of the two groups of artists then espousing new and related ideas, the dominant art historical narrative of this period—originally propagated in large part by the German art dealer Daniel-Henry Kahnweiler (1884–1979)—has favored the other group of artists, primarily Georges Braque (1882–1963), Juan Gris (cat. 19), and Pablo Picasso (cats. 38–40). The group of artists with which Gleizes was associated generally exhibited their work through the Salons, whereas the other group showed paintings in Parisian galleries. In addition, while Gleizes and his cohorts continued to depict a variety of traditional painting subjects, the artists around Picasso largely painted still lifes and portraits, and cared more about formal innovation than subject matter (Briend in exh. cat. Lisbon 2002–3, pp. 53–55).

After its exhibition at the Salon d'Automne of 1912, Gleizes exhibited the present work in New York's controversial Armory Show in 1913. The present identification of the sitter as Doctor Morinaud stems from a series of letters in the curatorial files of the Philadelphia Museum of Art. A letter of May 30, 1954, from Marcel Duchamp asserts that the sitter is not Jacques Nayral, as had earlier been suggested, and recommends contacting Doctor Henri Barzun, who knew Gleizes about 1912; Barzun's letter of June 14, 1954, says he always believed it to be a self-portrait "on the basis of its likeness with Gleizes," but he provided the address of Madame Juliette Roche Gleizes (Gleizes's widow), whose letter of June 26, 1954, says it is a picture of "doctor Morinaud." Daniel Robbins wrote in 1964 that it depicts Morinaud, likely in his office on the avenue de l'Opéra, and indicates that this is probably the second portrait Gleizes made of the doctor—the first being *Church at Créteil* (1908; ill. in Varichon 1998, no. 235). The catalogue raisonné of Gleizes's work notes that the artist had a childhood friend named Théo Morineau but states that no further information about a Doctor Morinaud can be found (ibid., p. 143). Théo Morineau, a dentist whom Gleizes had known at Courbevoie, served with the artist in World War I (Brooke 2001, p. 45). The exhibition of Gleizes's work in Barcelona and Lyon in 2001 also

speculated that it may be a portrait of Théo Morineau (exh. cat. Barcelona 2001, p. 46), and a catalogue of works from the collection of the Philadelphia Museum of Art that traveled to Kyoto and Tokyo in 2007 modifies the identification slightly: it concludes that the sitter is Doctor Théo Morinaud, a Parisian dental surgeon, and it confirms the painting's setting as the view from the balcony of Morinaud's office, on the street named by Robbins (exh. cat. Kyoto 2007, p. 126). Thus, further work remains to be done to identify the figure securely and to glean more historical information about him, whoever he may be.

By contrast to the enigma of the sitter, the composition is clear, or, as the painting's first owner, Arthur Jerome Eddy, put it, "There is no mystery about the 'Man on the Balcony.' He is quite in evidence; the background is a little puzzling, yet fairly obvious" (Eddy 1914, p. 70). In the painting, a man leans casually against the railing of an outdoor balcony, crossing his legs; behind him extends an urban vista, complete with buildings, smokestacks, and a bridge. As Gleizes wrote in 1912–13, he was extremely interested in depicting people and scenes simultaneously from multiple points of view (Varichon 1998, p. 140). A study for the present work (ill. in ibid., no. 391), with its less fragmented figure and clearer depiction of the balcony, suggests that Gleizes began with a more traditional representation, which he gradually broke down into Cubist planes. Indeed, he wrote that in Cubist paintings, a lessening of detail was sometimes necessary: "That which belongs particularly to Cubism is that special desire to maintain true values even though this means sacrificing certain elements of descriptiveness" (quoted in exh. cat. Chicago 1964, p. 24).

As noted above, Gleizes had a strong social conscience that manifested itself throughout his career: the early Créteil experiment; his involvement with the later utopian community Moly-Sabata, at Sablons in 1927; his creation of pochoir copies of his paintings so that they could be available to a wider public; and his strong belief in abstraction, which he pursued later in his career, as a social art. As scholars have observed, the large size of this painting suggests Gleizes's intention to show it in Parisian exhibitions, through which he hoped to engage a broad public with the principles of Cubism (Temkin, Rosenberg, and Taylor 2000, p. 33; exh. cat. Kyoto 2007, p. 126). In addition, Peter Brooke has noted that Gleizes wrote that the common man—with less education and intellectual sophistication—had an easier time appreciating his paintings than more culturally aware viewers (Brooke 2001, p. 45); this, no doubt, gratified the idealistic, egalitarian artist.

The connections among the artists and sitters in this exhibition are myriad, but Gleizes seems to have had especially wide-ranging acquaintances: in 1913 the writer Ricciotto Canudo (cat. 38) introduced Gleizes to his future wife, Juliette Roche, who would bring together Gleizes and her childhood friend Jean Cocteau (cat. 33), who just happened to be the godchild of Gleizes's father. In addition, Paul Colin (cats. 6, 7) served with Gleizes during World War I, and many years later, in 1931, Gleizes joined Auguste Herbin's (cat. 21) Abstraction-Création movement.

Selected bibliography: Arthur Jerome Eddy, *Cubists and Post-Impressionism* (Chicago, 1914), pp. 70–71; Willard Huntington Wright, *Modern Painting: Its Tendency and Meaning* (New York, 1915), p. 257; Ozenfant and Jeanneret, *La Peinture moderne* (Paris, n.d.), n.p., ill. (as *Portrait de Jacques Nayral*); Daniel Robbins, "From Symbolism to Cubism: The Abbaye of Créteil," *Art Journal* 23, no. 2 (Winter 1963–64), pp. 111–16; exh. cat. New York, Solomon R. Guggenheim Museum, *Albert Gleizes, 1881–1953: A Retrospective Exhibition*, cat. by Daniel Robbins, 1964, pp. 11, 26, no. 32, ill.; exh. cat. Chicago, International Galleries, *Metzinger: Pre-Cubist and Cubist Works, 1900–1930*, 1964, p. 24; Pierre Alibert, *Albert Gleizes: naissance et avenir du cubisme* (Paris, 1982), pp. 86, 88, 81, ill. (detail), 87, ill.; Robert L. Herbert, Eleanor S. Apter, and Elise K. Kenney, eds., *The Société Anonyme and the Dreier Bequest at Yale University: A Catalogue Raisonné* (New Haven, 1984), p. 301; John Golding, *Cubism: A History and an Analysis, 1907–1914*, 3rd ed. (Cambridge, Massachusetts, 1988), p. 171, pl. 84; *Paintings from Europe and the Americas in the Philadelphia Museum of Art: A Concise Catalogue* (Philadelphia, 1994), p. 361, ill.; Anne Varichon, ed., *Albert Gleizes, catalogue raisonné*, 2 vols. (Paris, 1998), vol. 1, no. 392, ill., vol. 2, p. 812; Ann Temkin, Susan Rosenberg, and Michael Taylor, *Twentieth Century Painting and Sculpture in the Philadelphia Museum of Art* (Phildelphia, 2000), p. 33, ill.; exh. cat. Barcelona, Museu Picasso, *Albert Gleizes: le cubisme en majesté*, cat. by Christian Briend (also shown at Lyon, Musée des Beaux-Arts), 2001, p. 46, no. 34, ill.; Peter Brooke, *Albert Gleizes: For and Against the Twentieth Century* (New Haven, 2001), pp. 20, 36, 45, pl. 19; exh. cat. Lisbon, Fundação Centro Cultural de Belém, *Albert Gleizes: Cubism in Majesty*, cat. by Christian Briend, 2002–3, pp. 13–27, 53–55, 67–68, fig. 15; Jennifer R. Gross, ed., *The Société Anonyme: Modernism for America* (New Haven, 2006), p. 174; exh. cat. Kyoto Municipal Museum of Art, *Masterpieces from the Philadelphia Museum of Art: Impressionism and Modern Art* (also shown at Tokyo Metropolitan Art Museum), 2007, no. 38, ill.

Juan Gris
(Spanish, 1887–1927)
Portrait of Max Jacob
1919
Pencil on paper
36.5 x 26.7 cm
The Museum of Modern Art,
New York. Gift of James Thrall Soby,
1958, 84.1958

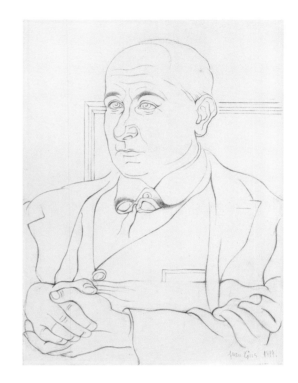

The name of Juan Gris (1887–1927) is not usually associated with strictly representational art, let alone traditional portraiture. Yet he produced this drawing, and others in a similar style, in the period following World War I. Such works were part of the so-called Ingres revival, initiated by Pablo Picasso (cats. 38–40), which spread among the Parisian avant-garde. It is particularly interesting that Gris followed Picasso in this, since he wrote to the art dealer Daniel-Henry Kahnweiler (1884–1979) in a letter of September 3, 1919—the same year that Gris drew this portrait—"Picasso produces fine things still when he has the time between a Russian ballet and a society portrait" (Cooper 1956, p. 67). As Kenneth E. Silver has noted elsewhere, Gris was critical of Picasso's stylistic and lifestyle changes when he made this comment (Silver 1989, p. 144). Moreover, he also internalized the view, held by so many in France at that time, of the importance of valuing history and the art of the past; in addition, it was particularly important to many foreign artists, such as Picasso and Gris, to reaffirm their French patriotism, and nothing could serve as a more potent symbol of that than the style and values of the French master Jean-Auguste-Dominique Ingres (1780–1867) (Silver 1989, pp. 251, 144–45).

A Spaniard, Gris was born José Victoriano Gonzales in Madrid to a middle-class family. He studied with an academic artist and trained further at the School of Art and Industry—simultaneously earning much-needed money by sending his drawings to humor publications—before leaving Spain for France in 1906. Once in Paris, Gris produced illustrations for satirical French magazines, while painting at the same time. He settled in the fertile environment of Montmartre, where his studio in the famous Bateau-Lavoir was next to that of Picasso. The two became friends—if competitors at times—and Picasso introduced Gris to Max Jacob (1876–1944), who lived on the same street as the Bateau-Lavoir. Picasso also drew at least two portraits of Jacob, one of which inaugurated the Ingres revival in the fall of 1914.

A critic, poet, novelist, occasional artist, and friend of numerous members of the avant-garde, Max Jacob was born in Quimper to a Jewish family. Two visions, which he reported to his friends, convinced him to convert to Catholicism, which he did in 1915, with Picasso standing as his godfather. Several of Gris's letters display his condescending attitude toward Jacob's conversion, including one, probably from late May 1915, in which he wrote that Jacob "gets sillier every day since his conversion" (Cooper 1956, p. 29). Jacob eventually moved to a monastery, but this did not prevent his deportation by the Nazis and his death in a concentration camp at Drancy.

Jacob and Gris collaborated on the publication *Ne Coupez pas, Mademoiselle ou Les Erreurs des P.T.T.* (1921), which was written by Jacob and illustrated with four lithographs by Gris.

Selected bibliography: Douglas Cooper, ed. and trans., *Letters of Juan Gris (1913–1927)* (London, 1956); exh. cat. New York, Museum of Modern Art, *Juan Gris*, cat. by James Thrall Soby (also shown at Minneapolis Institute of Arts; San Francisco Museum of Art; Los Angeles County Museum), 1958, pp. 87, 96, ill.; Douglas Cooper, "The Temperament of Juan Gris," *Metropolitan Museum of Art Bulletin*, n.s., 29, no. 8 (April 1971), pp. 358–62; exh. cat. New York, Museum of Modern Art, *Seurat to Matisse: Drawing in France; Selections from the Collection of the Museum of Modern Art*, cat. ed. by William S. Lieberman, 1974, no. 69, p. 62, ill.; exh. cat. Buffalo, N.Y., Albright-Knox Art Gallery, *The School of Paris: Drawing in France* (also shown at Saint Louis Art Museum; Seattle Art Museum), 1977, p. 62, ill.; Kenneth E. Silver, *Esprit de Corps: The Art of the Parisian Avant-Garde and the First World War, 1914–1925* (Princeton, N.J., 1989).

Hermann Haller
(Swiss, 1880–1950)
Head of Marie Laurencin
c. 1920
Terra cotta
25.4 x 16.5 x 17.8 cm
Collection Albright-Knox Art Gallery,
Buffalo, New York, Bequest of A.
Conger Goodyear, 1964, 1966:9.27

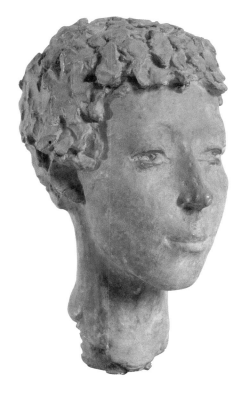

As is evident from the range of origins of the artists and sitters in this exhibition, Paris in the early twentieth century lured artists from across Europe and beyond. The Swiss sculptor Hermann Haller (1880–1950) had studied painting and architecture in Germany and had traveled in 1901 with his childhood friend Paul Klee (1879–1940) to Rome—where the former began to sculpt—before settling in Paris in 1907; he remained there until 1914.

Haller probably knew Marie Laurencin (1883–1956) while he was in Paris, since he was the brother-in-law of Otto van Wätjen, whom Laurencin met in 1913 and married the following year. Haller sculpted two portraits in terra cotta of Laurencin during or following her visit to Zurich in 1919. The present work was presumably Haller's second effort, since "II" is inscribed on the back of the neck; his first portrait of her, which is quite similar, is in the collection of the Atelier Hermann Haller in Zurich.

As in other portraits of Laurencin—both her self-portraits and likenesses by André Salmon (1881–1969), Roger de La Fresnaye (1885–1925), and Moïse Kisling (1891–1953) (ill. in exh. cat. Martigny 1993–94, pp. 188, 192, 194, respectively)—Haller emphasizes her curly hair, which here appears as a stylized mosaic of tufts reminiscent of classical sculpture. In its tranquility and composure, this portrait resembles Laurencin's self-portrait of many years earlier in this exhibition (cat. 22).

Although Haller is a little-known figure today, he was lauded during his lifetime. A brief feature in *International Studio* of July 1924 discussed a contemporary outcry against transposing works from clay into marble—when sculptors hired assistants to cut the stone—and warmly praised Haller for his willingness to make his final products in terra cotta. Moreover, the article noted his facility at modeling and the seeming lightness of his works—an element also noted in an article in *Cahiers d'art* of 1928—calling him a "master" of his media.

Selected bibliography: "Haller—Modeler Extraordinary," *International Studio* 79, no. 326 (July 1924), p. 277; Willi Grohmann, "Enquête sur la sculpture moderne en Allemagne et en France," *Cahiers d'art* 3, no. 9 (1928), pp. 371–72, unpaginated ill.; Giovanni Scheiwiller, *Hermann Haller* (Milan, 1931), p. 15, unpaginated ill.; Pierre du Colombier, *Hermann Haller* (Paris, 1933), pp. 5–13; Bernard S. Myers, ed., *McGraw-Hill Dictionary of Art* (New York, 1969), vol. 3, p. 49; exh. cat. Birmingham (Alabama) Museum of Art, *Marie Laurencin: Artist and Muse*, cat. by Douglas K. S. Hyland and Heather McPherson (also shown at Memphis, Dixon Gallery and Gardens), 1989, pp. 82–85; Philippe Comte, *Paul Klee* (Woodstock, N.Y., 1991), pp. 6–7; exh. cat. Martigny, Switzerland, Fondation Pierre Gianadda, *Marie Laurencin: cent œuvres des collections du Musée Marie Laurencin au Japon*, cat. by Daniel Marchesseau, 1993–94, pp. 185–99; "Haller, Hermann," *Grove Art Online* (accessed March 10, 2008).

Auguste Herbin
(French, 1882–1960)
Portrait of a Man
c. 1909
Oil on canvas
54.6 x 46 cm
William Kelly Simpson, New York

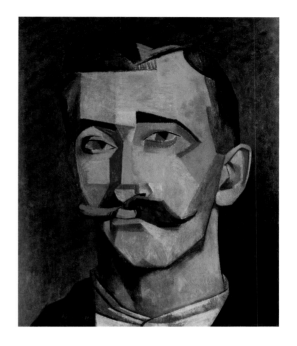

Auguste Herbin (1882–1960), who was born in Quiévy, began studying at the Ecole des Beaux-Arts in Lille in 1899 and two years later arrived in Paris, where he settled in Montparnasse. His early work in the Fauvist vein may explain the ebullient colors that he continued to use when working in a more geometrically structured idiom. In 1909 Herbin was living in the Bateau-Lavoir in Montmarte along with Pablo Picasso (cats. 38–40), Georges Braque (1882–1963), Juan Gris (cat. 19), and other artists. This painting is dated 1909, although the suave handling of Cubism evinced here suggests that it may have been painted a few years later—perhaps closer to 1912, the year Herbin showed works with the Cubists at the Section d'Or. In later years, Herbin worked mostly in an abstract mode.

Such brightly colored planes as appear here are somewhat unusual in Cubist works, but Herbin's vividly warm colors that define the surfaces of his sitter's face heighten the intensity of this intimate, closely cropped portrait. Unlike the lineally defined regions and color changes across the sitter's melancholy face, the background presents smoothly changing hues. The influence of the portraiture of Paul Cézanne (1839–1906) can be seen in the planes defining the sitter's features.

Selected bibliography: exh. cat. San Francisco, Montgomery Gallery, *European Modernists, 1910–1940*, cat. by Ellen M. Storck, 1990, p. 2; exh. cat. Madrid, Guillermo de Osma Galería, *Ismos: arte de vanguardia (1910–1939) en Europa*, 2000, p. 69; Ludwigshafen am Rhein, Wilhelm-Hack-Museum, *Auguste Herbin: der Pionier der geometrischen Abstraktion in Frankreich/le pionnier de l'art non figuratif en France*, cat. by Richard W. Gassen et al., 1997, pp. 127–35; Geneviève Claisse, *Herbin: catalogue raisonné de l'oeuvre peint* (Paris, 1993), no. 192, ill.; Paris, Galerie Resche, *Herbin*, 1989.

Marie Laurencin
(French, 1883–1956)
Self-Portrait
1906
Colored pencil and
pencil on notebook paper
19.8 x 12.5 cm
The Museum of Modern Art,
New York. Gift of Steven C.
Rockefeller, 1970, 591.1970

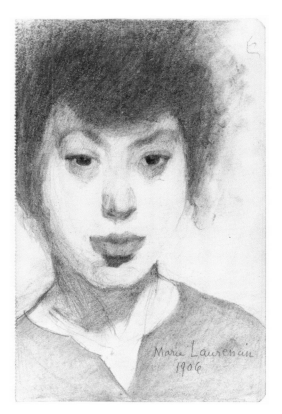

When Marie Laurencin (1883–1956) drew this self-portrait in 1906, she had completed her official artistic education, first at the Sèvres factory, where she studied porcelain painting, and at a city-operated school with the floral painter Madeleine Lemaire, and subsequently at the Académie Humbert, where she met the painter Georges Braque (1882–1963). Laurencin executed this drawing the year before Braque introduced her to Pablo Picasso (cats. 38–40), which places it before the latter arranged for her momentous encounter with the poet Guillaume Apollinaire (cat. 25). The intense and somewhat tumultuous affair between Apollinaire and Laurencin lasted for about six years from the time they met in 1907 and left its mark on the work of each; it significantly affected Laurencin's critical reputation.

Her inclusion, at times, in the Cubist group—with whom she exhibited on several occasions—has often been attributed purely to her relationship with Apollinaire and friendship with artists working in avant-garde styles. Indeed, the style she subsequently made her own shows few affinities with Cubism. Apollinaire, in his role as an art critic, described her pastel, curvilinear, flowing, and highly stylized forms as distinctly feminine, and this characterization has also been taken up by art historians. Thus, this portrait offers a particularly fascinating glimpse at Laurencin as an artist before she established the social connections that would help her develop her own style.

Laurencin said that she had learned to draw at the Académie Humbert (Gere 1977, p. 14), and indeed, this is an impressive drawing. Providing an intimate view of the artist, it shows her pressed against the picture plane, seemingly in the viewer's space. She has placed herself just left of center on the paper, and the image is cropped close to her head on all sides; the sheet's left and upper edges halt the frizzy wisps of dark hair. She faces directly outward, and no shadows obscure her face; thus, she appears particularly vulnerable to close scrutiny. A deep shadow beneath her lower lip underscores the prominence of that feature, and her dark eyes seem to just miss the viewer's glance. It is a restrained and rigorous drawing, in which her use of color—such an important element of her later work—is elegant. Red highlights deepen the cavities of her eyes, outline her hairline and chin, and seem to moisten her lips. Blue lines add to the cool, melancholy aura of the sitter.

Laurencin completed numerous self-portraits around this time, including two that are closely related to the present work: another drawing from the same year (also Museum of Modern Art, New York) and a painting from two years earlier (Musée de Grenoble), yet each has a somewhat different expression. As for many artists, mastering her self-portrait seems to have been an important first step before turning her gaze outward on those around her—as she so famously did in her group (and self-) portraits (Silver essay, ill. 31).

Selected bibliography: exh. cat. New York, Museum of Modern Art, *Seurat to Matisse: Drawing in France; Selections from the Collection of the Museum of Modern Art*, cat. ed. William S. Lieberman, 1974, no. 85, p. 38, ill.; exh. cat. Buffalo, N.Y., Albright-Knox Art Gallery, *The School of Paris: Drawing in France* (also shown at Saint Louis Art Museum; Seattle Art Museum), 1977, p. 38, ill.; Charlotte Gere, *Marie Laurencin* (New York, 1977); Renee Sandell, "Marie Laurencin: Cubist Muse or More?" *Women's Art Journal* 1, no. 1 (Spring–Summer 1980), pp. 23–27; exh. cat. Birmingham (Alabama) Museum of Art, *Marie Laurencin: Artist and Muse*, cat. by Douglas K. S. Hyland and Heather McPherson (also shown at Memphis, Dixon Gallery and Gardens), 1989; exh. cat. Martigny, Switzerland, Fondation Pierre Gianadda, *Marie Laurencin: cent oeuvres des collections du musée Marie Laurencin au Japon*, cat. by Daniel Marchesseau, 1993, pp. 185–98.

Jacques Lipchitz
(American, born Lithuania, 1891–1973)
Gertrude Stein
Original model 1920; cast before 1948
Bronze
34.1 x 21 x 27 cm
The Baltimore Museum of Art:
The Cone Collection, formed by
Dr. Claribel Cone and Miss Etta Cone
of Baltimore, Maryland
(BMA.1950.396)

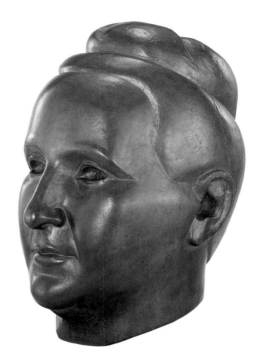

In the friendship of Jacques Lipchitz (1891–1973) and Gertrude Stein (1874–1946), each carefully considered the other, and their observations yielded sculptural and literary fruit. Lipchitz produced three sculpted portraits of Stein—the first in 1920 and the others in 1938. Stein composed a literary portrait of Lipchitz published in 1934, and in *The Autobiography of Alice B. Toklas* (1933), she described the circumstances of her posing for Lipchitz and responded briefly to his portrait. Lipchitz, in turn, wrote in his memoirs of his relationship with Stein, noted her mention of him in *The Autobiography of Alice B. Toklas,* and reacted to her literary portrait of him: "Someone translated it for me, but I did not understand a word of it" (Lipchitz 1972, p. 23). Their relationship, at least to the extent that it is preserved, revolved in large part around their perceptions of the other and, years later, their reactions to how each portrayed the other.

With no formal art background and against his father's wishes but with his mother's financial support, Lipchitz left his birthplace of Lithuania in 1909 to train in Paris. He immediately began his art education at the Ecole des Beaux-Arts, where he entered as a "free pupil" under Jean-Antoine Injalbert (1845–1933), but soon left to study instead at the Académie Julian, where he joined the sculpture class of Charles Raoul Verlet (1857–1923). At the same time, he took evening classes at the Académie Colarossi. Living in Montparnasse, he became friendly with many members of the Parisian avant-garde, including Diego Rivera (cat. 43) who introduced him to Pablo Picasso (cats. 38–40) and other Cubist painters in 1913. Around this time, Lipchitz began experimenting with Cubist sculpture. He probably met Juan Gris (cat. 19) about 1915 or 1916, and they were close friends and influences on each other for several years thereafter. It was Gris who introduced Lipchitz to Stein. Although Lipchitz secured a contract with Léonce Rosenberg in 1916, he broke it in 1920 due to the dealer's insistence that he continue to work in a Cubist style. The same year, Maurice Raynal published the first monograph on Lipchitz. It was in this year—a time of both critical success and financial insecurity—that Lipchitz undertook portraits of three different sitters: Jean Cocteau (cat. 33), his lover Raymond Radiguet (1903–1923), and Gertrude Stein.

Stein, in the voice of Alice B. Toklas, wrote that she and Toklas encountered Lipchitz on the street purchasing an iron cock. She noted that they had known one another in the past, but this meeting ignited a friendship, and Lipchitz soon asked her to pose for him: "She never minds posing, she likes the calm of it and although she does not like sculpture and told Lipschitz so, she began to pose" (Stein 1933/1993, p. 275). She returned the "s" to Lipchitz's name, which had been accidentally omitted by an immigrations official years before (Rubinstein 2007). Indeed, Stein's calm while posing was masterfully captured by Lipchitz. Stein further described the intense heat of Lipchitz's studio and his talents as a gossip, the latter of which entertained her. She noted that she liked the portrait, and one can only imagine that this detail perturbed Lipchitz, since she did not offer to purchase it.

In his memoirs, Lipchitz recounted that he "made her portrait, hoping she would buy it" (Lipchitz 1972, p. 23). The style he chose for his depiction seems to reflect a number of things: the general artistic conservatism after World War I (exh. cat. Saint Louis 2006–7); Lipchitz's movement at this time away from strict Cubism, evidenced in his breaking of the Rosenberg contract; and possibly a desire to make the portrait more saleable (Rubinstein 2007). Equally important, it is in keeping with Lipchitz's stated views about portraiture. He said, "I have never made

an abstract portrait. I have only made abstract heads." He further noted, "My Cubist friends were all making Cubist portraits. I was always against that. I had long discussions about it, especially with my good friend Gris. I felt, and still do, that it is not legitimate, because a portrait is something absolutely different. It has to do with likeness, with psychology, and at the same time it must be a work of art" (quoted in van Bork 1966, pp. 115–16).

Although Lipchitz's sculpture conveys a degree of psychological depth, he has made Stein so monumental that she seems less an individual than an icon. He wrote in his memoirs, "I was particularly impressed by her resemblance to a fat, smooth, imperturbable Buddha, and it was this effect that I tried to get," referring to the sculpture later on as presenting "her as a massive, inscrutable Buddha" (Lipchitz 1972, pp. 23, 63). He also recalled the difficulty he experienced while creating the eyes; he ultimately made them hollow, which captured his idea of her "shadowed introspection" (ibid., p. 63).

Raphael Rubinstein has noted the contrast between Lipchitz's desire for at least some correlation between physical appearance and representation and Stein's disregard for this goal in her writing. Her literary portrait of Lipchitz devotes much time to ideas of "like"—attacking Lipchitz's idea of likeness, Rubinstein suggests (Rubinstein 2007)—as well as looking and knowing. She also refers again a bit obliquely to the beginning of their friendship: the incident with the iron cock, or here, "looking through the glass and the chicken" (Stein 1934, p. 63).

In 1938, when Lipchitz and Stein's paths crossed again, he was astounded at how much she had aged: "She had lost a great deal of weight. She looked now like a shriveled old rabbi, with a little rabbi's cap on her head" (Lipchitz 1972, p. 63). He made two terra cotta sketches, but carried only one to completion. In the finished version (sale Christie's, New York, May 13, 1987, lot 322), Stein appears elderly, wearing a skullcap over her famous cropped haircut—which she sports in Pavel Tchelitchew's portrait (cat. 45)—rather than the younger incarnation with a rigid bun atop her head presented here.

In 1960 Jacques Lipchitz wrote of his artistic evolution, "Little by little I felt the necessity to bring more evident order into what nature showed me and which seemed to me too chaotic" (exh. cat. Washington, D.C., 1960, n.p.). Although he was probably thinking of his Cubist works, this idea of ordering nature and giving logic to its forms calls to mind the serenity and sense of order evoked by the present sculpture: its symmetry, clearly delineated lines, separation of forms, and the way all the pieces fit so elegantly together.

Selected bibliography: Gertrude Stein, "Lipschitz," in *Portraits and Prayers* (New York, 1934), pp. 63–64; exh. cat. Washington, D.C., Corcoran Gallery of Art, *Jacques Lipchitz: A Retrospective Exhibition of Sculpture and Drawings* (also shown at Baltimore Museum of Art), 1960, no. 10; Bert van Bork, *Jacques Lipchitz: The Artist at Work* (New York, 1966); Jacques Lipchitz with H. H. Arnason, *My Life in Sculpture* (New York, 1972); A. M. Hammacher, *Jacques Lipchitz*, trans. James Brockway (New York, 1975); Nicole Barbier, *Lipchitz: oeuvres de Jacques Lipchitz (1891–1973); Catalogue* (Paris, 1978), p. 53, no. 19, ill.; *The Tate Gallery 1982–84: Illustrated Catalogue of Acquisitions* (London, 1986), no. T03479; Gertrude Stein, *The Autobiography of Alice B. Toklas* (New York, 1933/1993), pp. 275–76; Alan G. Wilkinson, with intro. by A. M. Hammacher, *The Sculpture of Jacques Lipchitz: A Catalogue Raisonné*, vol . 1, *The Paris Years, 1910–1940* (New York, 1996), no. 115, ill.; Raphael Rubinstein, "Imperturbable Buddha? Not likely: Why Gertrude Stein didn't like this likeness, or likenesses, for that matter," *Poetry Foundation: Online Journal* (2007); exh. cat. online, Saint Louis, Pulitzer Foundation for the Arts, *Portrait/Homage/Embodiment*, 2006–7.

Louis Marcoussis
(French, 1878–1941)
Portrait d'Edouard Gazanion
1912
Gouache, watercolor, brush,
and india ink on paper
63.5 x 48.9 cm
William Kelly Simpson, New York

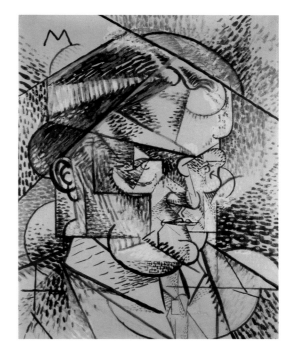

Louis Marcoussis (1878–1941) moved in Cubist circles about 1912, when he produced this portrait. He also, notably, had a number of friends who were writers, and both portraits by Marcoussis exhibited in this exhibition depict poets (see cat. 25). Very little is known about Edouard Gazanian, a poet apparently from Le Valay, a town in the Auvergne in central France. Marcoussis's portrait, drawn at the moment when Cubism was being developed and shown publicly, presents an array of textures and intersecting lines to evoke his subject's face. A sense of energy, expressed through strong lines and shapes, radiates outward from the sitter's face, and touches of blue, gray, white, and red animate the figure. The lines and interlocking planes do not obscure the sitter's individuality; rather, they highlight a sharply defined double chin, deep brow, and pointed, protruding nose. Lines and forms such as those suggesting the sitter's tie are remarkably successful at evoking, through different planes, the objects they represent.

Selected bibliography: Jean Lafranchis, *Marcoussis: sa vie, son oeuvre* (Paris, 1961), no. D.8, ill., pp. 64, 62, ill.; Douglas Cooper, *The Cubist Epoch* (London, 1971), no. 206, pl. 118, p. 132.

Louis Marcoussis
(French, 1878–1941)
Apollinaire, 5th state
c. 1920
Etching, aquatint, drypoint
49.6 x 27.8 cm
William Kelly Simpson, New York

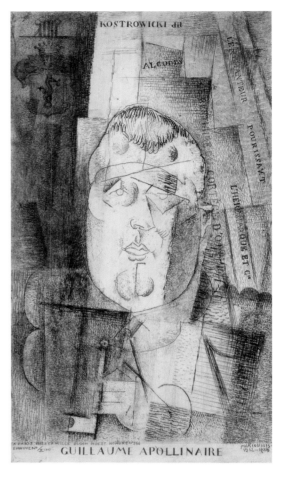

A number of figures in the Parisian avant-garde assumed different names. One of these, the Polish artist Louis Marcoussis (1878–1941), had been born Louis Casimir Ladislas Markus. After an abortive study of the law and training at the Academy of Fine Arts in Krakow, he moved to Paris and entered the Académie Julian in 1903. While working as an illustrator, he befriended the French artist Georges Braque (1882–1963) and the half-Polish poet and art critic Guillaume Apollinaire (1880–1918), who urged Marcoussis to change his name, inspired by the French town in which they met.

Marcoussis's exposure to Cubism, through Apollinaire, Braque, and later Pablo Picasso (cats. 38–40), would critically affect his style. He exhibited with the Cubists at the Salon de la Section d'Or in 1912, the same year that Albert Gleizes (cat. 18) and Jean Metzinger (cats. 9, 31) published their treatise *Du cubisme* and Apollinaire produced *The Beginnings of Cubism*. In this atmosphere of intense exploration and critical examination of Cubist works—by artists themselves and critics—Marcoussis made the portrait of Edouard Gazanian (cat. 24) and the first state of the present print. He subsequently created additional portraits of Apollinaire, as well as numerous versions of this print, of which this is the fifth state.

Apollinaire is presented against a backdrop of overlapping grained planks—possibly the spines of books—bearing the titles of his poetry. Overhead, "Kostrowicki," his mother's surname, appears; it may have been of particular interest to Marcoussis because of their shared ethnicity. Marcoussis's cubistic approach, which Apollinaire classified as "Scientific Cubism" in *Les Peintres cubistes* (1913), does not compromise Apollinaire's recognizability.

Both Apollinaire and Marcoussis served in World War I; Apollinaire was severely wounded—a bandage appears on his head in this print—and later died during the flu epidemic of 1918. This print, then, was finished after his death. In 1933–34 Marcoussis illustrated Apollinaire's *Alcools* with forty prints.

Selected bibliography: exh. cat. San Antonio, Marion Koogler McNay Art Institute, *Louis Marcoussis: An American Premiere*, cat. by Lois W. Burkhalter, 1958; Douglas Cooper, *The Cubist Epoch* (London, 1971), pp. 103, 109, 131–33; exh. cat. London, Tate Gallery, *The Essential Cubism: Braque, Picasso and Friends, 1907–1920*, 1983, p. 434; Solange Millet, *Louis Marcoussis: catalogue raisonné de l'oeuvre gravé* (Copenhagen, 1991), no. 33; Daniel Robbins, *"Marcoussis,"* Grove Art Online (accessed March 31, 2008).

Henri Matisse
(French, 1869–1954)
Lorette in a Red Jacket
(*Lorette à la veste rouge*)
1917
Oil on panel
46.4 x 36.2 cm
Columbus Museum of Art, Ohio:
Gift of Ferdinand Howald, 1931.065

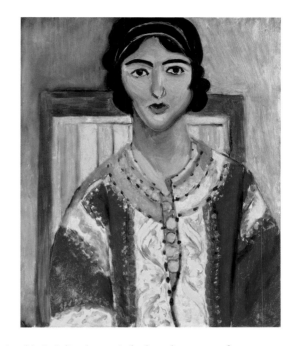

Raised in Bohain-en-Vermandois near Belgium, Henri Matisse (1869–1954) took drawing lessons first in his hometown and later in St.-Quentin. He set off for Paris in 1891 with a letter of introduction to the staunchest of academic painters, William-Adolphe Bouguereau (1825–1905). He promptly enrolled in Bouguereau's course at the Académie Julian but switched teachers soon after, subsequently studying at the Ecole des Beaux-Arts with Gustave Moreau (1826–1898). In evening courses at the Ecole des Arts Décoratifs, Matisse met Albert Marquet (1875–1947) and Henri Manguin (1874–1949), who would become close friends and fellow painters associated with the Fauve movement, which burst on the Parisian scene at the Salon d'Automne of 1905.

By the time Matisse painted this portrait, more than a decade had passed since his art first shocked the Parisian public, and he had spent several years heading the art school he founded. Known today only as Lorette (and sometimes Laurette), the model who posed for this painting first sat for Matisse in November 1916. She modeled for him extensively over much of the next year, almost always in his Paris studio, and appeared in close to fifty paintings but few drawings, wearing many outfits and pictured from different angles; most frequently, she appeared in his canvases viewed directly from the front.

John Klein has observed that in the paintings of Lorette that are most like traditional portraiture in format, Matisse seems tentative. Klein attributes this to the lack of tension between sitter and artist when the sitter is a hired model; since Lorette was not trying to impose her identity on the picture, Matisse was left to explore her on his own (see cat. 27 for further discussion of this aspect of Matisse's images of models) (Klein 2001, p. 225). Perhaps as a manifestation of his control, Matisse often changed the proportions of Lorette's face to suit his decorative goals, and here her jaw appears particularly pointed and her neck especially long. Jack Flam has observed Lorette's apparent discomfort, particularly in the present work, and as one explanation, he suggests that she seems uncomfortable with her role: she sports an exotic jacket yet sits rigidly in a European chair (in exh. cat. West Palm Beach 2006, p. 22).

Here, the sitter wears a brightly colored and elaborately patterned jacket, no doubt taken from Matisse's stock of clothing in which he dressed up his models. The bright reds and yellows of this garment continue in the sunny upholstery and cherry-colored wood frame of the chair on which she sits. The black stitching outlining the jacket's neckline recurs in the smooth, jet black arc of curly hair surrounding the sitter's face and her dark eyes. The only muted colors on the canvas are the softer shades of gray, pale yellow, and green of the background and the sitter's gray-beige flesh. Matisse's concern with decoration is evident in this painting. His treatise "Notes of a Painter" (1908) expressed this facet of painting, and in 1912 he remarked, "I seldom paint portraits, and if I do only in a decorative manner. I can see them in no other way" (quoted in Klein 2001, p. 230).

Selected bibliography: exh. cat. Fort Worth, Kimbell Art Museum, *Henri Matisse: Sculptor/Painter: A Formal Analysis of Selected Works*, cat. by Michael P. Mezzatesta, 1984, no. 34, ill.; exh. cat. Washington, D.C., National Gallery of Art, *Henri Matisse: The Early Years in Nice, 1916–1930*, cat. by Jack Cowart and Dominique Fourcade, 1986–87, no. 15, pl. 13; Hilary Spurling, *The Unknown Matisse: A Life of Henri Matisse; The Early Years, 1869–1908* (New York, 1998); exh. cat. Paris, Institut du Monde Arabe, *Le Maroc de Matisse*, 1999–2000, p. 113, fig. 36; John Klein, *Matisse Portraits* (New Haven, 2001); exh. cat. Osaka, Daimaru Museum Umeda, *Masterpieces of Impressionism and European Modernism from the Columbus Museum of Art* (also shown at Chiba Sogo Museum of Art; Hokkaido Obihiro Museum of Art; Gifu, Museum of Fine Arts; Miyagi Museum of Art), 1993, no. 34, ill.; exh. cat. West Palm Beach, Florida, Norton Museum of Art, *Matisse in Transition: Around Lorette*, cat. by Jack Flam, 2006, no. 14, ill.

Henri Matisse
(French, 1869–1954)
Henriette I (27a)
1925
Bronze
H. 42.5 cm
Private collection

Henriette II (27b)
1927
Bronze
H. 34.3 cm
Private collection

Henriette III (27c)
1929
Bronze
H. 41.3 cm
Private collection

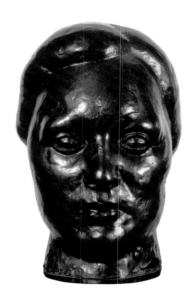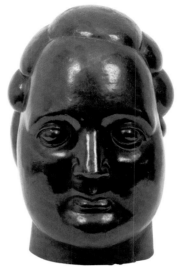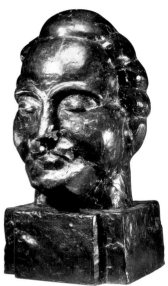

These three bronze heads by Henri Matisse (1869–1954) of his model Henriette Darricarrère (b. 1901) pose certain challenges in the context of an exhibition concerned with portraiture: To what extent are depictions of paid models portraits? These three works offer an excellent example of the artist moving from an individualized presentation of a sitter's features to a general one, raising another question: At what point does the loss of likeness obviate the idea of portraiture?

To address the first question, it is important to consider the circumstances of Henriette's modeling and her relationship with Matisse. Unlike the models who came for several sittings and then moved on, Henriette was Matisse's model for seven years. Matisse had used other models for extended periods, including Lorette (cat. 26), but Henriette would be his longest yet. He spotted her when she was working as a film extra at the Studios de la Victorine in Nice in 1920, and by the spring of 1921 she was posing for him full time, with regular hours and tasks. She worked all day long six days a week in Matisse's studio, modeling—she became the quintessential Matisse orientalized odalisque—as well as cleaning brushes, preparing tea, and performing whatever errands arose. With Henriette, as with all his models, Matisse was careful about providing payment for any time spent modeling.

Despite Henriette's highly professional relationship with Matisse, she also became close with him and his family. She came from a working-class family from the north, and the Matisses stayed friendly with Henriette and her family even after her modeling days were over. Years later Henriette's own daughter modeled for Matisse. The Matisses encouraged Henriette, a ballet dancer, violinist, and pianist, to pursue her talents, and she and Matisse played duets in the evenings and even studied with the same violin teacher for a time. Matisse began giving her painting lessons in 1924, and she exhibited some of her paintings in Nice in 1925 and in Paris the next year. The Matisses included Henriette in family activities—trips to the opera, country drives, and shopping expeditions with Matisse's wife—and Henriette and Matisse's daughter Marguérite were especially friendly. Thus, Matisse's relationship with Henriette by 1925, when he began working on these heads, was particularly warm.

John Klein has argued that, in general, Matisse's depictions of hired models are not portraits; in paying his models, Matisse was shielding himself from any responsibility to preserve their identities (Klein 2001, pp. 11, 243, 236–38). Paid to perform a service, models did not expect artists to present them in a particular manner, and so did not, as Klein has said, "offer the same resistance, the same force of ego," as unpaid or paying sitters (ibid., p. 225). Klein further contends that this liberation from the usual portrait constraints—displaying a sitter's true likeness, personality, aura—enabled Matisse to shape his models' features more freely (ibid., p. 242). Finally, he notes that Matisse almost never titled his images of models to reflect a portrait status (ibid., p. 243).

Might the present works be portraits? The first head is a reasonably straightforward, traditional representation. A photograph of Henriette from 1921 (reproduced in Hahnloser 1988, p. 70) displays Henriette's long nose and large eyes, which Matisse has captured in *Henriette I* (1925). The expression is serious and composed. It seems fair to argue, as Heather MacDonald and others have done, in favor of

the portrait status of the first head (exh. cat. Dallas 2007–8, p. 208). Unlike Matisse's paintings of Henriette, no decorative or compositional components challenge the viewer's focus on this face. Yet the next two heads pose different problems, beyond the question of the model, that make portrait interpretation more difficult.

Albert E. Elsen, who notably uses the word "portrait" with respect to these works, has written that Matisse's interest in the mid-1920s in monumentality and his classicizing inclinations led to depictions entirely lacking in psychological depth (Elsen 1972, p. 161)—often such an important aspect of a portrait. Particularly in *Henriette II*, Elsen has noted the lack of expression (ibid., p. 166). Indeed, it seems that Matisse took increasing liberties with the form of the initial work in his two subsequent explorations. In *Henriette II* (1927), which Matisse called *Large Head*, he has thoroughly smoothed the surface, stylizing Henriette's features and rounding out her cheeks so that the face loses much of the individuality and specificity of the first iteration. The more naturalistic presentation of hair in the first head yields to neatly arranged volumes. Various scholars have suggested that Matisse was influenced by the style of Jacques Lipchitz, and comparison with Lipchitz's *Gertrude Stein* (cat. 23) certainly supports this claim (ibid., p. 170; exh. cat. Dallas 2007–8, pp. 24, 208).

By the time Matisse began work on *Henriette III* (1929), which has also been called *Smiling Head*, Henriette had ceased modeling for him on account of ill health. Thus, her physical presence no longer placed any restrictions on the artist. Yet he seems to have returned to a more conventionally human depiction. He roughly worked the surface, restoring definition to her cheeks and making the process of modeling the work visible. This human quality is countered by Matisse's decision to place this head on a base. Nor does the human quality restore Henriette's likeness, which seems to have undergone, as Steven Nash has written, a "progression of subjectivity" (in exh. cat. Dallas 2007–8, p. 10). In this respect, it recalls other series of Matisse sculptures such as the heads of Jeannette.

The lump on the brow of *Henriette I* may be a *pastille*, as it was called in the Matisse family; the artist would leave a mound of clay somewhere on his work at the end of the day to create an imperfection that would serve as a point of access—a problem to solve—when he resumed work (Elsen 1972, p. 161).

Selected bibliography: Albert E. Elsen, *The Sculpture of Henri Matisse* (New York, 1972); exh. cat. Washington, D.C., National Gallery of Art, *Henri Matisse: The Early Years in Nice, 1916–1930*, cat. by Jack Cowart and Dominique Fourcade, 1986–87; Margrit Hahnloser, *Matisse: The Graphic Work* (New York, 1988); John Klein, *Matisse Portraits* (New Haven, 2001); exh. cat. London, Tate Modern, *Matisse Picasso*, cat. by Elizabeth Cowling et al. (also shown at New York, Museum of Modern Art; Paris, Galeries nationales du Grand Palais), 2002–3; Hilary Spurling, *Matisse the Master: A Life of Henri Matisse, the Conquest of Colour, 1909–1954* (New York, 2005); exh. cat. Dallas Museum of Art and Nasher Sculpture Center, *Matisse: Painter as Sculptor*, cat. by Dorothy Kosinski, Jay McKean Fisher, and Steven Nash et al. (also shown at San Francisco Museum of Modern Art; Baltimore Museum of Art), 2007–8.

Henri Matisse
(French, 1869–1954)
Maria Lani
1928
Aquatint with roulette in black
on wove paper
23.9 x 18.2 cm
National Gallery of Art,
Washington, D.C.,
Gift of Evelyn Stefansson Nef,
2004.55.4

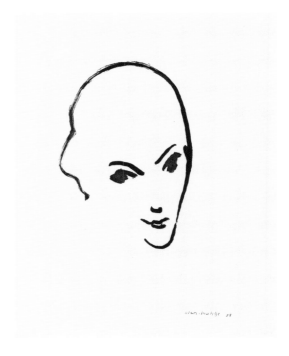

The Maria Lani affair hit Paris at the close of the 1920s. Even now, the nature of this woman's background is almost as clouded as that of her likeness—which was captured, or evaded, by more than fifty artists in Paris in the 1920s. Kenneth E. Silver has written elsewhere that when Maria Lani (1905/6–1954) arrived in Paris with the self-proclaimed movie producers the Abramovicz brothers, they billed her as a German actress—or "cinemactress," as a *Time* magazine article of November 18, 1929, described her. Lani and her companions asked artists to make her portrait, explaining that she was an art lover, and the avant-garde accepted the challenge, apparently portraying her without compensation. Not long after, an exhibition of more than fifty depictions of Lani was mounted. Stories of origin for this exhibition abound. The article in *Time* claimed that after several artists had depicted her, she showed the works to her friend Joseph Brummer, who said that if she assembled a larger group he would display them. Another version attributed the exhibition's creation to Henri Matisse (1869–1954), who supposedly, while sketching Lani in a Parisian café, proposed a book ("Speaking of Pictures . . . These Are the Faces of Parisian Model Maria Lani").

The pictures were spirited away to showings in New York at the Brummer Gallery for much of November 1929, then taken to the gallery of Alfred Flechtheim in Berlin in May 1930, before arriving at the Parisian Galerie Georges Bernheim for an exhibition opening November 15, 1930. The final venue was accompanied by a publication with essays by Jean Cocteau (cat. 33) among others, and illustrations of fifty-one renditions of Maria Lani, by such artists as Pierre Bonnard, Georges Braque, Marc Chagall (cat. 5), Cocteau, Robert Delaunay (cat. 9), André Derain, Kees van Dongen, Raoul Dufy, Foujita (cats. 15, 16), Max Jacob (cat. 19), Moïse Kisling, Fernand Léger, Matisse, Man Ray, Louis Marcoussis (cats. 24, 25), Chana Orloff (cat. 34), Jules Pascin (cat. 36), Francis Picabia (cat. 37), Paul Poiret (cat. 47), Georges Rouault, and Chaim Soutine (cat. 44). Suggesting the even greater number of portraits of Lani that were produced, a shorter catalogue of the show listed fifty-four portraits, and of the four works in the present exhibition depicting Lani (see cats. 34, 36, 44), only those by Orloff and Soutine were shown. A different print by Matisse was illustrated, as was a painting, rather than a drawing, by Pascin.

The show was heavily covered in the American press, with critics marveling at the myriad interpretations of Lani: "Is she beautiful? Is she thin, fat, dropsical, anemic, senile, kittenish or reptilian?" mused the *Time* reviewer, echoing Cocteau's comments in the catalogue: "Every time you take your eyes off her she changes. You see her in turn as a young girl, a ravaged woman, a college girl, a cat with thin lips, thick lips, a slender neck, a herculean neck, vanquished shoulders, broad shoulders, with Chinese eyes, with the eyes of a dog. I have forgotten to tell you that she has three profiles. She turns round and you cannot recognize her" (Cocteau, Ramo, and George 1929, p. 7, trans. in Vincent 1966, p. 255).

Critics also raised questions about the extent to which the works were portraits of Lani, as opposed to portraits of the artists who portrayed her. A reviewer for *Art News* wrote, "These portraits are less character studies of the sitter than revelations of the painters' or sculptors' personalities," going on to note that "the impression is of a woman who has a host of entertaining friends and not of one who dominates a salon or creates a style" ("Brummer Shows Fifty-one Portraits," 1929, p. 6). Ruth Green Harris wrote in the *New York Times*, "Apparently no matter whom an artist utilizes by way of inspiration, if the subject is at all stimulating he makes his own portrait, injecting into the living mask that

reflects his own likeness the variations resulting from his inspiration" (Harris 1929). Indeed, as becomes particularly clear in the Maria Lani exhibition—and in the smaller group of portraits of her displayed here—portraits necessarily contain a certain amount of tension between the artist and the sitter. Even as we take photographs to represent true likeness, photographers introduce their own perspectives into their work just as painters and sculptors present likenesses that may seem to tell more about the artist than the sitter. The present print, by Henri Matisse, is a good example of this tension. Its sparse, economical lines bring to mind Matisse, that great master of efficient lines, yet there is a sense of an individual's likeness insinuated as well in the narrow, pointed chin, sharply slanting eyebrows, broad forehead, and slightly coy lips. One article described Lani's memories of modeling for Matisse, who produced several portraits of her:

> She still dreams about a quiet afternoon in the studio of Henri Matisse, with a church bell ringing in the distance and Matisse humming as he worked behind his canvas, then changing suddenly and with mixed emotions of anger and despair analyzing the mysterious attraction Maria Lani's face had for Paris artists: "What kind of creature are you, anyway? . . . There is something between you and me . . . I cannot find you. God doesn't want me to." ("Speaking of Pictures. . . ")

This account had also appeared in Mac Ramo's essay in the catalogue (Cocteau, Ramo, and George 1929, p. 11). Judging from the reliability of Lani's other tales, such recollections must be taken with a grain of salt. Nonetheless, the supposed quote from Matisse captures the elusiveness of this strange, forced muse.

At some point, Lani's background as a stenographer from Prague and the identities of the Abramovicz brothers as her husband and brother were revealed (exh. cat. New York 1985–86, p. 44). Yet as late as 1954, when the *New York Times* published Lani's obituary, it printed a biography of the woman more or less in keeping with that presented in 1929–30. It claimed that she had been born in Warsaw, Poland, and had trained in Berlin at Max Reinhardt's School of the Theatre, before beginning an acting career in Paris—complete with a role in a silent movie and a position at the Theatre Gaston Baty. It reported that she had married Maximilian Ilyin in 1923, an art critic who seems to have translated Cocteau's *The Human Voice* in 1960. The obituary noted that in 1941 she had moved to the United States, where she became involved with the Red Cross, regularly serving soldiers at the Stage Door Canteen in New York. She was evidently back in Paris living in Passy and writing a book about her life during the war when she had a brain operation; she died a month later. Like so many aspects of the Maria Lani legend, different stories compete and contradict, leaving the art as the primary evidence that this woman—who was apparently never famous anywhere for her acting—succeeded in convincing dozens of Parisian artists to portray her.

Selected bibliography: "Brummer Shows Fifty-one Portraits," *Art News* 28 (November 2, 1929); Ruth Green Harris, "C'est pas la Meme Chose: How the Many Look at Maria Lani—Artists Offer Pictures in Various Galleries," *New York Times*, November 3, 1929; "51 Portraits," *Time*, November 18, 1929; exh. cat. New York, Brummer Gallery, *Portraits of Maria Lani by Fifty-one Painters*, 1929; Jean Cocteau, Mac Ramo, and Waldemar George, *Maria Lani* (Paris, 1929); exh. cat. Paris, Galerie Georges Bernheim, *Les portraits de Maria Lani,* 1930, preface by Jean Cocteau; "Speaking of Pictures . . . These Are the Faces of Parisian Model Maria Lani," unidentified clipping, probably from c. 1942–46, curatorial files, Art Institute of Chicago (in file of acc. no. 1932.1086), ill.; "Maria Lani, 48, Model, Author," *New York Times*, March 13, 1954; Clare Vincent, "In Search of a Likeness: Some European Portrait Sculpture," *Metropolitan Museum of Art Bulletin*, n.s., 24, no. 8 (April 1966), pp. 253, 255; exh. cat. New York, Jewish Museum, *The Circle of Montparnasse: Jewish Artists in Paris, 1905–1945*, cat. by Kenneth E. Silver and Romy Golan, 1985–86, p. 44; Claude Duthuit, with Françoise Garnaud, *Henri Matisse: catalogue raisonné des ouvrages illustrés* (Paris, 1988), no. 45, ill.; Billy Klüver and Julie Martin, *Kiki's Paris: Artists and Lovers, 1900–1930* (New York, 1989), pp. 196–97.

Henri Matisse
(French, 1869–1954)
Portrait of Fabiani
1943
Charcoal and estompe on paper
55.9 x 38.1 cm
Malcolm Wiener Collection

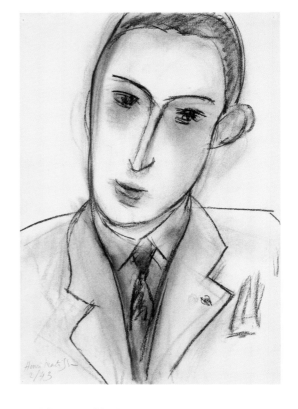

The Corsican art dealer and sometime owner of a racing stable Martin Fabiani was evidently involved in nefarious activities in Paris before and during World War II. His relationship with Ambroise Vollard (cats. 39, 42) has been viewed with particular suspicion. Vollard made Fabiani an executor of his estate, and when Vollard died in a car crash in 1939, Fabiani took over his gallery. Vollard supposedly died when his driver stopped the car suddenly, causing an Aristide Maillol (1861–1944) bronze sculpture or perhaps a pot of chicken curry to strike Vollard's head. David D'Arcy, following the lead of Picasso's biographer John Richardson, has suggested that Vollard's death—the circumstances of which were indeed enigmatic—was no accident at all but part of a plot by Fabiani. Richardson was told by the brother-in-law of one of Vollard's mistresses that the driver intentionally hit Vollard, and that the latter's death and the death soon after of a workman who cared for the gallery were orchestrated by Fabiani. Fabiani profited significantly from his role in handling Vollard's estate (D'Arcy 2006, p. 136; D'Arcy 2007, n.p.).

Fabiani subsequently became known as a Nazi collaborator, receiving works from the ERR (Einsatzstab-Reichsleiter Rosenberg), the Nazi organization that supervised the plundering of art from Jewish collectors and dealers. Fabiani was arrested in 1945 on charges related to his collaboration and fined 146 million francs the next year.

Fabiani arrived in Nice during World War II with hopes of representing Henri Matisse (1869–1954), since Paul Rosenberg (1881–1959), the artist's dealer, had fled the Nazis. Fabiani published two books illustrated by Matisse, *Henri Matisse: dessins; thèmes et variations* (1943) and Henry de Montherlant's *Pasiphaé: chant de Minos* (1944). Fabiani had protested the inclusion of an introduction by Louis Aragon (1897–1982) to the *Thèmes et variations* because Aragon was a Communist, but Matisse prevailed.

Matisse drew Fabiani several times during their joint work on the illustrated books, and a drawing in the Los Angeles County Museum of Art is particularly close to the present work even though in that drawing Fabiani does not cock his head.

In the present portrait, the figure fills nearly the entire sheet; the top of his head and his arms are cut off by the paper's edges. Fabiani looks downward, evading the viewer's gaze. Matisse's pentimenti are visible, particularly beneath Fabiani's left ear and along the right side of his head, suggesting that the artist experimented with different poses. Matisse's work with estompe—used here to smudge his charcoal lines and model the areas around Fabiani's eyes and necktie—is especially visible and sensitive.

It is exciting to be able to juxtapose Matisse's portrait of Fabiani in this exhibition with the portrait of Fabiani by Pablo Picasso (cat. 40).

Selected bibliography: "Parisian Held in Art Sales," *New York Times*, September 22, 1945; Alfred Barr, *Matisse: His Art and His Public* (New York, 1951), pp. 257, 259, 268, 270–71; Lynn H. Nicholas, *The Rape of Europa: The Fate of Europe's Treasures in the Third Reich and the Second World War* (New York, 1994); Hector Feliciano, *The Lost Museum: The Nazi Conspiracy to Steal the World's Greatest Works of Art* (New York, 1997); "The Art Trade under the Nazis," *Art Newspaper*, no. 88 (January 1999), p. 12; Sotheby's, New York, *Impressionist and Modern Art, Part Two*, November 8, 2001, lot 275, ill.; exh. cat. London, Tate Modern, *Matisse Picasso*, cat. by Elizabeth Cowling et al. (also shown at New York, Museum of Modern Art; Paris, Galeries nationales du Grand Palais), 2002–3, pp. 382, 383; Hilary Spurling, *Matisse the Master: A Life of Henri Matisse, the Conquest of Colour, 1909–1954* (New York, 2005), pp. 408, 494; David D'Arcy, "Ambroise Vollard," *Art & Auction* 30, no. 1 (September 2006), pp. 134–39; David D'Arcy, "The Mysterious Mr. Slomovic," *artnet Magazine* (January 10, 2007).

Henri Matisse
(French, 1869–1954)
Self-Portrait
1945
Pencil on paper
40.5 x 52.5 cm
The Museum of Modern Art,
New York. John S. Newberry Fund,
1965, 634.1965

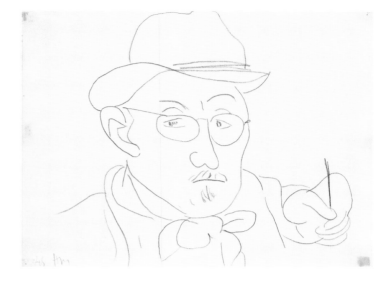

When Henri Matisse (1869–1954) drew this self-portrait in 1945, he was in his late seventies, but he did not emphasize his age as he did in other self-portraits from around the same period, in which sparse curls suggest graying hair. No hair emerges from his hat here, and he wears a debonair mustache and goatee. He sports a jaunty hat and knotted scarf, and the viewer is thrust closely into his space. Such a close view and the tendency of the subject to extend, by implication, off the page are characteristic of Matisse, as is his depiction of himself with pen in hand; indeed, his radically foreshortened left arm and hand emphasize that we are privy to the view Matisse had of himself in the mirror.

Matisse said in an interview in 1909, "The painter no longer has to preoccupy himself with details. The photograph is there to render the multitude of details a hundred times better and more quickly" (quoted in Flam 1973, p. 48). Like so many of Matisse's drawings, his lines are few and sure, leaving the viewer to imagine the rest.

Selected bibliography: exh. cat. Los Angeles, UCLA Art Galleries, *Henri Matisse: Retrospective 1966*, cat. by Jean Leymaire, Herbert Read, and William S. Lieberman (also shown at Art Institute of Chicago; Museum of Fine Arts, Boston), 1966, no. 214; Jack D. Flam, ed., *Matisse on Art* (London, 1973); exh. cat. New York, Museum of Modern Art, *Seurat to Matisse: Drawing in France, Selections from the Collection of the Museum of Modern Art*, cat. ed. by William S. Lieberman, 1974, no. 111; John Klein, *Matisse Portraits* (New Haven, 2001), pp. 212–15, fig. 173; exh. cat. London, Tate Modern, *Matisse Picasso*, cat. by Elizabeth Cowling et al. (also shown at New York, Museum of Modern Art; Paris, Galeries nationales du Grand Palais), 2002–3, pp. 27, 339.

Jean Metzinger
(French, 1883–1956)
Portrait of Madame Metzinger
1911
Oil on canvas board on panel
27.3 x 21.6 cm
Philadelphia Museum of Art:
A. E. Gallatin Collection, 1952

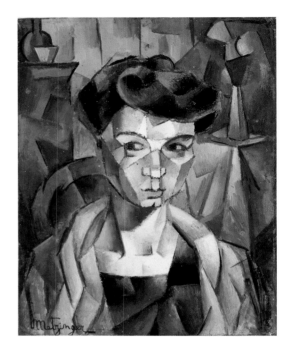

Born and raised in Nantes, Jean Metzinger (1883–1956) excelled in mathematics in school and received artistic training from the portraitist Hippolyte Touront at the local painting academy. After exhibiting paintings in Paris, he moved there in 1903. His early work shows the influence of Paul Cézanne (1839–1906), and he subsequently painted in a Divisionist vein—along with his good friend Robert Delaunay (cat. 9)—until he began his forays into Cubism about 1908, the year he met Pablo Picasso (cats. 38–40) and Georges Braque (1882–1963). Metzinger wrote an article, "Note sur la peinture" in *Pan* (October–November 1910), in which he identified certain aspects of the new aims of painting, notably linking the work of Picasso and Braque with that of Delaunay and Henri Le Fauconnier (1881–1946). Metzinger was significant in the early years of Cubism as a link between the two groups of artists with related goals, all of whose work would come to be described as Cubism: he knew Picasso and Braque, but he also was involved with the group of painters who gathered at the Puteaux studios of the Duchamp brothers (exh. cat. Iowa City 1985–86, p. 9). In addition to Delaunay and Le Fauconnier, the latter group included Albert Gleizes (cat. 18) and Fernand Léger (1881–1955). Daniel Robbins has noted that the relegation of these painters by some scholars to the role of minor artists, merely imitating the Cubist aesthetic, anachronistically ignores the public conception of Cubism beginning in 1911, the year of the word's inception. At the time, these painters, rather than Braque and Picasso, were seen to epitomize Cubism (ibid., p. 9). This public awareness of Cubism began with the Salon des Indépendants of 1911, for which Metzinger served on the hanging committee for the renowned room 41 that was filled with Cubist paintings, including his own.

Metzinger's writings continued to define Cubism as it emerged. With his friend Gleizes, whom he had probably met in 1909, he wrote *Du cubisme* (1912), which set forth some of the basic principles of the movement. The critic and poet Guillaume Apollinaire's (cat. 25) influential publication of the following year, *Les Peintres cubistes* (1913), gave Metzinger the honor of having painted the first Cubist portrait—of Apollinaire, incidentally—which had hung at the Salon des Indépendants of 1910 (exh. cat. Chicago 1964, p. 8).

As in most of Metzinger's paintings of women from about 1911–18, this work depicts his first wife, Lucie Soubiran, whom he married on December 30, 1909. Wearing a pale jacket or shawl over a dark blue top, Madame Metzinger sits on a wood-framed chair with green upholstery; this green is echoed in the carafe at upper left and in the shapes emerging from a vase on the table at back right. Metzinger's division of the surface into carefully defined planes does not hinder the recognizability of his sitter or the overall comprehensibility of the still-life elements behind her. Metzinger painted an extremely similar portrait of his wife, more than twice the size of the present work, from the same angle and in the same clothing but without the still-life elements in the background (c. 1911; ill. in exh. cat. Iowa City 1985–86, no. 25). Several years after Lucie Soubiran's death in about 1918, Metzinger became involved with the painter Suzanne Phocas, whom he eventually married.

When commenting on some of Metzinger's paintings in 1910, the year before this painting was produced, Apollinaire wrote that the works were "solidly painted" but lamented their "unfortunate air of commemorating an earthquake" (quoted in ibid., p. 13).

Selected bibliography: exh. cat. Chicago, International Galleries, *Metzinger: Pre-Cubist and Cubist Works, 1900–1930*, 1964, pp. 3–10; Robert L. Herbert, Eleanor S. Apter, and Elise K. Kenney, eds., *The Société Anonyme and the Dreier Bequest at Yale University: A Catalogue Raisonné* (New Haven, 1984), pp. 453–55; exh. cat. Iowa City, University of Iowa Museum of Art, *Jean Metzinger in Retrospect*, cat. by Joann Moser, with an essay by Daniel Robbins (also shown at Archer M. Huntington Art Gallery, University of Texas at Austin; David and Alfred Smart Gallery, University of Chicago; Pittsburgh, Museum of Art, Carnegie Institute), 1985–86; Jennifer R. Gross, ed., *The Société Anonyme: Modernism for America* (New Haven, 2006), p. 179.

Amedeo Modigliani
(Italian, 1884–1920)
Portrait of Frank Burty Haviland
1915
Pencil on paper
36.2 x 27 cm
William Kelly Simpson, New York

The life of Amedeo Modigliani (1884–1920)—so tragic in many respects—has elicited endless scholarship, speculation, and even films. Born to a Jewish family living in Livorno, Italy, Modigliani had pleurisy and typhoid in his youth and suffered ill health throughout his short and often debauched life. He took drawing lessons beginning in 1898 in Livorno. He then studied in Florence and Carrara—to nurture his interest in sculpture—and Venice before arriving in 1906 in Paris, where he entered the Académie Colarossi. Spending time in Montmartre and Montparnasse, Modigliani soon met, among others, the artists Pablo Picasso (cats. 38–40), Louis Marcoussis (cats. 24, 25), and Francis Picabia (cat. 37), as well as the writers Max Jacob (cat. 19) and Guilllaume Apollinaire (cat. 25). In 1909 he met Constantin Brancusi (cat. 3), with whom he became extremely close and whose works proved influential for Modigliani. By 1914 Foujita (cats. 15, 16), Chaim Soutine (cat. 44), and Diego Rivera (cat. 43) were also his intimates. Through poverty, many love affairs, and consumption of much alcohol and many drugs, Modigliani's health deteriorated until he died from tubercular meningitis in 1920. Adding to his mythical aura, two days after his death, Modigliani's final lover, Jeanne Hebuterne, then nine months pregnant, hurled herself out a window to her death.

This exhibition includes two portrait drawings by Modigliani, which are strikingly different in approach. The present work is representative of his first consideration of a given sitter. Swiftly penciled curves suggest the sitter's coiffure and create an undulating frame for his forehead. Rapid curlicues delineate an ear. Rougher, jagged lines define the neck and back of the head. Like many of Modigliani's works of 1915–16, and in emulation of Cubist practice, this drawing contains several words inscribed on its surface. Here, the sitter's first name, Frank, descends in a line from beside his high cheekbone down to his chin; his last name, Haviland, is a bit harder to discern, as it is written partly on a diagonal and partly broken up into rows. The other words that are visible seem to indicate the date: "jeudi 1 avril 015" (Thursday, April 1, 1915). Tamar Garb has noted the strangeness of Modigliani's integration of text and image and its effect of reminding the viewer—contrary to the goal of most Western artists since the Renaissance—of the flatness of the image (Garb 2004–5, pp. 51–52). Indeed, it is somewhat surprising that just as Modigliani indicates depth through the three-quarter view of the sitter's face, reinforced by the subtle hairline leading to the ear, he simultaneously places floating text prominently beside the face—a reminder of the limitations of both text and images and, perhaps, of their evocative power when joined.

Modigliani portrayed Frank Burty Haviland (1886–1971) several times. He captured him twice in oil in 1914 in a similar pose—though with a more severe profile—both times emphasizing Haviland's elegant hairstyle (Los Angeles County Museum of Art; Gianni Matttioli Collection on long-term loan to the Peggy Guggenheim Collection, Venice). He also drew Haviland in 1914, probably as a sketch for the painted portraits (Musée d'Art moderne de la Ville de Paris). Thus, if the present portrait is indeed from 1915, then it is not a study for the portraits but perhaps a spontaneous sketch, such as Modigliani was famous for producing in Parisian cafés.

Modigliani probably met Haviland about 1914. Haviland came from a Franco-American family of porcelain producers based in Limoges. His brother, the photographer Paul Burty Haviland (1880–1950), worked with Alfred Stieglitz (1864–1946) on both *291* and *Camera Work*, and Frank aspired to be a painter. Although unsuccessful in this regard, he amassed an impressive collection of African sculpture that impressed Modigliani who, along with Picasso, was friendly with him. Haviland and Modigliani made trips together to the Cernuschi and Guimet museums and the Trocadéro, probably to view the African holdings. Thus, it is especially appropriate that Modigliani portrayed Haviland in the stylized, elongating approach the artist developed from his study of African sculpture.

It has been suggested that Juan Gris's *The Smoker* (Museo Thyssen-Bornemisza, Madrid) represents Haviland, in part because he dedicated one of the preparatory sketches (Metropolitan Museum of Art, New York) to Haviland (Alarcó 2008).

Selected bibliography: Christie's, London, *Impressionist, Modern and Contemporary Paintings, Sculpture, Drawings and Watercolours*, March 25, 1986, lot 221, ill.; Osvaldo Patani, *Amedeo Modigliani: catalogo generale; disegni, 1906–1920* (Milan, 1991–94), no. 60, ill.; Anette Kruszynski, *Amedeo Modigliani: Portraits and Nudes*, trans. John Brownjohn (New York, 1996), pp. 30–32; Marius de Zayas, *How, When, and Why Modern Art Came to New York*, ed. Francis M. Naumann (Cambridge, Massachusetts, 1998), p. 236; John Richardson, *The Sorcerer's Apprentice: Picasso, Provence, and Douglas Cooper* (New York, 1999), p. 134; exh. cat. Buffalo, N.Y., Albright-Knox Art Gallery, *Modigliani and the Artists of Montparnasse* (also shown at Fort Worth, Kimbell Art Museum; Los Angeles County Museum of Art), 2002–3, cat. by Kenneth Wayne, pp. 28, 47; exh. cat. New York, Jewish Museum, *Modigliani: Beyond the Myth*, ed. by Mason Klein, 2004–5, pp. 186–202; Tamar Garb, "Making and Masking: Modigliani and the Problematic of Portraiture," in exh. cat. New York 2004–5, pp. 42–53; Paloma Alarcó, "Gris, Juan/The Smoker," online catalogue of Museo Thyssen-Bornemisza, Madrid (accessed June 26, 2008).

Amedeo Modigliani
(Italian, 1884–1920)
Portrait of Jean Cocteau
c. 1916–17
Pencil on paper
41 x 25.7 cm
William Kelly Simpson, New York

An essential member of the Parisian avant-garde, Jean Cocteau (1889–1963) defies simple classification. He worked in a variety of media—poetry, prose, playwriting, drawing, painting, and film, to name a few—and he continued to have an illustrious career well after World War II. He came from a wealthy family and was born in the Parisian suburb of Maisons-Laffitte. He enmeshed himself in the theater and wrote poetry until the arrival of Serge Diaghilev's (1872–1929) Ballets Russes in 1909 transformed his tastes. He was absorbed into the company, creating posters for shows, sketches of company members, and even a ballet scenario commissioned by Diaghilev. He met Pablo Picasso (cats. 38–40) and his circle, including Amedeo Modigliani (1884–1920), about 1915. As Francis Steegmuller has observed, Cocteau formed a link between the otherwise quite separate artistic scenes surrounding the Ballets Russes and the Left Bank avant-garde (Steegmuller in *Jean Cocteau and the French Scene* 1984, p. 21). He collaborated with a number of artists on his ballet *Parade*, for which Picasso designed the sets and costumes and Erik Satie (1866–1925) wrote the music.

Frequently photographed in varied settings and costumes, Cocteau proved a popular subject with the Parisian avant-garde artists: Romaine Brooks (cat. 4), Albert Gleizes (cat. 18), Marie Laurencin (cats. 20, 22), Jacques Lipchitz (cat. 23), Francis Picabia (cat. 37), Picasso, and Diego Rivera (cat. 43), to name some of the artists in this exhibition, all depicted him. Cocteau made numerous appearances in Modigliani's work—in drawings (New Orleans Museum of Art; Rijksmuseum, Amsterdam; and private collections) and in a painting of 1916–17 (Henry and Rose Pearlman Foundation, Inc.)—all in similar clothing and attitude. Here, the elegant curl of his hair—like that of Frank Burty Haviland (cat. 32)—long, narrow neck, erect posture, deliberate folding of his hands, straight bow tie, and neat jacket all evoke Cocteau's well-bred demeanor. Modigliani inscribed this drawing at upper left, "A Jean Cocteau. Modigliani," but according to Modigliani's lover, Beatrice Hastings (1879–1943), he disliked Cocteau (Meyers 2006, p. 164). There is indeed an excessive stiffness, even hauteur, to be seen in Modigliani's portraits of Cocteau. Yet despite this perceived arrogance, Cocteau purported—several decades later, in 1946—to be unimpressed with his own appearance: "I've never had a handsome face. In me, youth took the place of beauty. My bone structure is good but the flesh is badly arranged on top" (quoted in exh. cat. Paris 2003–4, p. 203).

Like several of the works in this exhibition (cats. 19, 38, 43), the artist produced this portrait in a style inspired by Jean-Auguste-Dominique Ingres (1780–1867), with thin lines and little in the way of shading, save the cross-hatching on Cocteau's hair and the shading of his bow tie.

Selected bibliography: exh. cat. Palm Beach, Florida, Society of the Four Arts, *Modigliani: A Retrospective* (also shown at Miami, Lowe Gallery), 1954, no. 31; *Jean Cocteau and the French Scene* (New York, 1984); William Doyle Galleries, New York, *Important 19th and 20th Century European Paintings*, May 16, 1985, lot 62, ill.; Julie Saul, ed., with an essay by Francis Steegmuller, *Jean Cocteau: The Mirror and the Mask, a Photo-Biography* (Boston, 1992), pp. 7–11; exh. cat. Paris, Centre Pompidou, *Cocteau: Jean Cocteau, sur le fil du siècle*, trans. Trista Selous (also shown at Montreal Museum of Fine Arts), 2003–4; Jeffrey Meyers, *Modigliani: A Life* (New York, 2006).

Chana Orloff
(French, born Ukraine, 1888–1968)
Portrait of Maria Lani
1929
Cast bronze
31.8 x 19.1 x 26.7 cm
Mount Holyoke College Art Museum,
South Hadley, Massachusetts,
Gift of Mrs. Randall Chadwick

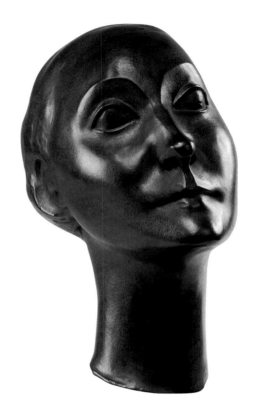

The sculptor Chana Orloff (1888–1968) was among the many members of the Parisian avant-garde to depict Maria Lani (1905/6–1954) (see cat. 28 for the Maria Lani story). Orloff was born in the Ukrainian village of Tsaré-Constantinovska, where she lived until her family moved to Petah-Tikva, a Jewish settlement in Palestine in 1905. She moved to Paris five years later and began her artistic training. Awarded second place in a competition for entrance to the Ecole Nationale des Arts Décoratifs, she entered a drawing class, while at the same time training in sculpture at the Russian Academy in Montparnasse. She soon met many of the artists living in Montparnasse and in 1912 became friendly with Amedeo Modigliani (cats. 32, 33). It was through Orloff that he met his lover Jeanne Hebuterne, who had been sharing a studio with the sculptor. Seizing perhaps on Orloff's idealizing tendencies, as Kenneth E. Silver has suggested, Modigliani inscribed "Chana, daughter of Raphael" in Hebrew on a portrait he had sketched of Orloff on an envelope (1916; ill. in exh. cat. New York 1985–86, fig. 31; in ibid., p. 19).

Although Orloff was in close contact with radical new styles being developed—and she did experiment with Cubism—her work generally adhered to her own sense of simplicity, her portraits stressing, stylizing, and even deforming certain essential characteristics (Haim Gamzu in exh. cat. Tel Aviv 1969, n.p.; Jean Cassou in exh. cat. Tel Aviv 1961, n.p.). She produced many portraits during her career, including commissions beginning in the early 1920s and an album of forty-one portrait sketches of figures in the Parisian art world. One of her penetrating portraits prompted the following comment from the critic Edmond des Courières: "I would hesitate to sit for Chana Orloff. One day she did the portrait of the writer Mac Orlan (cat. 35), and since then he is only a reflection of the real Mac Orlan, which is the sculpture" (quoted in exh. cat. Tel Aviv 1969, n.p.).

Orloff's portrait of Lani streamlines the sitter's hair, focusing on the structure of the skull and the overlying contours of her flesh. She geometrically molds the planes of Lani's eyelids, nose, and upper lip, and the subtle gradations of flesh covering Lani's cheekbones allow for the play of light on their surfaces. Although this portrait bears little physical resemblance to the portrait of Lani on view here by Jules Pascin (cat. 36), Orloff seems to have grasped the structure of Lani's face in a way similar to that of Henri Matisse (cat. 28): both present strongly arching eyebrows and a face that narrows sharply on its way to a pointed chin. Likewise, despite their quite different media, both Orloff and Matisse treat Lani's eyes as dark voids, omitting her pupils and irises. Chaim Soutine's portrait of Lani (cat. 44) resembles the Orloff and Matisse depictions in the structure of the lower half of her face.

Orloff married the poet Ary Justman in 1916, who died two years later, leaving her with an infant son. In the year that Orloff was granted French citizenship, she was awarded the Chevalier de la Légion d'Honneur. During World War II, Orloff remained in Paris until she was warned that she would be arrested, at which point she and her son fled to Switzerland. She returned to Paris after the war and died in 1968 on a visit to Israel, just before the opening of a large retrospective of her work in Tel Aviv.

Selected bibliography: Jean Cocteau, Mac Ramo, and Waldemar George, *Maria Lani* (Paris, 1929), p. 37, ill.; "50 Künstler porträtieren eine Frau," *Deutsche Kunst und Dekoration* 66 (July 1930), pp. 226–45, ill.; exh. cat. Tel Aviv, Association des Musées d'Israël, *Chana Orloff: Sculptures, 1911–1961*, 1961, no. 22, n.p.; exh. cat. Musée de Tel Aviv, Pavillon Helena Rubinstein, *Chana Orloff (1888–1968): exposition retrospective, 120 sculptures, 60 dessins*, 1969, no. 45, n.p.; exh. cat. Paris, Musée Rodin, *Chana Orloff: sculptures et dessins*, 1971, n.p.; exh. cat. New York, Jewish Museum, *The Circle of Montparnasse: Jewish Artists in Paris, 1905–1945*, cat. by Kenneth E. Silver and Romy Golan, 1985–86, no. 90, fig. 45, pp. 19, 32–33, 55, 112–13; Félix Marcilhac, *Chana Orloff* (Paris, 1991), no. 148, ill., pp. 195–96.

Jules Pascin
(American, born Bulgaria, 1885–1930)
Pierre Mac Orlan
1924
Oil on canvas
92.1 x 73 cm
The Metropolitan Museum of Art,
The Mr. and Mrs. Klaus G. Perls
Collection, 1997 (1997.149.8)

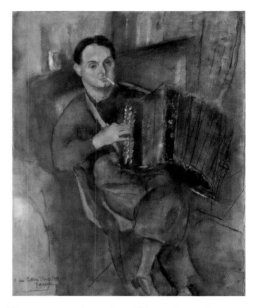

Legendary in his era, Jules Pascin (1885–1930), like Amedeo Modigliani (cats. 32, 33) before him, led an extravagant, often reckless life, which ended tragically. In 1902 Julius Mordecai Pincas (he later Frenchified his first name and used an anagram of Pincas for his surname) left his large Sephardic Jewish family in Bucharest—where they had moved from Vidin, Bulgaria, when Pascin was seven and where he was rumored to have regularly sketched prostitutes—and traveled to Vienna and later Munich, where he entered the Heymann Art School. While living in Germany, he worked as an illustrator for the magazine *Simplicissimus*—his early drawings reflect the influence of Jugendstil (the German version of Art Nouveau)—before moving to Paris in 1905. There he was welcomed into the group of Germans and eastern Europeans living in Montmartre and continued his studies at the Montparnasse academies. Pascin experimented with Fauvism and Cubism, but they never exerted a strong influence on his personal poetic style. Pascin remained above all a draftsman—the twelve works he sent to New York's Armory Show in 1913 were watercolors, drawings, and prints—and his oil paintings often have the light, fleeting quality of watercolors.

He spent the war years in America, where he married his longtime lover Hermine David (1886–1971) and also acquired citizenship. He returned in 1920 to Paris, where he would finally achieve the financial success that had long eluded him. This allowed him to throw legendary parties that spilled onto the street and into nearby restaurants, where Pascin invariably treated the assembled crowds. Yet the social, witty, and multilingual Pascin was often anxious and eager to escape, fleeing at times to the south of France, the United States, Africa, and the warmer parts of Western Europe. Pascin's second love, Lucy Krohg, was the wife of Pascin's friend, the Swedish painter Per Krohg (1889–1965), and accompanied Pascin on some of his journeys. It was to Lucy that an ill, forty-five-year-old Pascin wrote his suicide note, in blood.

Lucy remembered Pascin's technique: "Pascin was aiming at an increasingly rapid execution. The technique that suited him best was oils, diluted with oil of turpentine on a very thin canvas. This technique enabled him to achieve very subtle variations, the most delicate shadings, an atmosphere of faded pink, dull violet or saffron yellow, reminiscent of Odilon Redon or, in music, Debussy" (quoted in Hemin et al. 1984, p. 11). The present portrait, with its washes of slightly dimmed colors and the dark outlines—particularly those delineating the sitter's clothing and accordion—displays Pascin's swift yet deliberate approach. The sitter, eyes intent, cigarette emerging from his mouth, blue-clad legs jauntily crossed, appears against a backdrop that is only hazily defined.

The painting is inscribed "au Patron Mac Orlan / pascin," and it depicts Pascin's close friend Pierre Mac Orlan, in whose home at St.-Cyr-sur-Morin Pascin spent much time. Pierre Dumarchey (1882–1970) had, like Pascin, adopted a new name: he supposedly assumed Mac Orlan when he discovered that his grandmother had been Scottish (Merrifield 2004). Like Pascin, Mac Orlan was a Montmartre resident, avid traveler, and sometime illustrator—he had originally come from his hometown of Péronne to pursue art—but he is best known for his large literary output: novels, poems, essays, memoirs, and songs to be sung to the accordion Pascin depicts him playing, almost as if it were an attribute. Pascin also did several drawings of Mac Orlan and his accordion, which were studies for another portrait of Mac Orlan, Pascin's *Embarkation for the Islands (Homage to Mac Orlan)* (c. 1924; Hirshhorn Museum and Sculpture Garden, Washington, D.C.). Pascin illustrated two of Mac Orlan's works: *Abécédaire des filles et de l'enfant chéri* in 1924 and *Aux lumières de Paris* in 1925, and, in turn, Mac Orlan wrote a tribute to Pascin, *Le Tombeau du Pascin* (1945), as well as the preface to André Warnod's *Pascin* (1954). Pierre Mac Orlan owned this portrait for thirty years from the time of its creation in 1924.

Selected bibliography: *Pascin*, preface by Paul Morand (Paris, 1931), pp. 40, 45, no. 15, ill.; Horace Brodzky, *Pascin* (London, 1946), pp. 36, 38, pl. 26; Alfred Werner, *Pascin* (New York, 1962), pp. 13–32, pl. 19; Gaston Diehl, *Pascin*, trans. Rosalie Siegel (New York, 1968), pp. 8, 18, 21, 25–26, 46, 50, 77–78, 90, 93, 54, ill.; "Pierre Mac Orlan, French Novelist, 88," *New York Times*, June 29, 1970; Yves Hemin, Guy Krohg, Klaus Perls, and Abel Rambert, *Pascin, catalogue raisonné: peintures, aquarelles, pastels, dessins* (Paris, 1984), vol. 1, pp. 11, 13, 15, no. XIX, ill.; exh. cat. New York, Jewish Museum, *The Circle of Montparnasse: Jewish Artists in Paris, 1905–1945*, cat. by Kenneth E. Silver and Romy Golan, 1985–86, no. 96, fig. 39, pp. 13, 37, 39–41, 50, 115; Billy Klüver and Julie Martin, *Kiki's Paris: Artists and Lovers, 1900–1930* (New York, 1989), pp. 32–35, 98–99; Bernard Baritaud, *Pierre Mac Orlan: sa vie, son temps* (Geneva, 1992), pp. 174–75; exh. cat. New York, Metropolitan Museum of Art, *Painters in Paris, 1895–1950*, 2000, pp. 124, 99, ill.; exh. cat. Kyoto Municipal Museum of Art, *Picasso and the School of Paris: Paintings from the Metropolitan Museum of Art, New York* (also shown at Tokyo, Bunkamura Museum of Art), 2002–3, p. 92, no. 52, ill.; Andy Merrifield, "The Strange Odyssey of Pierre Mac Orlan," *Brooklyn Rail*, September 2004.

Jules Pascin
(American, born Bulgaria, 1885–1930)
Maria Lani
c. 1929
Charcoal on paper
66.7 x 52.7 cm
The Phillips Collection,
Washington, D.C.,
Gift of Jean Goriany, 1943

The present work is yet another depiction of Maria Lani (1905/6–1954) (see cat. 28 for the Maria Lani legend). This drawing is one of at least two portraits Pascin made of Lani. Pascin's painting of Maria Lani (ill. in Hemin et al. 1984, no. XXIV, although not identified as Lani) appeared in the 1929 catalogue of the exhibition and, like the drawing, focuses on her bent arms and the way she holds her shoulders. In the painting Lani is seated, her back visible in a mirror, her legs crossed and hands clasped, staring solemnly past the viewer. Pascin's drawing of Lani, as if underscoring that even in the work of one artist the woman could look strikingly different, presents her as a less self-contained figure. She poses, her left leg stretched slightly back; her hands rest on her ample hips, and her head turns above erect shoulders. Her posture seems defiant, but her expression retains a hint of the solemnity—if not the calm—of Pascin's painted portrait.

Pascin has drawn Lani in charcoal, subtly outlining her arms and face and the lines of the background, even as he uses a dark, hard line to outline her legs, dress, and hair. The paler lines seem surer and more carefully applied, while the darker lines are frequently rougher and more rapidly sketched.

Pascin's wife, Hermine David (1886–1971), also produced a portrait of Lani (ill. in "50 Künstler porträtieren eine Frau," 1930). By the time they both portrayed Lani, in the late 1920s, they had been living apart for several years while Pascin pursued an affair with Lucy Krohg, the wife of a Swedish artist living in Paris named Per Krohg (1889–1965) who, incidentally, also painted Lani's portrait (ill. in Cocteau, Ramo, and George 1929, no. 41).

Selected bibliography: Jean Cocteau, Mac Ramo, and Waldemar George, *Maria Lani* (Paris, 1929); "50 Künstler porträtieren eine Frau," *Deutsche Kunst und Dekoration* 66 (July 1930), pp. 226–45, ill.; Yves Hemin, Guy Krohg, Klaus Perls, and Abel Rambert, *Pascin, catalogue raisonné: peintures, aquarelles, pastels, dessins* (Paris, 1984), vol. 1; *The Phillips Collection: A Summary Catalogue* (Washington, D.C., 1985), no. 1346, ill.; Billy Klüver and Julie Martin, *Kiki's Paris: Artists and Lovers, 1900–1930* (New York, 1989), p. 98.

Francis Picabia
(French, 1879–1953)
Portrait de Suzanne
1942
Oil on panel
63.5 x 51.7 cm
Collection Gian Enzo Sperone,
New York

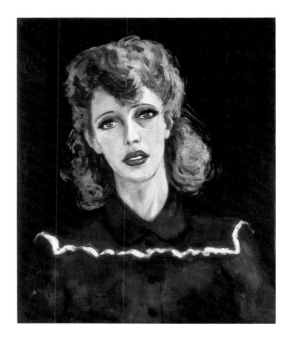

A central figure in the circle of Puteaux Cubists and soon after a leading member of the Dada movement, Francis Picabia (1879–1953) never rested long in a particular artistic style or ideological movement. His late works were largely ignored and pushed aside with embarrassment by much of the art world until the 1980s and 1990s, when, having been respected by artists for much longer, art historians began to be interested in them.

The son of a Spanish father and a French mother, Picabia was born in Paris in 1879. His grandfather Alphonse Davanne, who was extremely interested in the potential of photography, served on various photographic committees and wrote texts on the subject. Picabia drew and painted from a young age, beginning his formal training at the Ecole des Arts Décoratifs in 1895, where he studied in the studios of Humbert, Wallet, and later Fernand Cormon (1845–1924). From the beginning of his career, Picabia cycled through artistic styles: Barbizon-like landscapes in the 1890s, Impressionist scenes about 1903—the year he met Camille Pissarro (1830–1903)—and later pictures influenced by Fauvism. Meeting Marcel Duchamp (cat. 12) in 1910, Picabia soon became a part of the group who met regularly in Puteaux, at the Duchamp brothers' studios, to discuss new ideas about painting that led to the development of one branch of Cubism. Picabia was an organizer and participant in the Salon de la Section d'Or of 1912, and he also displayed works at the famed New York Armory Show in 1913. During his trip to New York for the latter show, he became friendly with the American photographer Alfred Stieglitz (1864–1946), through whom he met Marius de Zayas, whom Picabia, in turn, introduced to the producers of the journal *Les Soirées de Paris*, for which de Zayas produced a caricature of Picabia (Silver essay, ill. 27), among other things.

For several years beginning about 1915, Picabia produced images with machine parts to which he affixed texts, sometimes identifying them as portraits. Several years later, he became involved in the Dada movement, along with Tristan Tzara (1896–1963) and André Breton (1896–1966). However, in 1921, he officially left Dada, and his works of the 1920s continue his machinist interests but also include representational paintings. Many of his pictures of the thirties were also representational, but he changed from painting in transparent layers to using bold black outlines and bright colors. With his move to the south of France in 1940 following the outbreak of World War II, Picabia's style changed yet again. He embarked on a series of works based on photographs, often somewhat pornographic in nature, drawn from magazines. It was also in 1940 at a friend's party that he met Suzanne Romain, with whom he would have an intermittent, passionate, and emotionally trying affair for almost a decade.

Suzanne, called Zon, came from a military family and was married to Max Romain, a dentist who joined the Resistance. Picabia and his wife, Olga, began socializing frequently with the Romains, and the couples traveled together, although, as Suzanne later remembered, "almost without realizing it I soon found that I hardly saw anything of my husband but was spending all my time with Francis Picabia" (quoted in Borràs 1985, p. 424). Picabia produced numerous images of Suzanne, in addition to this one, including two paintings similar in format to the present work from 1941 and 1943 (ibid., nos. 751 and 785, figs. 931 and 965, respectively); a painting in which Suzanne sunbathes (ibid., no. 752, fig. 932); a postwar drawing (1945) and painting (1948) that are each quite abstract but are inscribed "Suzanne" (ibid., nos. 808 and 873, figs. 1007 and 1006, respectively); and an image in which a face appears amid colorful tentacles outlined in white entitled, *La Rêve de*

Su[z]anne (1949; ill. in exh. cat. Hamburg 1997–98, p. 134). He also wrote a thirty-page poem, "Ennazus," in 1946, which dealt with the pain of their separation. Suzanne's brother-in-law, the writer Paul Reboux, wrote her a letter in 1941 advising her against a risky life with an artist, as opposed to the bourgeois comfort and stability of her marriage to a dentist; indeed, Suzanne was ultimately unwilling to sacrifice her marriage and lifestyle, and the liaison ended in 1949 (Borràs 1985, p. 447).

The present picture, although not pornographic, falls squarely within Picabia's style of the early 1940s; it may even have been based on a photograph, as were so many of his works from that time. It presents the sitter against a dark background, wearing a blue-collared shirt with a white ruffle. Her golden pouffed hair, bright red lips, and heavily mascara-coated eyelashes suggest the fashions of the moment, in 1942, when it was painted, but the image is clearly not quite right. The figure cranes her elongated neck and parts her thickly outlined lips, suggesting a certain tension or anxiety, but she seems unable to connect with the viewer. Are her eyes mournful or vapid? The sense of objectification, akin to that in Picabia's paintings of pinups, seems especially significant in light of Suzanne's recollections of this period: "In those days, I must admit, I was a rather superficial creature, thinking only of my hair, my clothes, my grooming in general, like a sort of doll" (quoted in Borràs 1985, p. 424).

This picture and others Picabia created in the 1940s seem at once hugely earnest and bitingly ironic. They have been described as kitsch painting, applauded as Dada ideas about anti-art taken to new extremes, and recognized as groundbreaking uses of popular imagery in the realm of fine art that foreshadow the work of 1960s artists such as Andy Warhol (1928–1987) (Camfield 1979, p. 257). Maria Lluïsa Borràs has seen them as sarcastic affronts to Picabia's grandfather's appreciation of photography, with their highly polished finish and exaggerated contrasts between light and dark (Borràs 1985, p. 422). Robert Rosenblum wrote of this painting: it "looks like the work of a street-vendor portraitist on the banks of the Seine; an anonymous artist who might also have executed the visual pulp fiction" (in exh. cat. New York 2004, p. 8) that characterizes many of Picabia's erotic paintings of the same period. Indeed, with its at least superficial lack of sophistication, the picture represents the transition in portraiture that occurred in the 1940s and 1950s, when artists like Jean Dubuffet (cat. 11) presented portraits that, in their resort to childlike depiction of the human figure, transgressively questioned traditional assumptions about modern art.

Selected bibliography: William A. Camfield, *Francis Picabia: His Art, Life, and Times* (Princeton, N.J., 1979), pp. 256–57, 259, 266–67; Maria Lluïsa Borràs, *Picabia*, trans. Kenneth Lyons (New York, 1985), pp. 421–27, 447–64, no. 774, fig. 964; exh. cat. Hamburg, Deichtorhallen, *Francis Picabia: The Late Works, 1933–1953*, cat. ed. by Zdenek Felix (also shown at Rotterdam, Museum Boijmans Van Beuningen), 1997–98, pp. 7–31, 151–58; exh. cat. New York, Michael Werner, *Francis Picabia, Late Paintings*, essay by Dave Hickey (also shown at Cologne, Galerie Michael Werner), 2000; exh. cat. New York, Sperone Westwater, *Giorgio de Chirico, Francis Picabia, Andy Warhol: A Triple Alliance*, cat. ed. by Gian Enzo Sperone with an essay by Robert Rosenblum, 2004, pp. 5–18, 74–75, ill.

Pablo Picasso
(Spanish, 1881–1973)
Ricciotto Canudo
1918
Pencil on paper
35.4 x 26.2 cm
The Museum of Modern Art,
New York. Acquired through the
Lillie P. Bliss Bequest, 1951, 18.1951

Pablo Picasso (1881–1973) was the initiator of the Ingres revival that swept through the Parisian avant-garde in the period immediately following World War I. Jean-Auguste-Dominique Ingres (1780–1867) epitomized traditional French art, and so it is not surprising that in the patriotic historic moment following the war, Picasso focused on this artist, copying a figure from at least one work by Ingres (*Tu Marcellus Eris*, 1813; Musées royaux des beaux-arts, Brussels) and producing a number of refined pencil drawings in an Ingresesque style (see Silver 1989, esp. pp. 139–45, 244–50). In the present exhibition, contemporaneous portrait drawings by Juan Gris, Amedeo Modigliani, and Diego Rivera are executed in the same manner (cats. 19, 33, 43).

The present drawing is a portrait of the Italian writer Ricciotto Canudo (1879–1923), to whom it is inscribed "A mon cher Canudo / Le Poète / Picasso / Montrouge 1918" (To my dear Canudo / Poet / Picasso / Montrouge 1918). Montrouge is the Parisian suburb where Picasso moved during the war. Novelist, poet, art critic, and cofounder of the publication *Montjoie!*, Canudo lived in Paris. From 1902 until his death he was friendly with Picasso, and Guillaume Apollinaire (cat. 25), Robert Delaunay (cat. 9), and Marc Chagall (cat. 5) were also among the writer's companions. Chagall described Canudo in his autobiography: "There is Canudo. Black goatee, burning eyes. Every Friday you can meet at his house Gleizes, Metzinger, La Fresnaye, Léger. . . . It was warm and pleasant there" (Chagall 1960, p. 111). Canudo's writings include discussions of art, music, dance, and early commentary on film. He served as a captain in the Garibaldi Corps and subsequently with the same rank in the Zouaves during World War I—writing *Combats d'Orient* (1917) on his wartime experiences—and it is in the costume of the Zouaves that Picasso depicts him.

Picasso presents Canudo seated, holding a cane capped with a bird's head, which, like Canudo's legs and the bottom of the chair, is left unfinished. Using extremely thin lines and virtually no shading, Picasso carefully delineates Canudo's face—with a mustache but no goatee for the military man—and uniform with cap, long coat, trousers, and the beginning of a boot.

Selected bibliography: Christian Zervos, *Pablo Picasso* (Paris, 1954), vol. 6, no. 1351, ill.; exh. cat. New York, Museum of Modern Art, *Picasso in the Collection of the Museum of Modern Art*, 1972, p. 107, ill.; Kenneth E. Silver, *Esprit de Corps: The Art of the Parisian Avant-Garde and the First World War, 1914–1925* (Princeton, N.J., 1989); Marc Chagall, *My Life*, trans. Elisabeth Abbott (New York, 1960).

Pablo Picasso
(Spanish, 1881–1973)
Portrait of Vollard I (39a)
1937
Aquatint

Portrait of Vollard II (39b)
1937
Aquatint

Portrait of Vollard III (39c)
1937
Etching

All 44.5 x 34 cm
Malcolm Wiener Collection

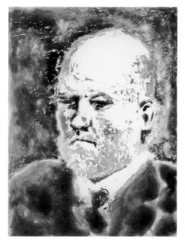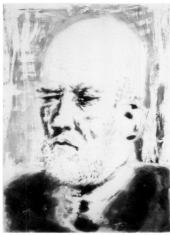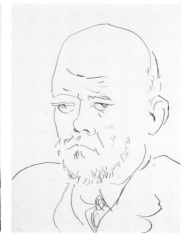

When Pablo Picasso (1881–1973) produced these three portrait prints of the dealer Ambroise Vollard (1866–1939) in 1937, it had been more than three decades since Vollard had first exhibited the work of the then young Spanish artist. Picasso had made a Cubist portrait of Vollard in 1910 (Pushkin State Museum of Fine Arts, Moscow)—the same year that Vollard purchased much of Picasso's work—and a drawing inspired by Jean-Auguste-Dominique Ingres (1780–1867) in 1915 (Metropolitan Museum of Art, New York), and their relationship had likewise evolved as both grew in reputation in the Paris art world.

As in the much earlier portrait of Vollard by Jean Puy (cat. 42) and Picasso's other portraits of the man, the dealer does not meet the viewer's gaze, and Vollard's deep-set eyes are somewhat overshadowed by his brow. Yet unlike in Puy's portrait, the sitter's erect posture indicates that he is certainly awake.

The three prints included in this exhibition are the final three images of the one hundred prints in the *Vollard Suite*, which Vollard probably commissioned about 1927 and for which Picasso was likely paid in paintings from Vollard's inventory. At some point in the process, Vollard hoped to pair Picasso's images with two texts by André Suarès (1868–1948), although this never occurred. When Vollard died in 1939, Picasso's prints went into storage, to be rediscovered only after the war.

Unlike many of the other images in the *Vollard Suite*—fanciful depictions of minotaurs and maidens, classical gods and beasts, and imaginative renderings of the artist in his studio—these three works are traditional portraits, rooted in the real rather than the fantastical. Yet despite their seeming basis in Vollard's physical appearance, they reflect Picasso's great interest—present throughout his career—in testing the boundaries and effects of different media. There is some uncertainty as to the order in which Picasso produced these three prints and the fourth related portrait of Vollard, which was not included in the *Vollard Suite*, but the numbers assigned here follow the catalogue raisonné of Picasso's graphic work by Brigitte Baer, with the print not from the *Vollard Suite* as number IV. Regardless, since they are distinct but related images, perhaps order is less significant than the varied technical approaches Picasso explored and how they yield different effects.

Primarily an aquatint with additional engraving, *Portrait of Vollard I* is a heavily saturated image, with a wide array of textures conveying the sitter's jacket and tie, the hair of his beard, and the murky background, somewhat reminiscent of night clouds. His face is partially in shadow, and the most brightly lit areas are Vollard's white forehead and cheek. Picasso conveys Vollard's enigma, a much discussed personality trait, through the way he is veiled in shadow.

Portrait of Vollard II, a crisper image, is also an aquatint, but without the additional work with the burin. Rendered more sparingly, Vollard's forehead is indicated not through outlines but through pure white—the absence of the background. Picasso has used fewer shades of gray than in *Portrait of Vollard I*.

Further simplifying his presentation, in the etching *Portrait of Vollard III*, Picasso economically renders the sitter's key features: the narrow eyes, wide forehead, upturned nose, beard, and mustache. Almost like a caricature, the sitter's features and expression are clearer when less information is given. Although this image presents the most legible view of Vollard's face, the others may be more evocative of the opaque qualities of Vollard's personality. Contrary to nineteenth-century practices of additively creating a composition, Picasso seems—if Baer's ordering is accurately chronological—to have gradually arrived at the most economical rendition of his subject.

Selected bibliography: Brigitte Baer, *Picasso: peintre-graveur; catalogue raisonné de l'oeuvre gravé et des monotypes, 1935–1945* (Bern, 1986), vol. 3, nos. 617–20, ill.; National Gallery of Australia, *Picasso, the Vollard Suite* (Canberra, 1997); Ambroise Vollard, *Recollections of a Picture Dealer*, trans. Violet M. MacDonald (Mineola, N.Y., 2002), pp. 219–25; exh. cat. New York, Metropolitan Museum of Art, *Cézanne to Picasso: Ambroise Vollard, Patron of the Avant-Garde*, cat. ed. by Rebecca A. Rabinow, with Douglas W. Druick, Gary Tinterow et al. (also shown at Art Institute of Chicago; Musée d'Orsay, Paris), 2006–7, pp. 4, 11, 17, 113–14, 279, 390, nos. 155–58.

Pablo Picasso
(Spanish, 1881–1973)
Portrait of Fabiani
c. 1943
Pencil on paper
51.1 x 32.1 cm
Malcolm Wiener Collection

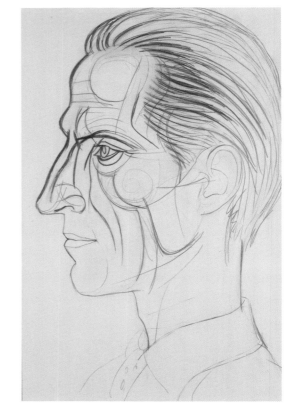

The opportunity to juxtapose comparable works—of the same subject matter, in the same medium, of similar size, and from the same year—by two of the twentieth century's great masters, Pablo Picasso (1881–1973) and Henri Matisse (cats. 26–30), is exceptional. Both artists produced portrait drawings of the rogue art dealer Martin Fabiani in 1943 (see cat. 29). It is especially interesting to consider these works together, since Fabiani was important to the two artists' relationship at this time, serving on occasion as an intermediary, and even working in similar ways with both artists, acquiring and often publishing their work.

In taking over the gallery of Ambroise Vollard (cats. 39, 42) after his death, Fabiani inherited some of Vollard's publishing projects, including the comte de Buffon's *Histoire naturelle* with prints by Picasso, which appeared in 1942. That same year, Fabiani made a trade with Picasso in which Picasso acquired a work by Matisse in exchange for one of his own paintings; Fabiani promptly informed Matisse. The following year, Matisse left a painting with Fabiani that Picasso had admired; Matisse wrote to Picasso on November 13 suggesting the latter take it in exchange for "a beautiful Picasso" (quoted in exh. cat. London 2002–3, p. 383).

Picasso obtained a work from Fabiani by Henri (Douanier) Rousseau (1844–1910) that, unbeknownst to Picasso, came from a collection stolen by the Nazis; after the war, when its origins began apparent, Picasso returned it to its rightful owner (Cone 1992, p. 148; Feliciano 1997, p. 121).

The Spaniard drew a number of portraits of Fabiani in July 1943, including a rather traditional frontal portrait with delicate lines and modeling (Museum of Modern Art, New York), and several additional drawings of Fabiani in complete or partial profile that were reproduced in Fabiani's memoirs. All of these emphasize the curves of Fabiani's seemingly greased hair. The present work is striking in its relationship to medical illustration; the viewer seems to be seeing through Fabiani's transparent flesh to the veins running through his head.

Picasso's portrait has a hard, cerebral quality. Its rigid anatomical clarity contrasts strongly with the soft, tentative lines and modeling of Matisse's portrait of Fabiani. Fabiani's erect posture in Picasso's drawing exudes confidence and determination, compared with the timid quality emitted by Matisse's portrait.

Selected bibliography: Martin Fabiani, *Quand j'étais marchand de tableaux* (Paris, 1976); Christie's, New York, *Impressionist and Modern Drawings and Watercolors*, November 11, 1987, lot 169, ill.; Michèle C. Cone, *Artists under Vichy: A Case of Prejudice and Persecution* (Princeton, N.J., 1992), pp. 49–50, 148; Hector Feliciano, *The Lost Museum: The Nazi Conspiracy to Steal the World's Greatest Works of Art* (New York, 1997); exh. cat. Fine Arts Museums of San Francisco, *Picasso and the War Years, 1937–1945*, cat. ed. by Stephen A. Nash, with Robert Rosenblum et al. (also shown at New York, Solomon R. Guggenheim Museum), 1998–99, p. 117, fig. 4; exh. cat. London, Tate Modern, *Matisse Picasso*, cat. by Elizabeth Cowling et al. (also shown at New York, Museum of Modern Art; Paris, Galeries nationales du Grand Palais), 2002–3, pp. 382–84.

Margit Pogany
(Hungarian, 1879/80–1964)
Self-Portrait
1913
Oil on cardboard
37.8 x 45.9 cm
Philadelphia Museum of Art:
Purchased with the Thomas Skelton
Harrison Fund, 1966

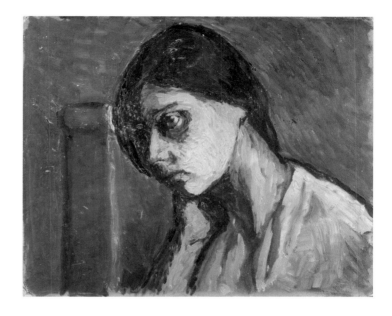

This intimate yet enigmatic self-portrait was painted by Constantin Brancusi's (cat. 3) famous subject, Margit Pogany (1879/80–1964). A Hungarian painter of Romanian origins who had gone to Paris to study painting, Pogany became friends with Brancusi during the summer of 1910, since he often ate his meals at the boardinghouse where she was living. After visiting his studio and discovering that he was working on a marble head that she thought represented her, she asked him to sculpt her portrait. Thus began Brancusi's series of three versions, in marble and bronze, of *Mademoiselle Pogany*, on which he worked for more than two decades.

Painted in 1913, the year before she received Brancusi's bronze portrait, Pogany's painted vision of herself is markedly different from Brancusi's in certain external qualities. Whereas Brancusi's portrait fixates on particular forms and abstracts them, Pogany's depiction of herself is entirely representational. Brancusi's sculpture has a glistening, smooth, machinelike surface; by contrast, Pogany uses visible, divided brushstrokes, reminding the viewer of the artist's hand in the act of painting.

Yet the works also share certain qualities. The private, mysterious aura evoked by the downward tilt and suggestion of lowered eyes in Brancusi's sculpture is shared in the tilted head of Pogany's self-portrait, with her face half hidden—partly turned and partly in shadow. In addition, both Pogany and Brancusi captured her heavily browed eyes, angular nose, and tendency to rest her face and neck against her hand.

Selected bibliography: Sidney Geist, *Brancusi: A Study of the Sculpture* (New York, 1968), Appendix 11, pp. 189–92, 189, ill.; Pontus Hultén, Natalia Dumitresco, and Alexandre Istrati, *Brancusi* (New York, 1987); Philadelphia Museum of Art, *Paintings from Europe and the Americas in the Philadelphia Museum of Art: A Concise Catalogue* (Philadelphia, 1994), p. 414, ill.; exh. cat. Philadelphia Museum of Art, *Constantin Brancusi: 1876–1957*, cat. by Friedrich Teja Bach, Margit Rowell, and Ann Temkin (also shown at Paris, Musée national d'Art Moderne, Centre Georges Pompidou), 1995, p. 120, ill.; Sanda Miller, *Constantin Brancusi: A Survey of His Work* (Oxford, 1995); Pierre Cabanne, *Constantin Brancusi* (Paris, 2002), pp. 79–83; Sanda Miller, "Brancusi's Women," *Apollo* 165, no. 541 (March 2007), pp. 56–63.

Jean Puy
(French, 1876–1960)
Portrait d'Ambroise Vollard
1908
Oil on canvas
81.9 x 130.8 cm
Private collection,
courtesy: Allan Stone Gallery,
New York

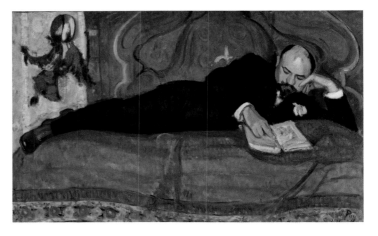

During the first third of the twentieth century, the French dealer Ambroise Vollard (1866–1939) demonstrated his keen discernment and willingness to take risks with even the most unproved members of the Parisian avant-garde. From lifting Paul Cézanne (1839–1906) from obscurity to promoting the Nabis and Fauves and mounting Pablo Picasso's (cats. 38–40) first solo exhibition, Vollard set the trends in the Paris art world and became a fixture in artistic circles. Born on the French island of Réunion in the Indian Ocean, he went to Paris in 1887 to finish his law degree but soon abandoned his studies to join the art world, first assisting in an art gallery, then opening his own. Following the 1905 Salon d'Automne, Jean Puy (1876–1960) and other exhibitors including Henri Matisse (cats. 26–30), Henri Manguin (1874–1949), Albert Marquet (1875–1947), and Charles Camoin (1879–1965) were aptly christened the Fauves (wild beasts) by the critic Louis Vauxcelles (1870–1943) for their canvases in which bright daubs of non-naturalistic color were applied without concern for how things appear in daylight. Vollard promptly made his move: in December, he acquired 76 drawings and 165 paintings from Puy, and he remained his dealer until 1926.

Puy had studied architecture in Lyon before settling in Paris in 1898 to attend the Académie Julian; disappointed with its limited approach to painting, he transferred to the Académie Carrière. Soon after his arrival there, the former students of Gustave Moreau (1826–1898), including Matisse and André Derain (1880–1954), entered the school, and it was through his friendship with these artists, more than by virtue of his own style, that he has been associated with the Fauves.

Puy's style remained more firmly rooted in traditional painting techniques than the styles of some of his friends. The present painting, though reminiscent of the Fauves in its bright colors, is more conservative in their application; its radicalism is most evident in its startling composition. Vollard's pose is a bit surprising, since such a position had far more frequently been used to present women. Indeed, Puy painted a number of works of women reclining on couches—some nude, others clothed—but the position is unusual for a male figure, and, moreover, it reflects a daring choice of pose for a formal portrait.

Captured in a casual moment, head resting on his left hand and the right hand fingering his book, Vollard's eyes face downward—he may be intent on the volume before him or, alternatively, he may have just dozed off, one of his well-known habits. The decorative floral border of the fabric on his couch may reflect the influence of Matisse, who devoted much attention to the intricacies of decorative fabrics; the swirling pattern with a fleur-de-lis behind Vollard is a reminder of the historical moment—Art Nouveau was just petering out. In the upper left corner, the hanging object appears to be a cap with feathers, and to its right the viewer may perhaps have a glimpse into another room.

Puy knew Vollard well by 1908, but they would become closer as the years progressed, with Puy writing detailed letters to his dealer as he served in the military during World War I. Years later the artist illustrated several texts for Vollard to publish in deluxe editions. Vollard also arranged for Puy and several other artists to produce ceramics under his patronage. This portrait suggests a certain level of comfort on Puy's part toward his dealer, yet at the same time it conveys a bit of the enigma that so famously surrounded Vollard. While capturing such distinguishing features as Vollard's round face, broadly balding head, and dark beard—as did the numerous other artists who portrayed the dealer, including Picasso and Pierre Bonnard (1867–1947)—Vollard looks down (as in a print by Bonnard), and so the viewer is prevented from engaging with him. Vollard's seeming indifference to the viewer, and to the painter, for that matter, may reflect the facet of his personality that once enabled him to keep the wealthy American collector Louisine Havemeyer waiting so long that she missed her boat back to New York.

Selected bibliography: Marcel Giry, *Fauvism: Origins and Development*, trans. Helga Harrison (New York, 1982), p. 247; Sarah Whitfield, *Fauvism* (London, 1991); exh. cat. Morlaix, Musée des Jacobins, *Un Fauve en Bretagne, Jean Puy*, 1995; Jean-Louis Ferrier, *The Fauves: The Reign of Colour* (Paris, 1992; Eng. ed. 1995), p. 214; exh. cat. Paris, Drouot-Montaigne, *Jean Puy, passions fauves*, 2001; Ambroise Vollard, *Recollections of a Picture Dealer*, trans. Violet M. MacDonald (Mineola, N.Y., 2002), p. 249; Lynn Boyer Ferrillo, "Puy, Jean," *Grove Art Online* (accessed March 12, 2008); exh. cat. New York, Metropolitan Museum of Art, *Cézanne to Picasso: Ambroise Vollard, Patron of the Avant-Garde*, cat. ed. by Rebecca A. Rabinow, with Douglas W. Druick, Gary Tinterow, et al. (also shown at Art Institute of Chicago; Musée d'Orsay, Paris), 2006–7, pp. 3, 4, 11, 12, 13, 26 n. 75, 17, 86, 125, 275–99.

Diego Rivera
(Mexican, 1886–1957)
Angeline Beloff
December 1917
Pencil on paper
33.7 x 25.4 cm
The Museum of Modern Art,
New York. Gift of Mrs. Wolfgang
Schoenborn in honor of René
d'Harnoncourt, 1975, 36.1975

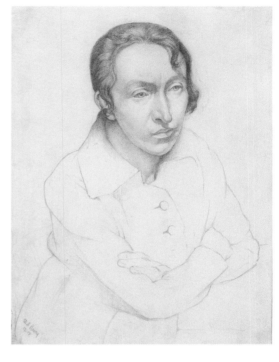

Long before Diego Rivera (1886–1957) met his now famous wife, Frida Kahlo (1907–1954), and preceding his career as a muralist, he lived in Paris with a different woman, also an artist: Angeline Beloff (1879–1969). Trained in St. Petersburg, first in science and subsequently in art, Beloff moved to Paris when her parents died in 1909.

After spending several years as a student at the San Carlos Academy of Fine Arts in his native Mexico, Rivera received a grant to pursue his artistic education in Europe. He soon tired of the artistic atmosphere of Madrid and left for Paris in 1909. On a visit to Bruges that year, Rivera and a friend encountered Angeline Beloff and her friend the painter María Blanchard; the four of them subsequently traveled and worked together. When they returned to Paris, Rivera, Beloff, and Blanchard all moved to Montparnasse, and in 1911 Rivera and Beloff began living together. During their years in Paris, Beloff played a critical role in introducing Rivera to the community of Russian expatriates who helped shape his leftist political sympathies. Rivera also developed friendships with many of the artists in Montparnasse whose work would affect the trajectory of his own, including Pablo Picasso (cats. 38–40), Foujita (cats. 15, 16), Jacques Lipchitz (cat. 23), Amedeo Modigliani (cats. 32, 33), and Chaim Soutine (cat. 44).

Despite Rivera's reputation today as an inveterate philanderer, he seems to have been faithful to Beloff in the early years of their life together. Yet by December 1917, when Rivera drew this portrait of Beloff, there had been much tragedy and strife between and around them: while Beloff stayed in the hospital after the birth of their son in the summer of 1916, Rivera began an affair with another Russian artist, known as Marevna. Beloff and Rivera separated for six months, but he returned to her in early 1917; their son died the following fall. Throughout all this, the Great War was raging.

From 1913 until about 1917, Rivera's paintings were Cubist. Yet, like others in this moment near the end of the war—particularly Picasso and Juan Gris (cat. 19)—Rivera abandoned Cubism and created a number of drawings inspired by the linear clarity of the Neoclassical French painter Jean-Auguste-Dominique Ingres (1780–1867). Ellen Sharp has noted that Rivera's drawings in this style tend to contain more shading and concentrate further on creating a sense of volume than those of Picasso (in exh. cat. Detroit 1986–87, p. 205).

Rivera had painted and drawn Beloff many times and in a variety of styles—from his Symbolist-inspired portrait (1909; property of the State of Veracruz) to several Cubist renditions to the Ingresque elegance of the present portrait. Here, Rivera uses generally smooth lines and exquisitely subtle shading, particularly on the face, to capture Beloff's features and melancholy as she folds her arms on a tabletop. Beneath her neck, the lines and modeling become increasingly spare, contributing to the sitter's apparent fragility.

After their son's death, Beloff and Rivera left Montparnasse. In 1921 Rivera abandoned Beloff for good, returning to Mexico to embark on the three decades of his career for which he is best known.

Selected bibliography: Florence Arquin, *Diego Rivera: The Shaping of an Artist, 1889–1921* (Norman, Oklahoma, 1971); Hayden Herrera, *Frida: A Biography of Frida Kahlo* (New York, 1983); exh. cat. Detroit Institute of Arts, *Diego Rivera: A Retrospective* (also shown at Philadelphia Museum of Art; Mexico City, Museo del Palacio de Bellas Artes; Madrid, Salas Pablo Ruiz Picasso; West Berlin, Staatliche Kunsthalle Berlin), 1986–87; Patrick Marnham, *Dreaming with His Eyes Open: A Life of Diego Rivera* (New York, 1998); Pete Hamill, *Diego Rivera* (New York, 1999).

Chaim Soutine
(French, born Lithuania, 1893–1943)
Portrait of Maria Lani
1929
Oil on canvas
73.3 x 59.7 cm
The Museum of Modern Art,
New York. Mrs. Sam A. Lewisohn
Bequest, 1954, 275.1954

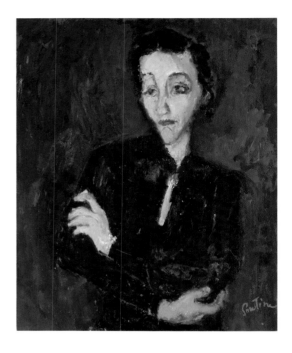

Friendly with many of the artists in Montparnasse, Chaim Soutine (1893–1943) made art that stands apart from that of his contemporaries in Paris. Although many artists among the Parisian avant-garde were Jewish—Marc Chagall (cat. 5), Jacques Lipchitz (cat. 23), Louis Marcoussis (cats. 25, 26), Amedeo Modigliani (cats. 32, 33), Jules Pascin (cats. 35, 36), and Chana Orloff (cat. 34), to name those in the present exhibition—Soutine and perhaps Chagall are the ones most associated in criticism and scholarship with their religion. This is odd in light of the fact that Soutine never painted Jewish subjects but did at times depict Christian ones. Chagall's imagery, by contrast, demands that his ethnicity be considered. Soutine's paintings have been described as Expressionist in style, but he cannot be easily grouped with the artists placed under that rubric in Germany or Scandinavia. In addition, in the 1950s Soutine was hailed as a precursor to Abstract Expressionism, despite the fact that his paintings always present subjects within the traditional genres of still life, landscape, and portraiture (see exh. cat. New York 1998–99 for more on the situation of Soutine within French art).

Born in the small, largely Jewish town of Smilovitchi outside Minsk, Soutine was one of eleven children in a poor family. He left for Minsk in 1909 to study art, traveling to Vilna the next year to enroll in the Academy of Fine Arts there. He apparently worked as a retoucher for a photographer in Vilna before moving again, in 1913, this time to Paris. He entered the Ecole des Beaux-Arts, where he studied with Fernand Cormon (1845–1924), and he also took evening drawing classes at the Russian Academy. He spent a great deal of time at the Musée du Louvre studying the old masters, and he became particularly fascinated with Rembrandt van Rijn (1606–1669) and Jean-Siméon Chardin (1699–1779). Already acquainted with many of the Montparnasse crowd, Soutine met Modigliani in 1915, who became an intimate friend. Soutine finally achieved a degree of financial success after the American collector Albert Barnes (1872–1951) purchased fifty-two of his paintings in 1922.

In dividing Soutine's work into periods during which different genres predominated—first landscape, then still life, and finally portraiture—Esti Dunow has importantly observed that through the earlier phases, Soutine's development moves toward portraiture, with images presented increasingly clearly and with careful attention to individual details, be they of a tree, an animal carcass, or finally a human subject (Dunow in exh. cat. New York 1973, pp. 7–11). Soutine painted this portrait of Maria Lani (1905/6–1954) at the beginning of the period during which images of people were his primary focus (see cat. 28 for the enigmatic tale of Maria Lani).

The brushwork, as in most paintings by Soutine, is striking. Rough slashes of dark blue fill the background, into which the brunette, darkly clad Lani seems to fade. Her dark blouse is speckled with light dabs of white, blue, and green, and its slit is held together at the neck with a brooch. The brightly painted flesh of the sitter's hands, face, neck, and the visible strip of her chest are enlivened with swift red highlights; these areas leap out so vividly against the dark clothing and background that she almost looks like a puppet on a stick or a hand-held mask. An article in *Time* magazine described Soutine's Lani as a "spectre" ("51 Portraits," 1929). Dunow and others have observed that this focus on face and hands set in sharp contrast to a dark backdrop, common to many of Soutine's works, may have been inspired by Rembrandt (Dunow in exh. cat. New York 1973, p. 13; Tuchman, Dunow, and Perls 2001, p. 512). As in the portraits of Lani by Henri Matisse (cat. 28) and Orloff (cat. 34), Soutine emphasizes Lani's sharp chin, yet he does not accentuate the arrangement of her eyebrows, eyes, and nose. She gazes to the viewer's left, her arms folded protectively around her.

The tension between representing the individuality of a sitter as opposed to the distinctiveness of the painter (see cat. 27) is evident here. Soutine favored painting people he did not know over those he did (Dunow in exh. cat. New York 1973, p. 11; Tuchman, Dunow, and Perls 2001, p. 509), and this may reflect the ease with which he could then entirely cast them within his personal vision. Scholars have commented on the strength of Soutine's style. As Sam Hunter wrote, citing Andrew Forge, Soutine's works "virtually 'reek' of Soutine: they are drenched and saturated by his presence" (Hunter in exh. cat. New York 1973, p. 16), and this painting is no exception.

The catalogue raisonné of Soutine's work includes the present painting as well as an extremely similar but slightly smaller portrait of Lani (ill. in Tuchman, Dunow, and Perls 2001, no. 130). Although it is unclear which portrait was exhibited in the Lani exhibitions, it seems most likely that it was the Museum of Modern Art's version, which has crisper forms and appears more fully resolved.

Reports of Soutine's artistic process indicate that, in addition to being fussy about materials—he preferred to work on old canvases, went through countless brushes, and insisted on painting from the same decaying pieces of meat for days on end—Soutine was also notoriously volatile and critical of himself. Consequently, modeling for him had its own difficulties. In her memoirs, *Life with the Painters of La Ruche* (1972), the painter Marevna recalled Soutine saying,

> To do a portrait, it's necessary to take one's time, but the model tires quickly and assumes a stupid expression. Then it's necessary to hurry up and that irritates me. I become unnerved. I grind my teeth, and sometimes it gets to a point where I scream. I slash the canvas, and everything goes to hell, and I fall down on the floor. I always implore them to pose without saying a word and without stirring their arms and legs. . . . I admit that this is stupid, and even horrible, and I am always terrified at this moment.
> (Quoted by Hunter in exh. cat. New York 1973, p. 16.)

Soutine had various lovers; his last was Marie-Berthe Aurenche (1906–1960), who had been Max Ernst's (cat. 14) first wife. They met in 1940 and hid together in the Loire region during the German occupation. Soutine had suffered from ill health for many years, and they traveled to Paris in 1943 so that he could have an operation on a perforated ulcer. He died immediately after the operation.

Selected bibliography: Elie Faure, *Soutine* (Paris, 1929), no. 30, ill.; exh. cat. New York, Brummer Gallery, *Portraits of Maria Lani by Fifty-one Painters*, 1929, no. 46; Jean Cocteau, Mac Ramo, and Waldemar George, *Maria Lani* (Paris, 1929), p. 46, ill.; "51 Portraits," *Time*, November 18, 1929; "50 Künstler porträtieren eine Frau," *Deutsche Kunst und Dekoration* 66 (July 1930), pp. 226–45, ill.; exh. cat. New York, Museum of Modern Art, *Paintings from New York Private Collections*, 1946, p. 7; exh. cat. New York, Museum of Modern Art, *Soutine*, cat. by Monroe Wheeler (also shown at Cleveland Museum of Art), 1950–51, pp. 92, 94, ill.; exh. cat. Hartford, Connecticut, Wadsworth Atheneum, *Twentieth Century Painting from Three Cities: New York, New Haven, Hartford; A Special Exhibition Drawn from the Collections of the Metropolitan Museum of Art, the Museum of Modern Art, the Brooklyn Museum, the Whitney Museum of American Art, the Solomon R. Guggenheim Museum, the Yale University Art Gallery and the Wadsworth Atheneum*, 1955, no. 49; Jean Leymarie, *Soutine*, trans. John Ross (New York, 1964), pl. XIX; exh. cat. Paris, Orangerie des Tuileries, *Soutine*, 1973, no. 48, ill.; exh. cat. New York, Marlborough Gallery, *Chaim Soutine, 1893–1943*, intro. by Maurice Tuchman, 1973, pp. 6–10, no. 58, ill.; Alfred Werner, *Chaim Soutine* (New York, 1977), no. 38, ill.; exh. cat. New York, Galleri Bellman, *Soutine (1893–1943)*, 1983–84, p. 67, cover, ill.; exh. cat. New York, Jewish Museum, *The Circle of Montparnasse: Jewish Artists in Paris, 1905–1945*, cat. by Kenneth E. Silver and Romy Golan, 1985–86, pp. 114–15, no. 104, fig. 46; exh. cat. Musée de Chartres, *Soutine*, cat. by Maïthé Vallès-Bled, 1989, no. 56, ill.; exh. cat. New York, Jewish Museum, *An Expressionist in Paris: The Paintings of Chaim Soutine*, cat. by Norman L. Kleeblatt and Kenneth E. Silver (also shown at Los Angeles County Museum of Art; Cincinnati Art Museum), 1998–99; Maurice Tuchman, Esti Dunow, and Klaus Perls, *Chaim Soutine (1893–1943): Catalogue* (Cologne/New York, 2001), pp. 509–13, no. 131, ill.

Pavel Tchelitchew
(American, born Russia, 1898–1957)
Portrait of Gertrude Stein
c. 1931
Sepia ink on paper
44.8 x 27.6 cm
William Kelly Simpson, New York

Pavel Tchelitchew (1898–1957) was trained in art and ballet, studying first at his home near Moscow with tutors and later at Moscow University and the Kiev Academy, where one of his teachers, a former student of Fernand Léger (1881–1955), provided him with training in Constructivist precepts. After stops in Constantinople, Sophia, and Berlin, he met Serge Diaghilev (1872–1929), who encouraged him to go to Paris, where he settled in 1923; he would remain there until his departure for the United States in 1934.

Tchelitchew and Gertrude Stein (1874–1946) met in 1925, after Stein had admired his *Basket of Strawberries* at that year's Salon d'Automne. They supposedly crossed paths on a bridge in Paris, and Stein went to Tchelitchew's house soon after; since he was not there, she forced open a locked cupboard to view his paintings. She subsequently included him in her circle, exposing him to her impressive art collection, acquiring some of his work, inviting him to her country house, and introducing him to her friends. The close relationship lasted just a few years, before the middle-aged American writer cast off the young Russian artist of aristocratic lineage.

Although Stein did not commission a portrait, Tchelitchew drew her several times. It seems likely that the present work was a study for a compositionally similar but more polished, crisper version, which has a head study of Stein in the lower left corner and a clearer delineation of the background wall and floorboards (dated 1931, but probably from 1929; Yale University Art Gallery, New Haven). Another version, from 1930, drawn in black ink and in which Stein and her chair do not seem to fade into one another, is in the Art Institute of Chicago, and yet another portrait of her, from about 1928—half-length and more traditional—was shown at the Alpine Club in London in 1974.

William Kelly Simpson's drawing depicts Stein cryptically—she seems physically both present and absent. Her head appears as if painted on a canvas, perched on the back of an armchair. Her classicizing robe with swathes of netting fastened at the shoulders seems to suggest Stein's physical presence, yet its shape is so molded over the armchair and the lower folds revelatory only of the chair beneath—not of the contours of Stein's body—that it could simply be elaborate upholstery. Two hands emerge from the faintly insinuated sleeves: the left hand points an index finger downward, while the right hand rests on an orb. In Yale's drawing, by contrast, the hands are clearly separated from the sleeves, and Lincoln Kirstein has described them as plaster models such as were used in academic art classes (Kirstein 1994, p. 44). The present drawing contains a sandaled foot emerging from beneath the robes, but in Yale's drawing, the foot is only subtly suggested.

Thus, it seems that the present work was a first step toward Tchelitchew's goal of creating a portrait of Stein that is also not a portrait, merely an assemblage of objects that seem to resemble her, including one—the canvas—that is a true portrait. Although this work may trigger associations with Surrealism, and Tchelitchew has sometimes been associated with the Surrealists, he eschewed that affiliation. Rather, it reflects his interest in depicting change and transformation, oneness and duality; he described art "as a kind of science of metamorphosis . . . as a magic which can transform any visible object into a whole series of other objects" (quoted in exh. cat. Norman 2002, p. 6). Here, the viewer is left to ponder whether Stein is present or not, whether she belongs to art or the real world.

Stein also portrayed Tchelitchew: a verbal portrait of him appeared in her *Dix Portraits* (1929), which also included portraits of Apollinaire (cat. 25) and Christian Bérard (cat. 2), a painter often grouped with Tchelitchew as a Neo-Romantic or Neo-Humanist.

Selected bibliography: Lincoln Kirstein, ed., *Pavel Tchelitchew Drawings* (New York, 1947), pp. 11, 15; exh. cat. London, Alpine Club, *Pavel Tchelitchew: A Selection of Gouaches, Drawings and Paintings*, cat. by Richard Nathanson, 1974, no. 5; Christie's, New York, *Impressionist and Modern Drawings and Watercolors*, May 15, 1986, lot 159; Lincoln Kirstein, *Pavel Feodorovitch Tchelitchew: 1898–1957* (Tokyo, 1994); exh. cat. Norman, Fred Jones Jr. Museum of Art, University of Oklahoma, *Pavel Tchelitchew*, cat. by Victor Koshkin-Youritzin, 2002.

Jacques Villon
(French, 1875–1963)
*Monsieur D(uchamp) lisant
(Monsieur D[uchamp] Reading)*
1913
Pencil on paper
55.9 x 40.6 cm
Ursula and R. Stanley Johnson Family
Collection

In the works in this exhibition, the talented Duchamp brothers are represented looking outward at a doctor and a couturier (cats. 13, 47), inward for an unusual self-portrait (cat. 12), and finally, in the present drawing, upward with a probing glance toward their father. Jacques Villon (1875–1963) was the elder brother of Raymond Duchamp-Villon (cat. 13) and Marcel Duchamp (cat. 12). He studied printmaking with his grandfather Emile Nicolle (1830–1894) and also attended the Ecole des Beaux-Arts in Rouen. Leaving for Paris in 1895 to pursue his art, Villon, born Gaston Duchamp, assumed a pseudonym: he took the name Villon from the medieval French poet François Villon and Jacques from the title character in Alphonse Daudet's novel *Jack* (1876). Villon studied at the Atelier Cormon while living with his brother Duchamp-Villon. Villon focused on prints until about 1910, when he turned his attention to paintings; around that time, he began working in a Cubist style.

This Cubist portrait of the lawyer Justin-Isidore Duchamp (also known as Eugène or Eusèbe) (d. 1925), was one of many portraits Villon made of his father, from an etched portrait in 1891 to a posthumous etching in 1929, and perhaps even a rather abstract portrait from 1958. In 1904 he had produced a naturalistic drypoint (ill. in exh. cat. New York 1970, frontispiece), in which the harsh and uncontrolled lines behind the sitter and on his collar seem to foreshadow the far more orderly hatching of the drawing in this exhibition. Villon produced a rather naturalistic seated portrait of his father reading a newspaper that is dated 1913, although this date has been disputed (Musée des Beaux-Arts, Rouen). The present work seems to be a study both for Villon's oval portrait of his father of 1913 (ill. in exh. cat. Cambridge 1976, no. 40a) as well as for the closely related, although reversed, drypoint, also of 1913 (ill. in ibid., no. 40). Villon was not the only Duchamp brother to portray their father; Marcel Duchamp painted a traditional portrait of their father in 1910 (Philadelphia Museum of Art).

In this highly controlled drawing, Villon extended the various planes of his father's face and body toward the sheet's edges, underscoring the idea that the subject is a composite of geometric forms. The subtly executed hatching and cross-hatching, with darker lines gradually fading into lighter ones, suggest shadows and the play of light on the figure. This drawing reflects Villon's interest in the Section d'Or (Golden Section), a mathematical proportion relating to the division of straight lines or rectangles into two parts such that the ratio of the smaller part to the larger equals the ratio of the larger part to the whole. The Puteaux Cubists—those who gathered around the Duchamp brothers' Puteaux studios beginning about 1911—studied this proportion and named their exhibition of 1912, at the Galerie de la Boétie, the Salon de la Section d'Or.

Villon said, "One mustn't force oneself to capture the sitter. Every portrait must come into being of its own accord. All one has to do is to be on the look out" (quoted in Shoemaker 2001, p. 35). Indeed, this portrait of his father has the feeling of disparate parts suddenly merging into a faintly recognizable form.

Selected bibliography: exh. cat. New York, Lucien Goldschmidt, *Jacques Villon: A Collection of Graphic Work, 1896–1913, in Rare or Unique Impressions*, 1970; exh. cat. Cambridge, Massachusetts, Fogg Art Museum, *Jacques Villon*, cat. ed. by Daniel Robbins (also shown at Roy R. Neuberger Museum, Purchase, N.Y.), 1976, pp. 24-25, 60-63; Ian Chilvers, "Section d'Or," in *The Oxford Companion to Western Art*, ed. Hugh Brigstocke (Oxford, 2001), *Oxford Reference Online* (accessed June 16, 2008); Innis Howe Shoemaker, *Jacques Villon and His Cubist Prints* (Philadelphia, 2001), pp. 18, 35–37, 56; exh. cat. Art Institute of Chicago, *Graphic Modernism: Selections from the Francey and Dr. Martin L. Gecht Collection at The Art Institute of Chicago*, 2003, no. 124, ill.; Chicago, R. S. Johnson Fine Art, *Fifty Drawings: Mantegna to Cézanne to Picasso*, 2008, no. 34, ill.

Jacques Villon
(French, 1875–1963)
Portrait (Caricature) of Paul Poiret
c. late 1920s
Ink or gouache on paper
32.7 x 24.8 cm
William Kelly Simpson, New York

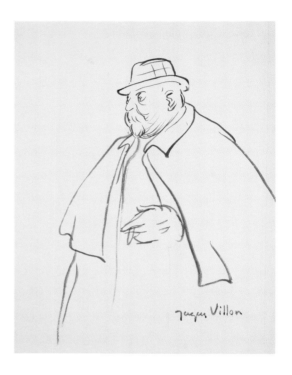

The caricatures presented in this exhibition and discussed in Kenneth E. Silver's essay reflect the cross-pollination between Parisian avant-garde artists and their visual and verbal commentators in the press. In mediating and often exaggerating the identities the artists sought to create, caricaturists helped forge larger-than-life personalities around the artists they depicted. Works like Pablo Gargallo's *Kiki de Montparnasse* (cat. 17) demonstrate how artists also utilized, at times, the techniques of caricaturists, choosing elements of caricature—amplification of distinctive features, simplification, humor—and incorporating them into fine art.

Similarly, caricatures survive that were produced by artists, not for the media, but perhaps on an impulse. Jacques Villon (1875–1963), the elder brother of Raymond Duchamp-Villon (cat. 13) and Marcel Duchamp (cat. 12), probably produced this caricature of the couturier Paul Poiret (1879–1944) in the late 1920s, to judge from Poiret's age. The fashion designer here appears robust and dignified; several lines indicate a flowing cloak, out of which emerges a hand bearing a cigar or cigarette. His distinctive beard and girth make him recognizable, but aside from his elegance, Villon does not refer to Poiret's claim to fame. Poiret worked for two prestigious couturiers in Paris—Jacques Doucet and the House of Worth—before starting his own house in 1903. He set himself apart immediately by abandoning the petticoat and the corset—thus changing forever the social expectations for the appropriate female silhouette. He promoted his distinctive new clothing with numerous costume fêtes, and in 1911 he opened two related businesses, one purveying specially designed perfume and cosmetic products, named for his elder daughter, Rosine, and the other selling decorative arts, named for his second daughter, Martine. This linking of fashion, perfume, and interior design—and selling all three essentially as art—was revolutionary in Paris. Poiret not only promoted his own work as art but also associated with artists in the avant-garde, purchased their work, and collaborated with some of them. The period before World War I was Poiret's heyday, and in the postwar years, his reliance on ornament and orientalist themes seemed outdated. His businesses closed in 1929.

Villon had worked as an illustrator early in his career, and this work is a reminder of the porous boundaries between the different kinds of visual material produced in Paris.

Selected bibliography: exh. cat. Philadelphia Museum of Art, *Jacques Villon, Poet of Precision: A New Acquisition in Context*, 2001; exh. cat. Paris, Galerie Schmit, *Rétrospective Jacques Villon, 1875–1963: peintre-dessinateur,* 2004, pp. 103–6; exh. cat. New York, Metropolitan Museum of Art, *Poiret*, cat. by Harold Koda and Andrew Bolton, 2007.

ARTISTS, FRIENDS, AND LOVERS

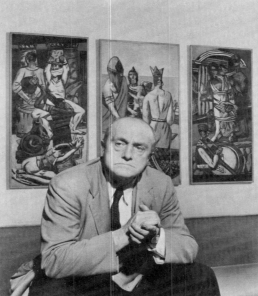

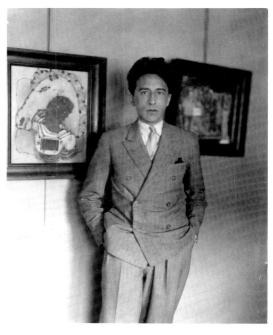

1. Josephine Baker

2. Max Beckmann

3. Christian Bérard

4. Constantin Brancusi

5. Marc Chagall

6. Jean Cocteau

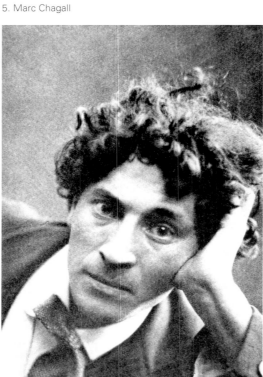

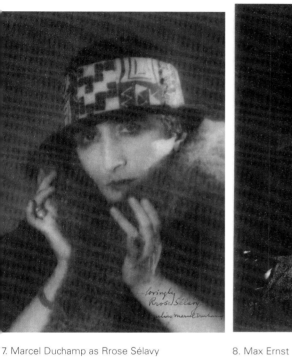

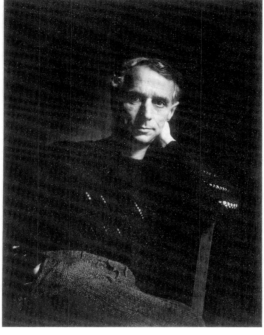

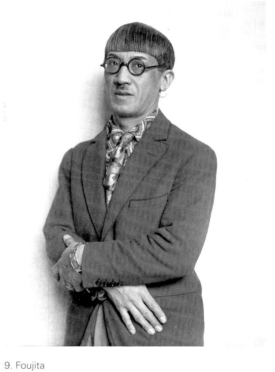

7. Marcel Duchamp as Rrose Sélavy

8. Max Ernst

9. Foujita

10. Gala Eluard

11. Albert Gleizes

12. Juan Gris

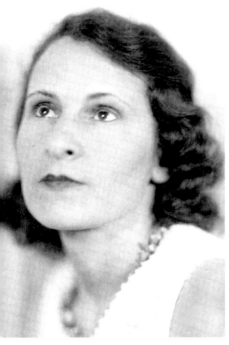

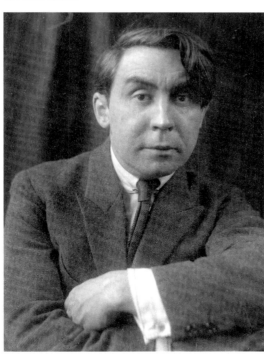

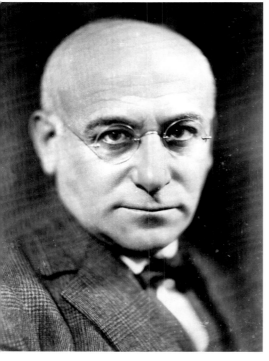

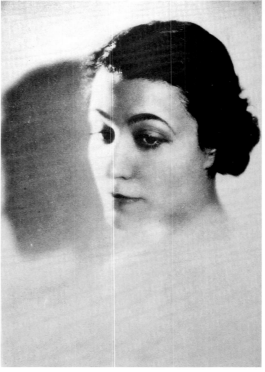

13. Max Jacob

14. Maria Lani

15. Marie Laurencin

16. Jacques Lipchitz

17. Man Ray

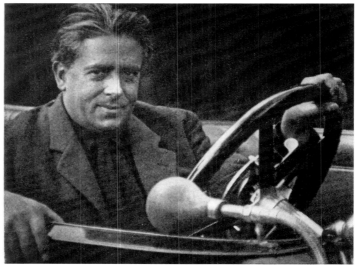

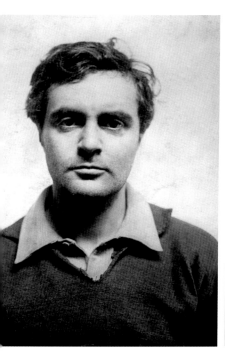

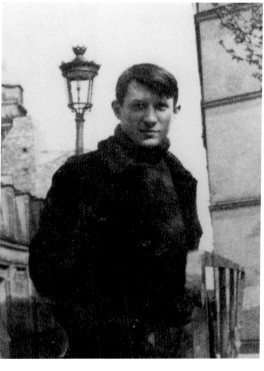

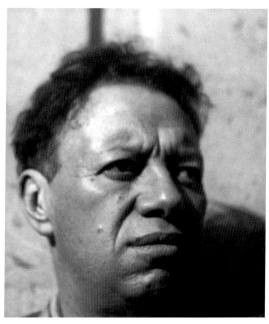

3. Amedeo Modigliani

19. Pablo Picasso

20. Diego Rivera

. Ida Rubinstein

22. Gertrude Stein

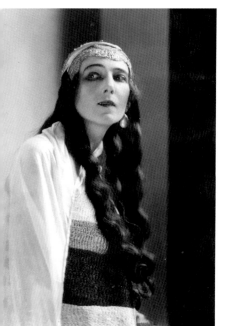

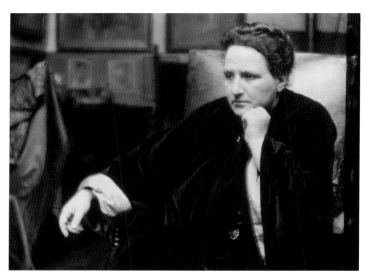

1. General Photographic Agency / Hulton Archive
Josephine Baker
Getty Images

2. *Max Beckmann in front of His Triptych, "Departure"*
(1932–33). The Museum of Modern Art, New York, 1947
Photograph
Photographic Archive, The Museum of Modern Art Archives,
The Museum of Modern Art, New York. Print given to MoMA
Photographic Archive in 1980 by Mrs. Max Beckmann (PA259)
Digital Image © The Museum of Modern Art / Licensed by
SCALA / Art Resource, NY. Photographer: Geoffrey Clements

3. Dmitri Kessel / Time & Life Pictures
Christian Bérard
Getty Images

4. Constantin Brancusi (Romanian, 1876–1957)
Self-Portrait in the Studio
Silver print
Musée national d'Art Moderne, Centre Georges Pompidou,
Paris, France
© 2008 Artists Rights Society (ARS), New York / ADAGP, Paris.
CNAC / MNAM / Dist. Réunion des Musées Nationaux / Art
Resource, NY. Photo: Bertrand Prevost

5. Imagno / Hulton Archive
Marc Chagall
Getty Images

6. Sasha / Hulton Archive
Jean Cocteau
Getty Images

7. Marcel Duchamp (French, 1887–1968)
Marcel Duchamp as Rrose Sélavy, c. 1920–21
Gelatin silver print, 21.6 x 17.3 cm
Philadelphia Museum of Art. The Samuel S. White 3rd and
Vera White Collection, 1957
© 2008 Artists Rights Society (ARS), New York / ADAGP, Paris /
Succession Marcel Duchamp. The Philadelphia Museum of Art
/ Art Resource, NY

8. André Rogi (Rosa Klein) (Hungarian, 1900–1970)
Max Ernst, 1936
Gelatin silver print, 40 x 30 cm
Musée National d'Art Moderne, Centre Georges Pompidou,
Paris, France, AM1982-291
CNAC / MNAM / Dist. Réunion des Musées Nationaux / Art
Resource, NY. Photo: Georges Meguerditchian

9. Lipnitzki / Roger Viollet
Foujita
Getty Images

10. Martinie / Roger Viollet
Gala
Getty Images

11. Choumoff / Roger Viollet
Albert Gleizes
Getty Images

12. Hulton Archive
Juan Gris
Getty Images

13. Martinie / Roger Viollet
Max Jacob
Getty Images

14. Jean Cocteau, Mac Ramo, and Waldemar George
Maria Lani (Paris, 1929)
Frick Art Reference Library

15. Anonymous
Portrait of Marie Laurencin, 1908
Photograph
Private collection, Paris, France
Snark / Art Resource, NY

16. Fred Stein (German, 1909–1967)
Jacques Lipchitz (1891–1973), French Cubist Sculptor, 1942
Photograph
© 2008 Estate of Fred Stein / Artists Rights Society (ARS),
New York. Art Resource, NY

17. Man Ray (American, 1890–1976)
Francis Picabia at the Wheel of a Car. Photograph became part
of a collage composition called *The Merry Widow,* 1921
© 2008 Man Ray Trust / Artists Rights Society (ARS), NY /
ADAGP, Paris. Snark / Art Resource, NY

18. Hulton Archive
Amedeo Modigliani
Getty Images

19. Pablo Picasso (Spanish, 1881–1973)
Pablo Picasso at Montmartre, place de Ravignan, c. 1904
Musée Picasso, Paris, France, Inv.: DP 7
© 2008 Estate of Pablo Picasso / Artists Rights Society (ARS),
New York. Réunion des Musées Nationaux / Art Resource, NY.
Photo: RMN-J.Faujour

20. Time Life Pictures / Time & Life Pictures
Diego Rivera
Getty Images

21. James Abbe / Hulton Archive
Ida Rubinstein
Getty Images

22. George Eastman House / Hulton Archive
Gertrude Stein
Getty Images

PHOTOGRAPHY CREDITS

Rights and Reproduction

Photographs of works of art reproduced in this volume have been provided in many cases by the owners or custodians of the works. Individual works of art appearing herein may be protected by copyright in the United States of America or elsewhere, and may thus not be reproduced in any form without the permission of the copyright owners. The following and/or other photography credits appear at the request of the artists's representatives and/or owners of individual works.

Cat. 1 © 2008 Artists Rights Society (ARS), New York / VG Bild-Kunst, Bonn
Cat. 2 © 2008 Artists Rights Society (ARS), New York / ADAGP, Paris. Photo by Paul Mutino
Cat. 3 © 2008 Artists Rights Society (ARS), New York / ADAGP, Paris
Cat. 5 © 2008 Artists Rights Society (ARS), New York / ADAGP, Paris. Image © The Metropolitan Museum of Art
Cat. 6a-j © 2008 Artists Rights Society (ARS), New York / ADAGP, Paris
Cat. 7 © 2008 Artists Rights Society (ARS), New York / ADAGP, Paris
Cat. 8 © 2008 Salvador Dalí, Gala-Salvador Dalí Foundation / Artists Rights Society (ARS), New York.
 Collection of the Salvador Dalí Museum, Inc., St. Petersburg, FL, 2008
Cat. 9 © L & M SERVICES B.V. The Hague 20080609
Cat. 11 © 2008 Artists Rights Society (ARS), New York / ADAGP, Paris. Photo by Lee Stalsworth
Cat. 12 © 2008 Artists Rights Society (ARS), New York / ADAGP, Paris / Succession Marcel Duchamp
Cat. 13 © 2008 Artists Rights Society (ARS), New York / ADAGP, Paris / Succession Duchamp.
 Copyright 2008 Indiana University Art Museum
Cat. 14 © 2008 Artists Rights Society (ARS), New York / ADAGP, Paris. Image © The Metropolitan Museum of Art
Cat. 15 © 2008 Artists Rights Society (ARS), New York / ADAGP, Paris. Photo by Paul Mutino
Cat. 16 © 2008 Artists Rights Society (ARS), New York / ADAGP, Paris © 2008 Museum Associates / LACMA
Cat. 17 © 2008 Artists Rights Society (ARS), New York / ADAGP, Paris. Photo by Lee Stalsworth
Cat. 18 © 2008 Artists Rights Society (ARS), New York / ADAGP, Paris
Cat. 19 Digital Image © The Museum of Modern Art / Licensed by SCALA / Art Resource, NY
Cat. 21 © 2008 Artists Rights Society (ARS), New York / ADAGP, Paris. Photo by Paul Mutino
Cat. 22 © 2008 Artists Rights Society (ARS), New York / ADAGP, Paris.
 Digital Image © The Museum of Modern Art / Licensed by SCALA / Art Resource, NY
Cat. 24 © 2008 Artists Rights Society (ARS), New York / ADAGP, Paris. Photo by Paul Mutino
Cat. 25 © 2008 Artists Rights Society (ARS), New York / ADAGP, Paris. Photo by Paul Mutino
Cat. 26 © 2008 Succession H. Matisse / Artists Rights Society (ARS), New York
Cat. 27a-c © 2008 Succession H. Matisse / Artists Rights Society (ARS), New York
Cat. 28 © 2008 Succession H. Matisse / Artists Rights Society (ARS), New York.
 Image courtesy of the Board of Trustees, National Gallery of Art, Washington, D.C.
Cat. 29 © 2008 Succession H. Matisse / Artists Rights Society (ARS), New York. Photo by Paul Mutino
Cat. 30 © 2008 Succession H. Matisse / Artists Rights Society (ARS), New York.
 Digital Image © The Museum of Modern Art / Licensed by SCALA / Art Resource, NY
Cat. 31 © 2008 Artists Rights Society (ARS), New York / ADAGP, Paris
Cat. 32 Photo by Paul Mutino
Cat. 33 Photo by Paul Mutino
Cat. 34 © 2008 Artists Rights Society (ARS), New York / ADAGP, Paris
Cat. 35 Image © The Metropolitan Museum of Art
Cat. 37 © 2008 Artists Rights Society (ARS), New York / ADAGP, Paris
Cat. 38 © 2008 Estate of Pablo Picasso / Artists Rights Society (ARS), New York.
 Digital Image © The Museum of Modern Art / Licensed by SCALA / Art Resource, NY
Cat. 39a-c © 2008 Estate of Pablo Picasso / Artists Rights Society (ARS), New York. Photos by Paul Mutino
Cat. 40 © 2008 Estate of Pablo Picasso / Artists Rights Society (ARS), New York. Photo by Paul Mutino
Cat. 42 © 2008 Artists Rights Society (ARS), New York / ADAGP, Paris. Photo by Paul Mutino
Cat. 43 © 2008 Banco de México Diego Rivera & Frida Kahlo Museums Trust. Av. Cinco de Mayo No. 2, Col. Centro,
 Del. Cuauhtémoc 06059, México, D.F.
 Digital Image © The Museum of Modern Art / Licensed by SCALA / Art Resource, NY
Cat. 44 © 2008 Artists Rights Society (ARS), New York / ADAGP, Paris.
 Digital Image © The Museum of Modern Art / Licensed by SCALA / Art Resource, NY
Cat. 45 Photo by Paul Mutino
Cat. 46 © 2008 Artists Rights Society (ARS), New York / ADAGP, Paris
Cat. 47 © 2008 Artists Rights Society (ARS), New York / ADAGP, Paris. Photo by Paul Mutino

Fig. 8 Photography © The Art Institute of Chicago
Fig. 9 © 2008 Artists Rights Society (ARS), New York / ADAGP, Paris
Fig. 10 © 2008 Salvador Dalí, Gala-Salvador Dalí Foundation / Artists Rights Society (ARS), New York
Fig. 11 © 2008 Estate of Pablo Picasso / Artists Rights Society (ARS), New York.
 Image copyright © The Metropolitan Museum of Art / Art Resource, NY
Fig. 12 Erich Lessing / Art Resource, NY
Fig. 15 © 2008 Artists Rights Society (ARS), New York / ADAGP, Paris. Snark / Art Resource, NY
Fig. 16 © Estate of George Platt Lynes. Digital Image © The Museum of Modern Art / Licensed by SCALA / Art Resource, NY

LENDERS

Albright-Knox Art Gallery, Buffalo, New York
The Baltimore Museum of Art
Collection of Frances Beatty and Allen Adler
Columbus Museum of Art, Ohio
Salvador Dalí Museum, St. Petersburg, Florida
Solomon R. Guggenheim Museum, New York
Hirshhorn Museum and Sculpture Garden, Smithsonian Institution, Washington, D.C.
Indiana University Art Museum
Ursula and R. Stanley Johnson Family Collection
Los Angeles County Museum of Art
The Metropolitan Museum of Art
Mount Holyoke College Art Museum, South Hadley, Massachusetts
The Museum of Modern Art, New York
National Gallery of Art, Washington, D.C.
Norton Museum of Art, West Palm Beach, Florida
Philadelphia Museum of Art
The Phillips Collection, Washington, D.C.
Private collection, courtesy: Allan Stone Gallery, New York
Private collections
The Rennert Collection, New York
John Richardson Collection, New York
William Kelly Simpson, New York
Smithsonian American Art Museum
Collection Gian Enzo Sperone, New York
Malcolm Wiener Collection